HOLLYWOOD

THEN & NOW

First published in the United Kingdom in 2013 by
PAVILION BOOKS
an imprint of Anova Books Company Ltd.
10 Southcombe Street, London W14 0RA, UK.

"Then and Now" is a registered trademark of Anova Books Ltd.

© 2013 Salamander Books

This book is a revision of the original *Hollywood Then and Now*, by Rosemary Lord, first published in 2003 by PRC Publishing, an imprint of Anova Books Ltd.

All notations of errors or omissions should be addressed to Salamander Books, 10 Southcombe Street, London W14 0RA, UK.

ISBN-13: 978-1-90910-839-4

Printed in China

10 9 8 7 6 5 4 3 2 1

Acknowledgments

Bruce Torrence, for so generously sharing his extensive knowledge; Jeannette Adler, for the gift of her time and her skills; Helene Demeestere of Historically Correct, for her invaluable help; Ron Kirchhoff, for always pointing us in the right direction; Dr. C. E. Krupp and Anthony Cook of the Griffith Observatory; Sam Cole of the Hollywood Roosevelt Hotel; Ben Barbose, Laval Howe, and Tiffany at Grauman's Chinese Theatre; Chantal Dinnage of the Hollywood Foreign Press Association; Alex Yemenidjian and Adrienne Sortino at MGM; Antoinette and Delmar Watson; The Immaculate Heart Community; Anna Martinez Holler of the Hollywood Chamber of Commerce; The Mary Pickford Foundation; Hollywood Forever Cemetery and most of all—my brilliant husband Rick Cameron, my coconspirator, for his support, encouragement, and his gift of laughter.

Picture Credits

All "Then" photographs were supplied courtesy of the Bruce Torrence Hollywood Historical Collection, with the exception of the following:
Library of Congress; pages 13 top left, 13 bottom right, 19 bottom, 26 bottom, 36, 37 top, 37 bottom, and 117 top left.
Immaculate Heart Community; page 20.
Griffith Observatory/Austin Chalk Collection; pages 26 top and 27 top.
Lord-Cameron Collection; pages 34 right center, 34 right bottom, 74 top, and 74 bottom.
Getty Images; page 34.
Delmar Watson (Watson Family Photograph Collection); pages 37 right, 41 top left, 72, 73 right, and 105 top.
Corbis Images; pages 48, 58, 66, and 141.
Los Angeles Public Library; pages 54 and 56.
Hollywood Forever Cemetery; page 60.
Church of Scientology; page 82.
Lance Alspauch; page104.
Greenblatt's; page 130.
California Historical Society, Title Insurance, and Trust Photo Collection, Department of Special Collections, University of Southern California; page 134 top.
Anova Image Library; postcards on pages 13, 20, 29, 47, 50, 81, 85, 101, 111, 123, 125, and 135.

All "Now" photographs were taken by Vaughan Grylls with the exception of the following:
Simon Clay/Anova Image Library; pages 11, 23, 25, 29 bottom, 31 top, 39 bottom, 49 bottom, 65 top right, 69 right, 87, 101 top, 105 bottom left, 121 bottom left, 125 right, 127 top left, 127 center left, 130-131 bottom, 133 bottom left, and 136.
Griffith Observatory/Anthony Cook; page 27 bottom left.
Getty Images; pages 35 top and 61 right.
Corbis Images; page 35 right.
Karl Mondon; pages 55, 57, 59, and 67.
Rex Features; page 75 (3).
Church of Scientology; page 83.
Library of Congress/Carol M. Highsmith; page 109.

Additional text by Dennis Evanosky and Eric J. Kos

HOLLYWOOD

THEN & NOW

ROSEMARY LORD

PHOTOGRAPHED BY
VAUGHAN GRYLLS

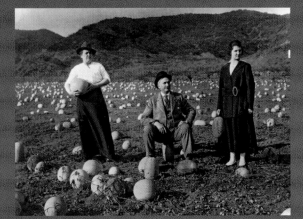

Sunset Boulevard, c. 1900 p.14

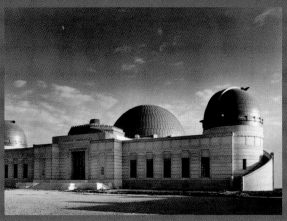

Beachwood Village, 1926 p.22

Griffith Observatory, 1935 p.26

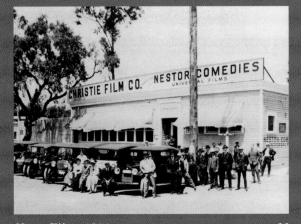

Nestor Films, 1916 p.32

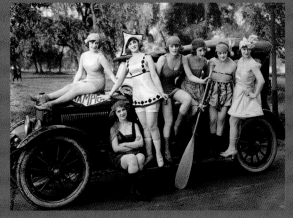

Biograph Film Company, c. 1920 p.36

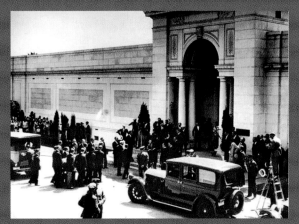

Clune Studios, 1915 p.42

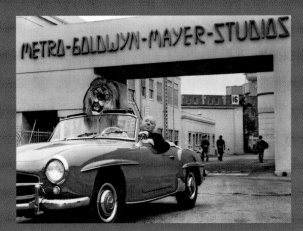

MGM Studios, 1959 p.48

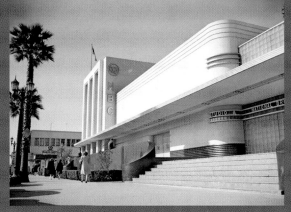

NBC at Sunset & Vine, c. 1940 p.58

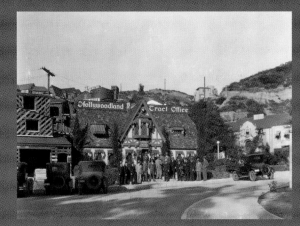

Valentino Funeral, 1926 p.64

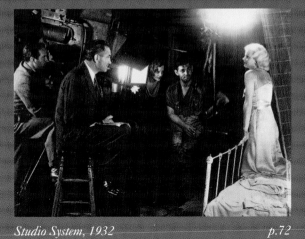

Studio System, 1932 p.72

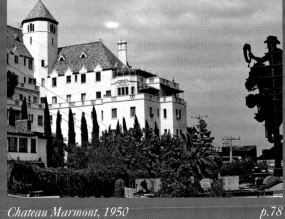

Chateau Marmont, 1950 p.78

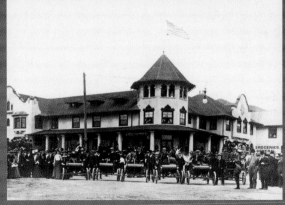

Hollywood Hotel, c. 1905 p.84

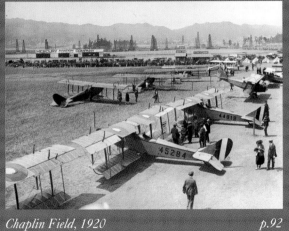

Chaplin Field, 1920 p.92

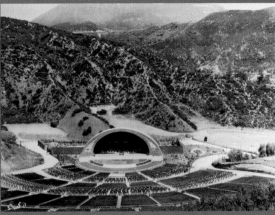

Hollywood Bowl, 1927 p.100

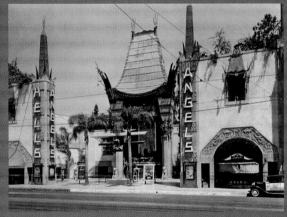

Grauman's Chinese Theatre, 1930 p.106

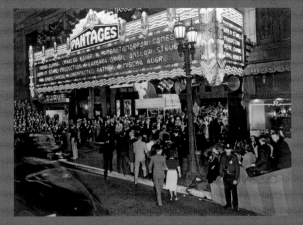

Pantages Theatre, 1939 p.114

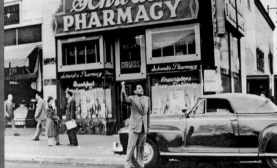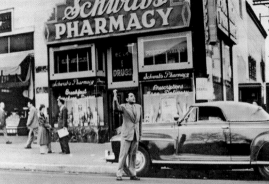

Schwab's Pharmacy, c. 1940 p.128

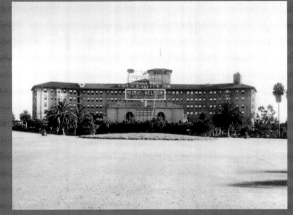

Cocoanut Grove, 1936 p.134

HOLLYWOOD

THEN & NOW INTRODUCTION

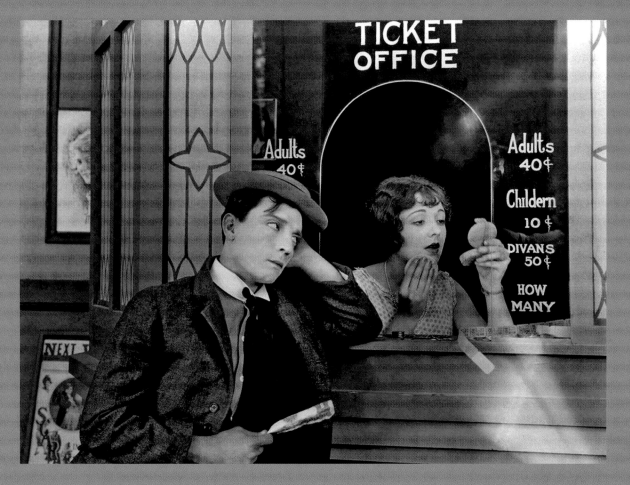

LEFT: Projectionist Buster Keaton tries to attract some attention in silent comedy *Sherlock Jr.* (1924).

There was a time when Hollywood was a sleepy, undeveloped place named Cahuenga (Place of Little Hills) by the local Gabrielino Indians. When the Spanish first came, they divided the Cahuenga Valley into two: The west (the Hollywood area) became Rancho La Brea, while Rancho Los Feliz was to the east. As the Indians were systematically displaced, the farmers came and tilled the dry soil. The agricultural community flourished producing subtropical fruits: oranges, lemons, and figs. The pioneers built adobe homes, planted bean fields, and tended their cattle.

In 1886 Harvey and Daeida Wilcox from Kansas bought an area of Rancho La Brea that was covered in fig and apricot trees. Their plan was to subdivide the land and call it Figwood. Lured by the pleasant climate, wealthy people would come from the Midwest, build beautiful homes along the wide streets, and "winter in California," Harvey predicted. While Daeida shared his dream, she did not like the name Figwood, so the new township was christened Hollywood. Wilcox divided his land into tracts and paved Prospect Avenue, the main road. Soon it was a prestigious residential avenue with elegant Victorian mansions and pepper trees. After Harvey's death in 1891, Daeida, a devoutly religious woman, continued his vision and offered land to anyone

wishing to build a place of worship. Meanwhile, other pioneers came to the land of sunshine pursuing a dream. John T. Gower came from Hawaii and brought harvesting machines and mowers for his new land. Jacob Miller bought land east of Laurel Canyon in the foothills, and Dennis Sullivan and his family planted pepper and eucalyptus trees on their new homestead. A Welsh colonel, Griffith J. Griffith, bought the Verdugo land, Rancho Los Feliz, in 1882. After developing some fine residential areas, he would later donate over 3,000 acres of his wilderness for city parkland, which would be called Griffith Park. Hollywood's population neared 700 as the nineteenth century grew to a close. But that was all about to change when oil was discovered in the Farmers Market area near Third Street and Beverly Boulevard. By 1900 the rush was on for black gold.

The community of Hollywood was prospering; churches, hotels, and schools were built, railroad tracks were laid, and the first horseless carriages appeared. But the Hollywood Board of Trade was not satisfied. Not enough of Hollywood's tax revenue was being spent by the County of Los Angeles on Hollywood street maintenance, more schools were needed, and many Hollywood residents wanted to ban alcohol to keep the cowboys and laborers from getting drunk in public and riding their horses wildly through the streets. The board members wanted to incorporate Hollywood as a city. On November 14, 1903, Hollywood gained its independence, not yet as the mecca for moviemakers, but as a bastion of sobriety for law-abiding citizens. With this came a number of ordinances: prohibiting sales of alcohol (except by pharmacists) and banning the riding of bicycles or tricycles on the two sidewalks in Hollywood. The driving of more than 200 cows (or 2,000 hogs) down Prospect Avenue at a time was forbidden.

Hollywood's independence, however, was short-lived. With the rapidly growing population, Hollywood did not have enough water.

Los Angeles County had plenty of water, however. In 1907 William Mulholland, a Dublin-born city engineer, had already realized there had not been enough available water to sustain the growth of a major city like Los Angeles. He had come up with a plan to divert water from the Owens Valley to Los Angeles, over 200 miles away. The longest aqueduct in the world was eventually inaugurated on November 5, 1913, when fresh water finally roared into Los Angeles.

By 1910 the city of Hollywood was technically no longer—it had become part of the city of Los Angeles. This was the price for water. But people, to this day, continue to call the area Hollywood. One of the final acts of this annexation was to change the name of Prospect Avenue to Hollywood Boulevard, thereby preserving the name for posterity. At that time, many street names were changed to honor the original settlers: Beachwood Drive, Cole Street, DeLongpre Avenue, Whitley Avenue, Wilcox Avenue (after Harvey Wilcox), Gower Street, Gardner Street, and so on.

Around this time, agriculture in Hollywood had begun to disappear. With a population now estimated to be 5,000, new residential areas were planned and new businesses opened. A new phenomenon had come to Hollywood—the moving picture business. The quiet times were over. Moviemaking started in Hollywood around 1907. Film companies were active in New York, but the Motion Picture Patents Company mercilessly controlled the movie industry, and the weather was unpredictable, with hostile winters causing costly delays. The independent film companies escaped to Hollywood.

The first Hollywood film studio was founded in 1911. Filmmakers came from New Jersey, Illinois, and New York and made their one- and two-reel westerns, "easterns" (sophisticated dramas), and comedies—all silent—in the California sun. Westerns were the most popular genre.

Filmmakers were drawn by the year-round sunshine, the variety of landscapes, and the longer daylight hours for filming. These short films took less than a week to shoot, and studios were producing two or three films a week, creating a huge collection of silent films—few of which have survived. Many small film companies fell by the wayside and many more stood in line to take their place.

Rudolph Valentino, Charlie Chaplin, Buster Keaton, and Harold Lloyd brought their unique talents to Hollywood. In 1927 the advent of talking pictures spurred Hollywood filmmakers to create more blockbusters and sagas. Along came the movie moguls—Louis B. Mayer, Jack Warner, Adolph Zukor, David Selznick, and Sam Goldwyn—who brought Hollywood to worldwide attention with the combination of entertaining films and gorgeous movie stars. In 1923, a twenty-one-year-old Kansas farm boy and his brother set up a studio in their uncle's Hollywood garage. Five years later the brothers brought us a different type of movie star, Mickey Mouse, and the Walt Disney Studio was born. Step by step, Hollywood had become the permanent and recognized heart of the film industry.

Soon thousands of hopeful young men and women were pouring into Hollywood seeking fame and fortune in the motion picture industry. Labor unions were later formed to help the struggling actors, writers, directors, and various industry craftspeople that sought a future here. But this thriving industry created radical changes on the Hollywood skyline. Gone were the remaining lima bean farms. Sprouting in their place were tall new buildings: offices along Hollywood Boulevard and towering apartments to house the huge number of workers that moviemaking required. From the biggest of the stars in their mansions, the directors, producers, writers, and crew members, to the struggling thespians and extras who stood in line hoping to get picked to appear in a crowd scene, Hollywood had to provide housing for them all.

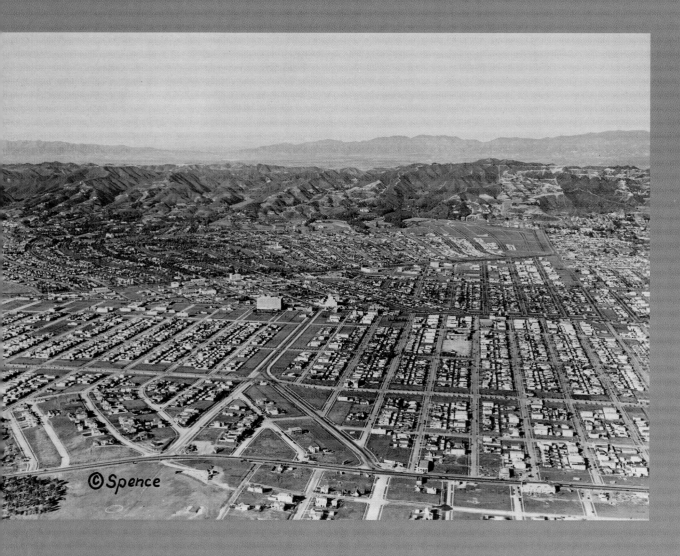

©Spence

better time to come. That was Hollywood's job. The glamour of the nightlife in the 1930s and 1940s was unsurpassed and the stars dressed like royalty for their adoring public. Fans stood patiently outside the restaurants frequented by celebrities, waiting for autographs. In the golden days of Hollywood, the fans were an integral part of the Hollywood scene.

Throughout the World War II years, Hollywood rallied. Jimmy Stewart, Clark Gable, director John Ford, William Wyler, Mickey Rooney, Audie Murphy, and many more brave souls joined the military. Others raised money for war bonds (Gable's wife Carole Lombard was killed in a plane crash on just such a mission). Some, like Bob Hope, traveled overseas to bring the magic of Hollywood to the troops.

The next decade saw one of Hollywood's darkest times. Joseph McCarthy's attempts to weed out and blacklist suspected communists and communist sympathizers persecuted and silenced many talents in the entertainment world. The hearings were broadcast on a new medium: television, the new face of Hollywood.

For decades, Hollywood was the prime real estate, the glamour capital of the entertainment industry, but in recent years other parts of Los Angeles have become popular. Many of the fashionable stores moved to Beverly Hills. The old dining and dancing favorites closed and were replaced by modern eateries. Hollywood was diversifying and changing with the times. In the postwar era, there was a shift to realism with new screenwriters and a new breed of actors. The raw performances of James Dean, Montgomery Clift, a now fully grown Elizabeth Taylor, and the young Marlon Brando changed the face of Hollywood. In the 1960s a young Jack Nicholson, Anne Bancroft, Steve McQueen, a fresh-faced Goldie Hawn, Rita Moreno, and Sidney Poitier all did things their own way as the system that bound stars to one studio crumbled away.

Stores, banks, restaurants, and clubs were also built, catering to the demands of the movie business.

In the 1920s and 1930s, forty million Americans were going to the movies each week, and the major film studios were pouring out fare for their unquenchable appetites. Movie magazines and trade papers, including *The Hollywood Reporter* and *Variety*, kept the world apprised of Hollywood comings and goings. The public emulated the hairstyles, clothes, and mannerisms of their screen

gods and goddesses. With the help of master showman Sid Grauman and dedicated Hollywood promoter Charles Toberman, fanciful and exotic movie palaces had been erected along Hollywood Boulevard. The fans thronged in the thousands to the grand premieres at the Chinese and the Egyptian Theatres, content to sit in the specially erected bleachers or stand quietly outside waiting for a glimpse of a favorite movie star.

While America suffered through the Depression, the magic of Hollywood gave them a glimpse of a

The movie moguls are long gone and the major studios have adapted or died. Some have sold off the lots where they made their big movies, while others have been absorbed into large media corporations. But the smaller, independent film companies have risen as if from the ashes of those first, struggling, independent companies.

We still celebrate the success of this city of dreams. The first three months of each year are crammed with award shows recognizing excellence in all fields of the industry. The Hollywood Foreign Press Association hands out the Golden Globe awards, while the 6,000 actors, directors, and industry professionals of the Academy of Motion Pictures and Sciences vote on the Academy Awards—also known as the Oscars. The ultimate moviemaking prize is still the Academy Award and the ceremony is watched by a massive global television audience.

Since 1985, Hollywood's commercial and entertainment district has been on the National Register of Historic Places, protecting it from further architectural erosion to ensure that the important sites of its past will be part of its future. Hollywood still advertises itself: The giant Hollywood sign, probably the most famous sign in the world, still watches over the area that bears its name, though the custodians are no longer the same people wishing to sell tracts of "Hollywoodland."

While film production still occurs within the Hollywood district, most major studios are now located elsewhere in the Los Angeles area. People originally came to Hollywood for the lemons, the oil, and the sunshine, but they stayed because of the movies. Everything in Hollywood has been touched by the movies. This book matches historical archive photographs with current images to reveal the fascinating history behind the old Hollywood dream factory. As legendary columnist Walter Winchell once said: "Hollywood is a town that has to be seen to be disbelieved."

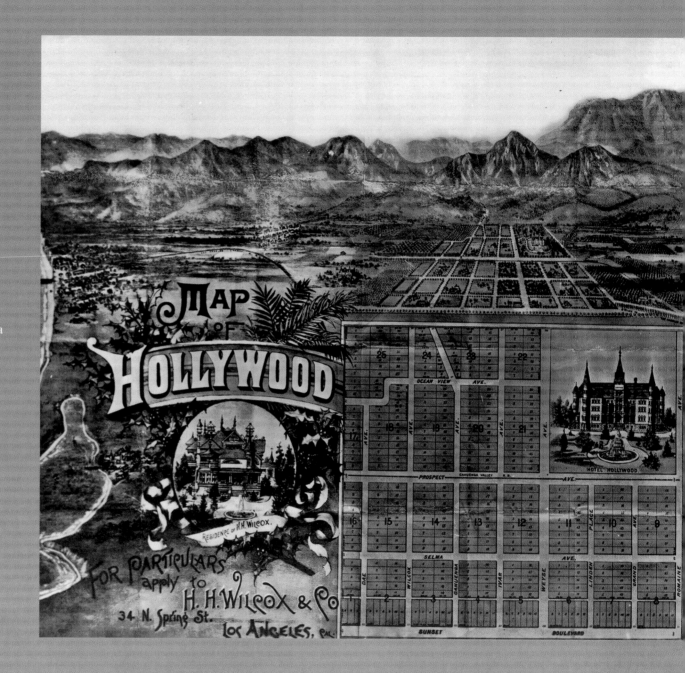

FAR LEFT: Beverly Hills from the air around 1931.

ABOVE: Hollywood's first tract map from 1887.

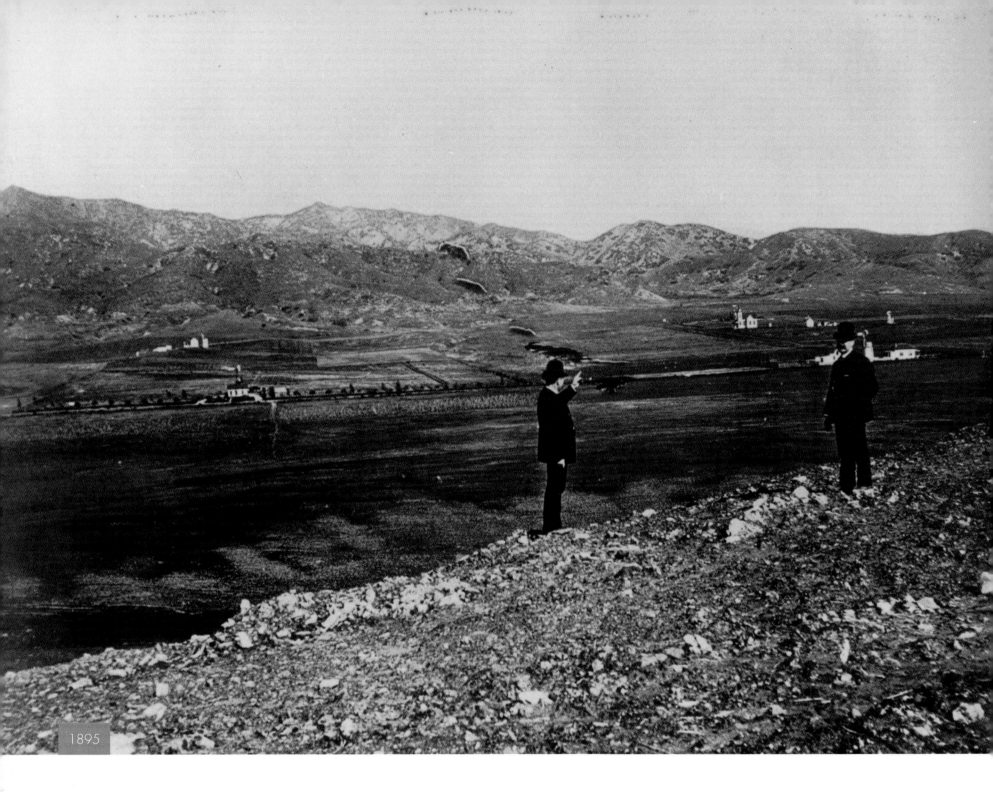

1895

BARNSDALL PARK
The olive groves in the Cahuenga Valley were short lived

THE CAHUENGA VALLEY

This dry, desert area became a magnet for people wishing to escape the blizzards back east. Traveling by horseback and in horse-drawn wagons, hardy pioneers headed west. The first settlers in the Cahuenga Valley found an arid basin of land surrounded by lush green hills. Sycamore trees and nopal cactus grew in the baking sun. Before it bore the name Hollywood, this part of California was marked by mountain ranges, deserts, and tar pits. When Gaspar de Portola, the Spanish governor of the Californias, first explored this region in 1769, asphalt swamps were discovered. Early Native Americans burned the black tar for fuel, and later settlers dug into the swamps for waterproofing their adobe roofs. The Mexican and Spanish governments had given large allotments of land to settlers to encourage colonization. One of these was Rancho La Brea (The Tar Ranch), and ownership was granted to Antonio Jose Rocha. John and Henry Hancock eventually became the Rancho La Brea owners. Henry built a refinery to prepare the tar for market. During these excavations, ancient fossils were uncovered, which proved the existence of saber-toothed tigers, sloths, and early man in this area. Twenty-three acres of this land was eventually donated to the city in 1915 as an excavation site, the La Brea Tar Pits. This western part of Hollywood is also where oil was found around the turn of the twentieth century. With Henry Hancock dead, his widow Ida permitted speculative drilling for oil on her land in 1895. That same year, a newspaper, the *Cahuenga Valley Suburban*, was started, with illustrated pieces on local farming aspects and blossoming residential areas. It offered glowing enticements of "lemon groves and sunshine" for prospective land buyers. The *Cahuenga Valley Sentinel* replaced it in 1899, soon becoming the *Hollywood Sentinel*. In 1905, a rival paper, the *Hollywood Citizen*, began with a forty-person subscription list. The two local papers merged in 1911 under the *Hollywood Citizen* name, with an impressive 800 subscribers. They ran advertisements and articles advocating the perfect life in "the land of sunshine, oranges and oil." The magic of the moving-picture business was still a future temptation.

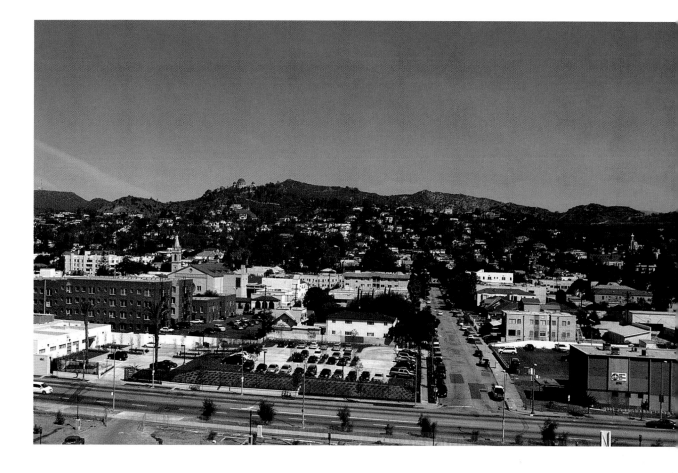

LEFT: This 1895 Hollywood panorama is looking north from the hilltop property that stretched from Sunset Drive to Prospect between Vermont and Edgemont. To the left of the photograph is Mount Lee, where the Hollywood sign would later sit. Owner J. H. Spires planted his thirty-six acres with olive trees here and called it Olive Hill. On June 3, 1919, oil heiress Aline Barnsdall bought the land, renaming it Barnsdall Park. Frank Lloyd Wright's first Los Angeles commission was Barnsdall's Hollyhock House, where the politically eccentric heiress struggled in vain to establish an artists' colony in her home. Long after Barnsdall's 1946 death, the city took over the deteriorating property for renovation. The hilltop view (above) shows the development of Mount Hollywood and Griffith Park and also includes the Hollywood sign. It was taken from Frank Lloyd Wright's Hollyhock House, one of four "textile block system" houses Wight built in California.

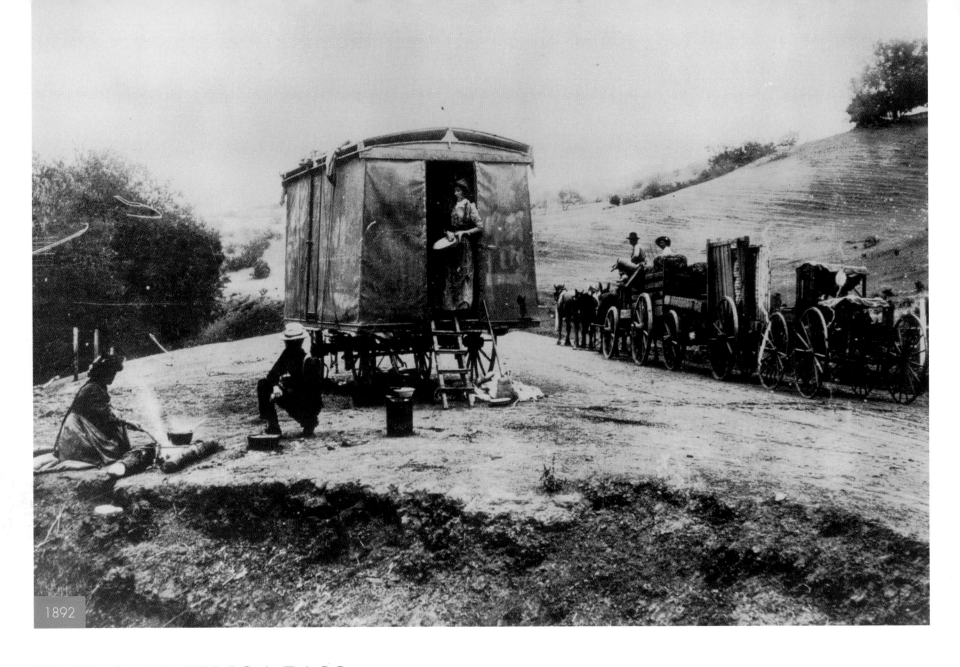

1892

THE CAHUENGA PASS
The ancient route from the San Fernando Valley into Hollywood

There is now scant trace of the Gabrielino Indians, the first recorded residents of what is now Hollywood. There are some Native American place names, however, that have survived, such as Malibu and Cahuenga. The Cahuenga Pass was the route through the hills to the valley beyond. Originally a simple winding trail over which cattle were driven, it was later used by the Spanish, Mexicans, and early settlers with their wagons and mule teams. The pass made history with the battles of 1831 and 1845. In 1847 the Treaty of Cahuenga, which ended the U.S.–Mexico War, was signed in a small adobe house at the north end of the pass, the present site of Universal City. The first overland mail delivery to Los Angeles was delivered as early as 1848, and the Cahuenga Pass was used as the route. Over the decades the pass has been widened and built up, and in 1911 the Pacific Electric Railroad tracks were laid for the famous Red Cars. The project was finally completed in 1926 and cost $500,000. The pass

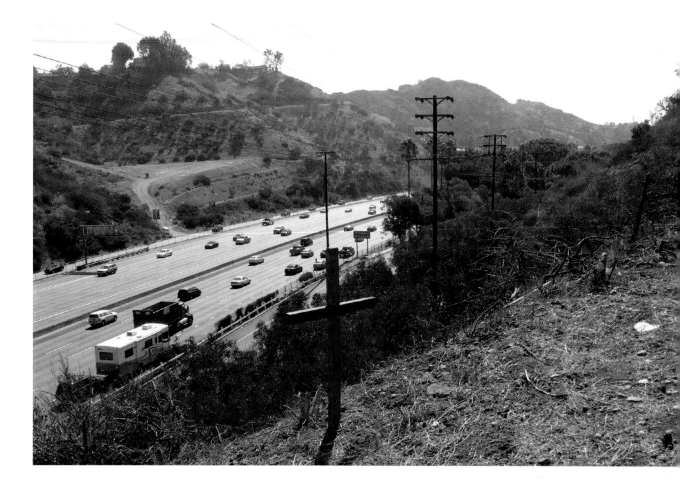

FRENCH VILLAGE

Completed in 1920, the French Village consisted of five cottages, each with their own names and architecture, designed in Provincial style by architects Walter S. and F. Pierpont Davis. The charm and location of the houses and their gardens, made them instantly popular with Hollywood's creative elite. Artist Minnie Muchmore became the first occupant of Monkey House, taking it in 1920. In 1923, Academy award-winning actor Wallace Beery moved into Sycamore House. In 1925, Tower House was partly demolished because of a street widening project. Costume designer Gilbert Adrian settled in Tower House in 1927. Throughout the 1930s and 1940s, the French Village continued to attract actors, writers, costume designers and dance instructors. But the increasing traffic in the Cahuenga Pass led to the construction of the Hollywood Freeway and French Village stood in the way. By 1952, all trace of the small artists community had vanished.

BELOW: At the turn of the century bicycle tourism brought pleasure seekers into the Cahuenga Valley.

was later paved over for bus routes. When the San Fernando Valley became a center for the movie studios, the pass was the main link to Hollywood. The increasing traffic led to the Hollywood Freeway opening in 1954. Today a new subway system has been constructed beneath the Cahuenga Pass that helps reduce traffic volume.

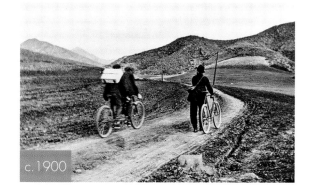

c.1900

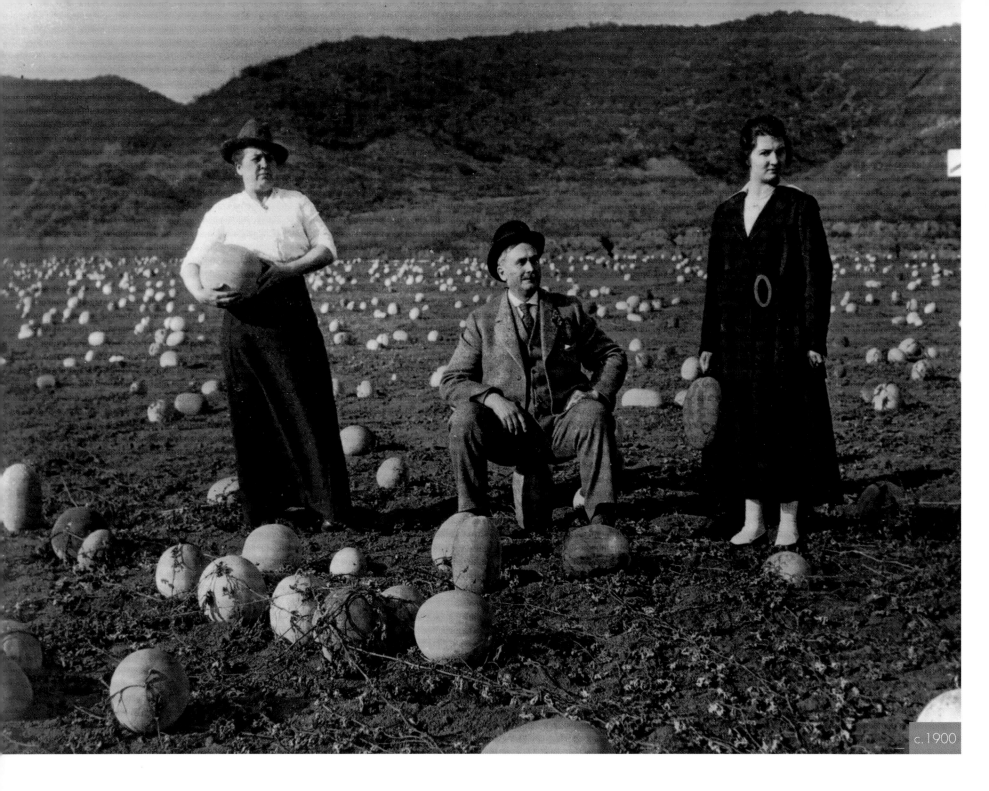

c.1900

SUNSET BOULEVARD & HARPER STREET
Hollywood's iconic route runs through an old melon patch

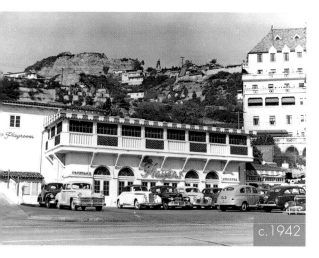

c.1942

ABOVE: The Players Club and The Playroom circa 1942.

LEFT: Victor Ponet is seen here posing with his wife and daughter, on the Casaba melon farm, a patch that was part of the 200 acres of land bought by the Belgian developer in 1890.

RIGHT: The architecture of the Japanese restaurant Miyagi's was not far removed from the Players Club (above), but the most recent venture, Pink Taco, has changed the frontage.

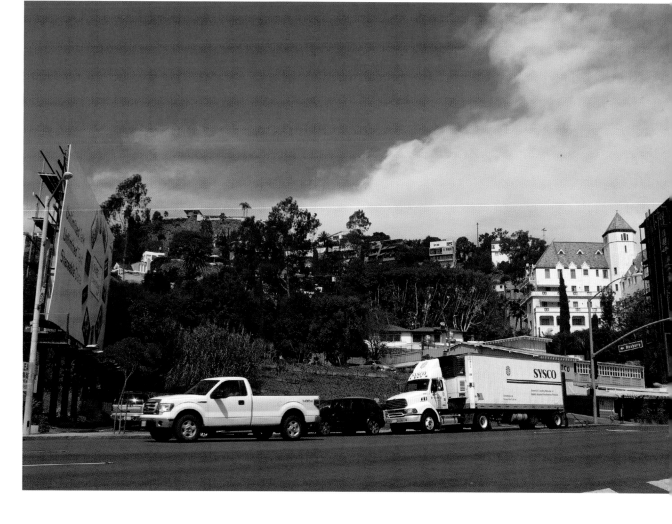

When people traveled west in search of a better life, they found balmy days and longer daylight hours in Hollywood. This climate was ideal for farmers, and the agricultural community flourished. By the 1880s, the farmers' crops of subtropical fruits, such as pineapples, oranges, lemons, and melons, were in plentiful supply. This casaba melon patch (left), seen here in the early 1900s, was the original site of the Sunset Strip, so named for the real estate term used for strips of land not incorporated in the city. A no-man's land, the Strip was dismissed as merely a link between Beverly Hills and Los Angeles. Owned by the county, this area was subject to lower taxes and less rigid laws. In the 1930s, Frances Montgomery constructed four French-style stores for his Sunset Plaza project. The Hollywood agents then moved in, attracted by the lower rents. As Hollywood grew, elegant homes and apartment houses sprang up along the Sunset Strip. This was an ideal place for gambling and nightclubs. Movie stars invested in clubs and businesses here. Film director Preston Sturges's Players' Club opened in 1940. Here Humphrey Bogart, Mario Lanza, Orson Welles, and other show-business friends tended bar and flipped hamburgers with him. The Players' Club was replaced by the Imperial Gardens, which then became the Roxbury Club. The Roxbury Club was replaced by the Japanese restaurant Miyagi's in 2002. A new version of the legendary Roxbury Club has been opened in 2011, just a few minutes' drive east of the original Sunset location. Miyagi's was purchased in 2008 by Harry Morton and opened as a Pink Taco restaurant in April 2012.

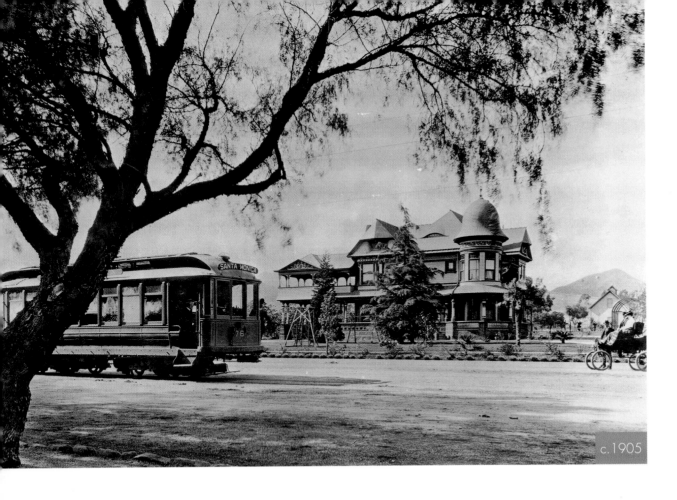

c.1905

PROSPECT AVENUE AND WILCOX

Now the street cars on Hollywood Boulevard are subterranean

LEFT: In 1896 the Consolidated Electric Railway cable cars cut through the very heart of the city that would become Hollywood. In 1898 Collis Huntington and his nephew Henry had taken control of the company from Moses Sherman, and by 1901 the Pacific Electric Railway had been established. They introduced the Red Car streetcars and later the "Balloon Route," which linked downtown with the ocean, via Hollywood. This elegant Queen Anne–style house on the corner of Prospect Avenue and Wilcox was bought by investor and developer H. J. Whitley in 1900. Prospect Avenue then became Hollywood Boulevard. Private cars soon replaced the railways and streetcars; the tracks were pulled up and freeways were introduced. Today, however, as appreciation for the neighborhood resurges, train cars are once again running along Hollywood Boulevard, but this time they are underground trains. The new Metro Red Line closely follows the routes of the old Red Cars.

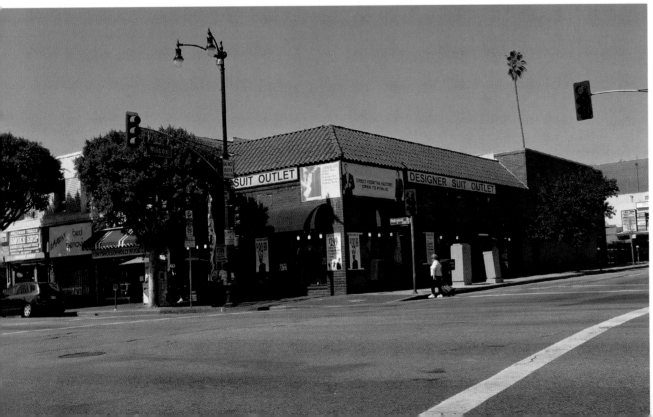

THE SACKETT HOTEL

The first hotel in the Cahuenga Valley, built in 1887

RIGHT: The first structure to be built as a hotel in the Cahuenga Valley was the Sackett Hotel on the southwest corner of Hollywood and Cahuenga Boulevards. Horace D. Sackett bought the land in 1887 and built a general store and the town's first proper hotel. The three-story building soon became a popular overnight spot for tourists and land prospectors. Staff served hot meals and sold dry goods, liquor, tobacco, and shoes. As more visitors came, Sackett added clothing items, hardware, teas, spices, and ice cream to his bill of fare. In November 1897 an official post office was established in the Sackett Hotel and later Mamie Sackett became the first postmistress in Hollywood. In 1912 this wooden structure was replaced with a two-story building, and at the height of Hollywood's prosperity in 1931, a three-story Art Deco building was built on the enlarged site. Today a fast-food establishment and offices occupy that same brick-and-tile building.

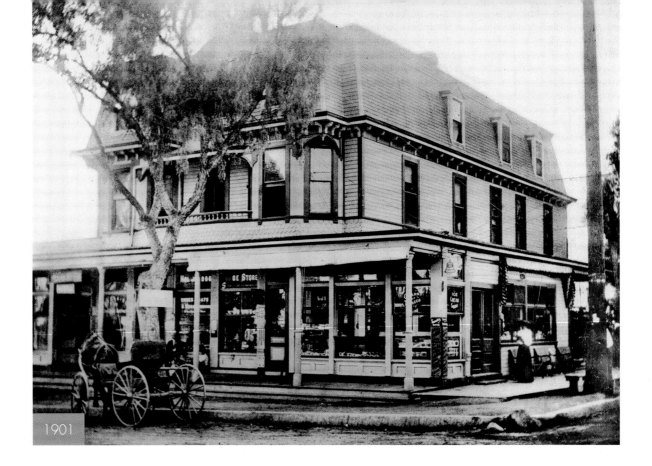

1901

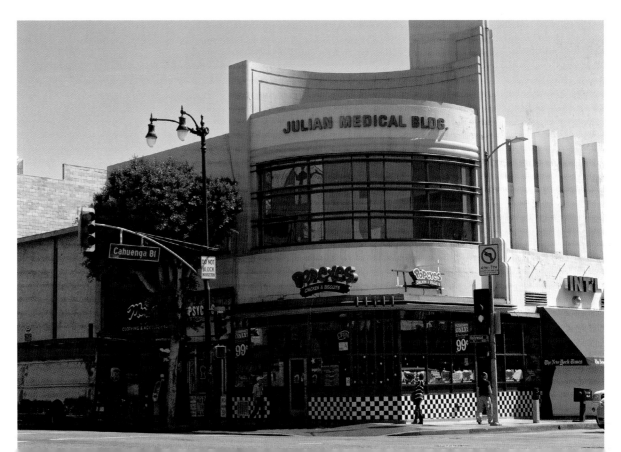

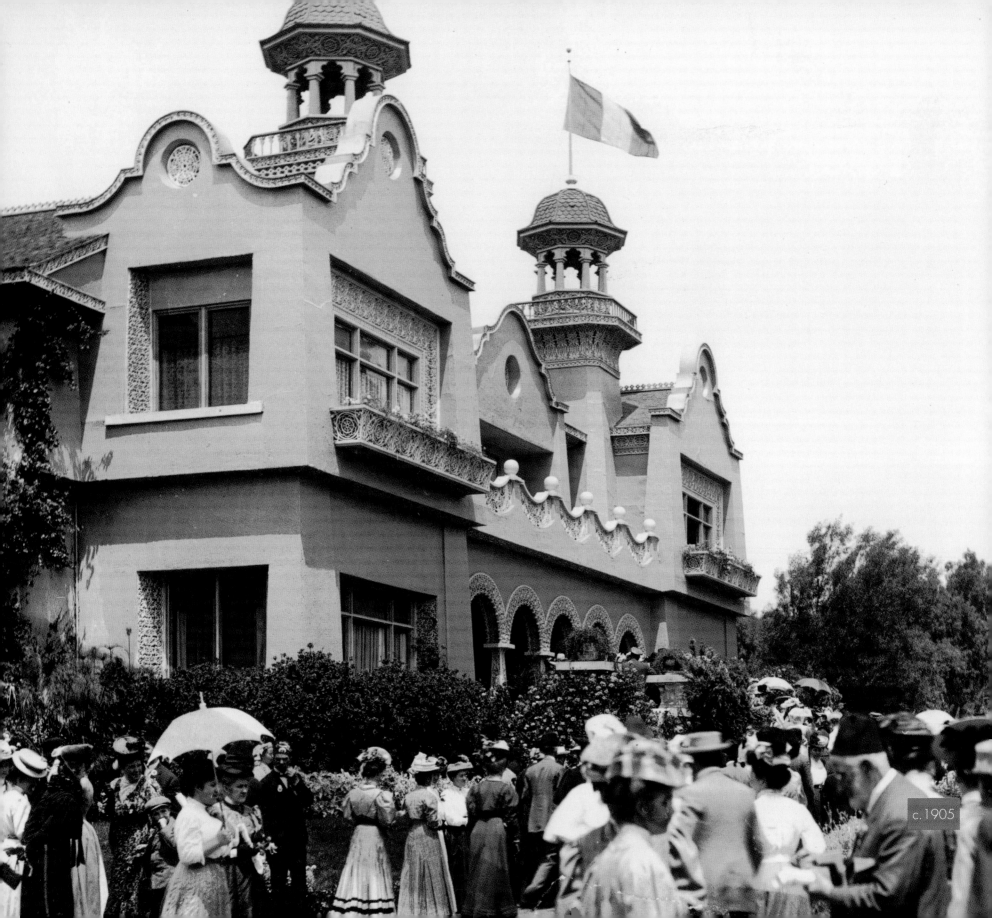

c.1905

THE DELONGPRE MANSION
Home of the French artist and a tourist attraction until 1925

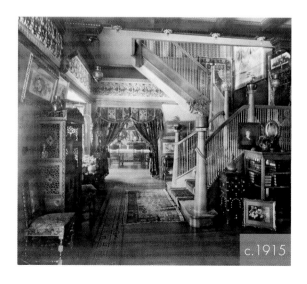

c.1915

Hollywood's first tourist attraction had nothing to do with the movies. Born in Lyon, France, in 1855, Paul DeLongpre became Southern California's first nationally renowned still-life painter. DeLongpre moved to Los Angeles in 1899 with his wife, Josephine, and three daughters. After a successful career in Paris and New York, he found the sunny weather perfect for painting the local flora. In 1901 he bought three sixty-five-foot lots on Cahuenga Boulevard near Prospect from Daeida Wilcox (now Mrs. Philo Beveridge). Finding his garden too small, the following year DeLongpre bought the corner lot, for which Beveridge accepted three paintings as payment. Paul DeLongpre's extravagant Moorish mansion soon became a tourist attraction. The DeLongpre

House was the first stop in Hollywood for the popular Balloon Route Excursions. After his death in 1911, the DeLongpre House remained a tourist attraction until it was demolished in 1925. Hollywood commemorated the artist by naming the DeLongpre Park for him. It is situated on DeLongpre Avenue at Cherokee and has two statues in remembrance of the silent movie star Rudolph Valentino: a bust and an Art Deco abstract titled Abstraction. The site of the DeLongpre House was a Greyhound bus station as recently as 2011.

LEFT. The reception hall of Paul DeLongpre's residence. The floral patterns characteristic of DeLongpre's work were repeated in the decoration of his house.

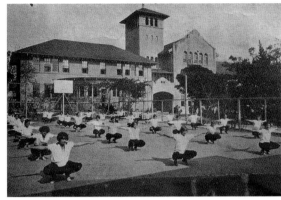

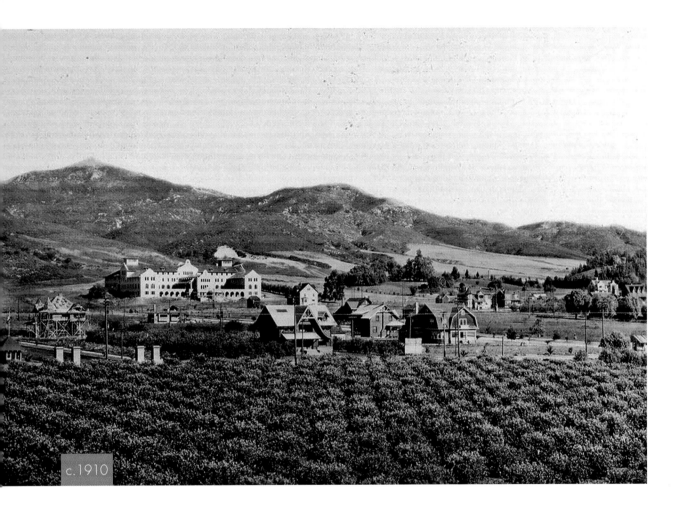

c.1910

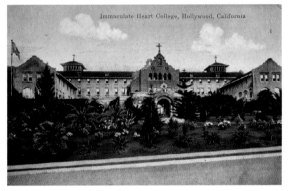

IMMACULATE HEART HIGH SCHOOL AND COLLEGE

The college closed in 1981 but the school went on to celebrate its centenary

ABOVE: In 1903, Western Avenue was just a rutted wagon road through a mustard field, where, for the princely sum of $10,000, the Sisters of the Immaculate Heart of Mary bought a fifteen-acre plot of land at Western and Franklin. In 1906, the Moorish-style Immaculate Heart high school, convent, and boarding school opened. The College for Girls commenced in 1908, welcoming students from all over the world. Immaculate Heart was the first private school to confer college degrees, awarding its first bachelor of arts degree in 1921.

ABOVE: After first establishing the school, the Sisters of the Immaculate Heart of Mary created a college. The college closed in 1981 due to financial difficulties and its successor, the Immaculate Heart College Center, closed in 2000; the buildings passing over to the American Film Institute.

ABOVE: The boarding school closed in 1967, but the high school remained and the middle school opened in 1976. In 1980, the American Film Institute acquired the college building for their library and film school, which funded the renovation of the high school. In 1991 the demolition of the old convent made way for a new playing field. The auditorium was renovated in 1998 and a news sport facility opened in 2005. Mary Tyler Moore, Lucie Arnaz, and Tyra Banks are among Immaculate Heart's famous alumnae. Since 1957, all graduation ceremonies have been held at the Hollywood Bowl.

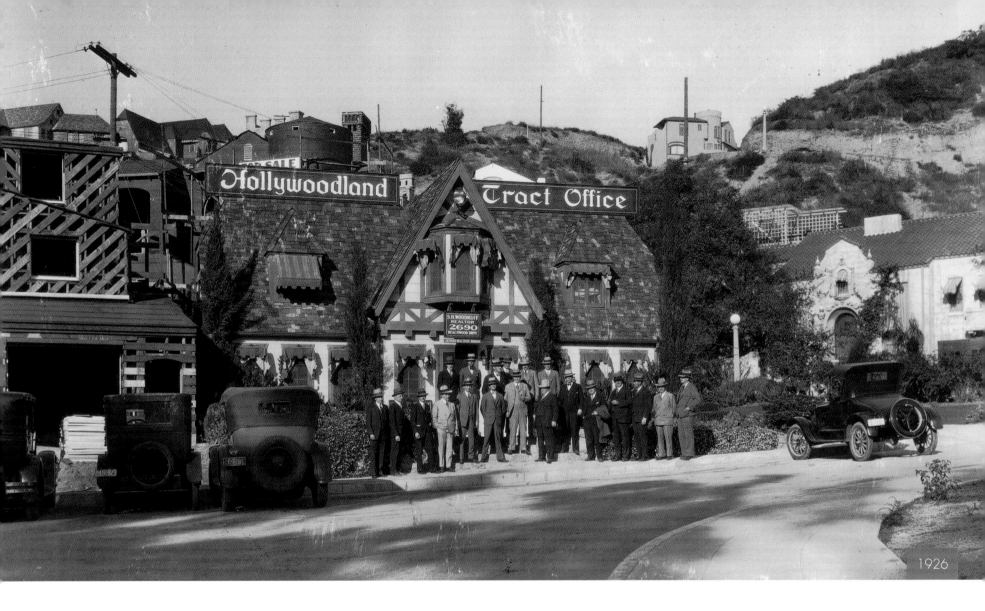

1926

BEACHWOOD VILLAGE
Distinguished residential area and haven for horse lovers

ABOVE: Harry Chandler, developer S. H. Woodruff, and Tracey Shoults joined M. H. Sherman, director of the Pacific Electric Railway to form the Hollywoodland Tract Office in 1923. They combined with Albert Beach, another developer, who paved the way through the Hollywood Hills with a road he named for himself: Beachwood Canyon. Together they planned a major sales campaign for the area, setting up office at the Hollywoodland entrance. Two stone towers were built on either side of the entrance and a gated community—with a guard on night duty—was planned. The gate and the guard never materialized.

RIGHT: Developers standing at the gates of Beachwood Drive. The construction sign in the back reads " You are now in Hollywoodland, Tray E. Shoults Co.".

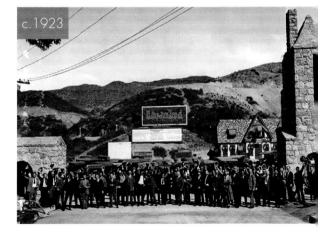

c.1923

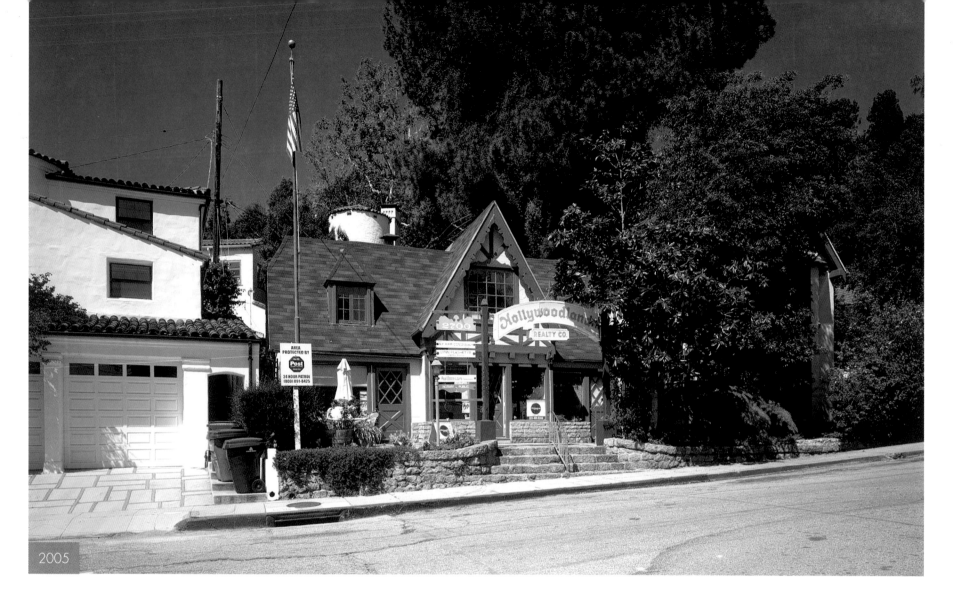

2005

ABOVE: Today Beachwood Village remains relatively unchanged—although property prices have soared. The family-style Village Café is where stars go for breakfast with the rest of the world. There are small shops and there is still a property business, now called the Hollywoodland Realty Company, which occupies the original building. At the foot of the Hollywood sign, Beachwood Canyon now stops at the Sunset Ranch, where cowboys, actors, and horse lovers alike stable their horses and ride through the Hollywood Hills at sunset.

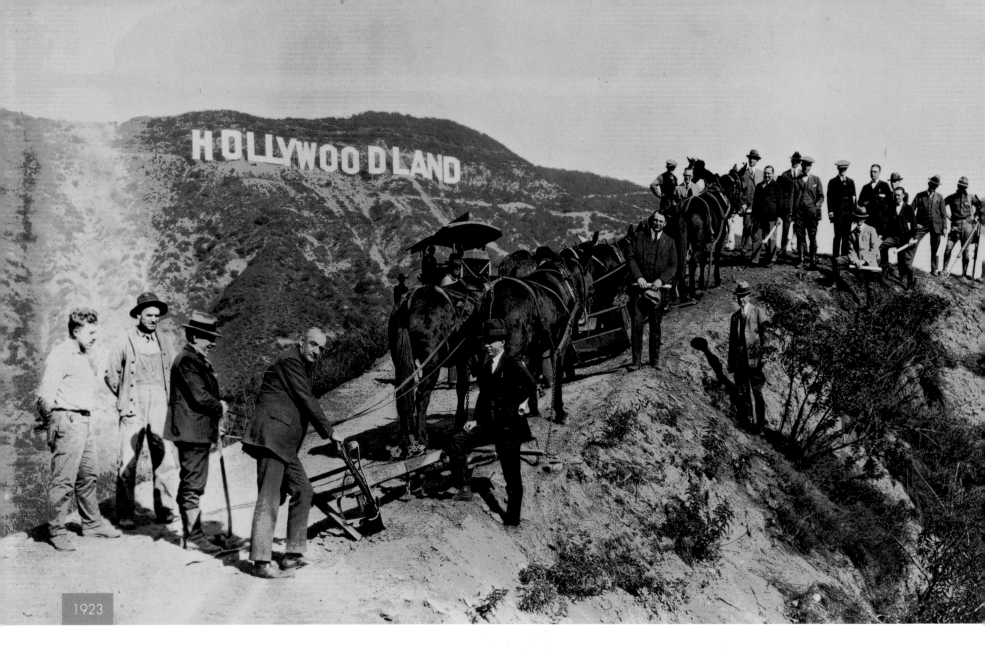

1923

HOLLYWOODLAND TOURISM
The historic heart of tourism in Hollywood

ABOVE: In 1900 Charles M. Pierce established the first sightseeing service, offering a "tour of the Cahuenga Valley with chicken-dinner" for seventy-five cents. He later started the Balloon Route Excursions, operated by the Los Angeles Pacific Railroad, with eighteen carloads of tourists a day. By 1925, Pierce was one of several guided tour operators in Hollywood. They were now using automobiles and small buses for sightseeing. A consortium of Hollywoodland developers had spent lavishly on promoting the district. They developed an area of more than 500 acres of rugged canyon, woodland, and knolls, which overlooked Hollywood. They built elegant Spanish- and Moroccan-style dwellings to attract an affluent clientele. Hollywoodland residents included Spring Byington, Boris Karloff, and successful English novelist Aldous Huxley, who emigrated to America and wrote screenplays for *Pride and Prejudice* and *Jane Eyre* among others.

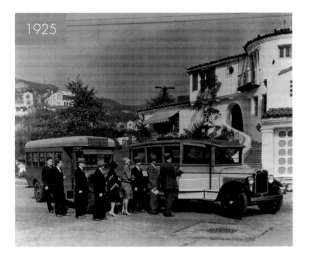

1925

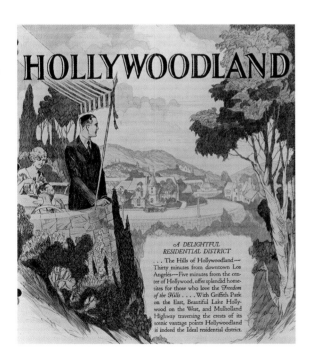

HOLLYWOODLAND

A DELIGHTFUL RESIDENTIAL DISTRICT

. . . The Hills of Hollywoodland— Thirty minutes from downtown Los Angeles—Five minutes from the center of Hollywood, offer splendid homesites for those who love the *Freedom of the Hills* With Griffith Park on the East, Beautiful Lake Hollywood on the West, and Mulholland Highway traversing the crests of its scenic vantage points Hollywoodland is indeed the Ideal residential district.

ABOVE: The developers advertised the tract to appeal to an affluent, upmarket clientele.

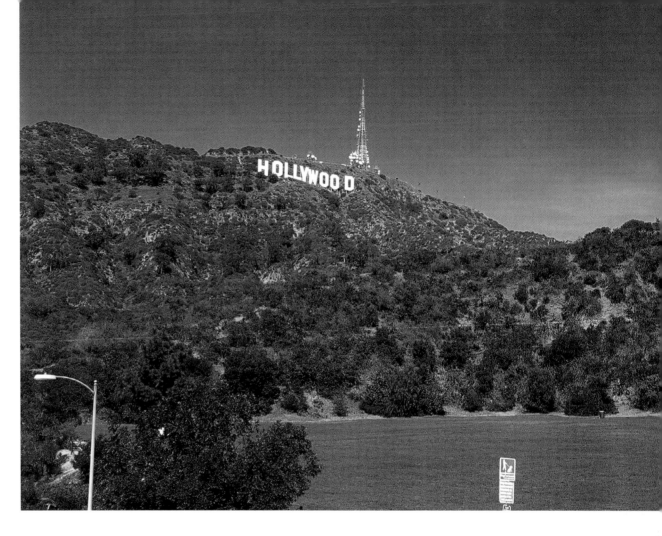

ABOVE: One of the most recognizable landmarks in the world, the Hollywood sign began as an advertising gimmick when developer Harry Chandler wanted to promote the 500-acre prime residential hill property overlooking Hollywood. At a cost of $21,000, the sign was made of white-painted sheet metal studded with 4,000 twenty-watt lightbulbs, with letters fifty feet high and almost thirty feet wide. The Hollywoodland sign was visible from over twenty-five miles away. The original caretaker, Albert Kothe, lived in a small house behind the letter L and had the job of changing any bulbs that burned out. Through the 1930s and 1940s, the sign's future seemed bleak. Disillusioned British-born actress Millicent "Peg" Entwistle jumped fifty feet to her death from atop the sign in 1932. By 1939 maintenance had ceased and all 4,000 lightbulbs had been stolen. In 1944, the bankrupt developer donated the sign to the city, which planned to tear it down. In 1949 the Hollywood chamber of commerce decided to restore the "Hollywood," abandoning the "land." But it wasn't until 1974, when the sign was given landmark status, that a new era of preservation and recognition began. Today the chamber of commerce, the Hollywood Sign Trust, and the City of Los Angeles are the official stewards. The sign is monitored 24 hours a day by City of Los Angeles security specialists. In 2010, grants from The Tiffany & Co. Foundation and Aileen Getty, along with contributions from Hollywood leaders and fans around the world ensured the sign will remain protected.

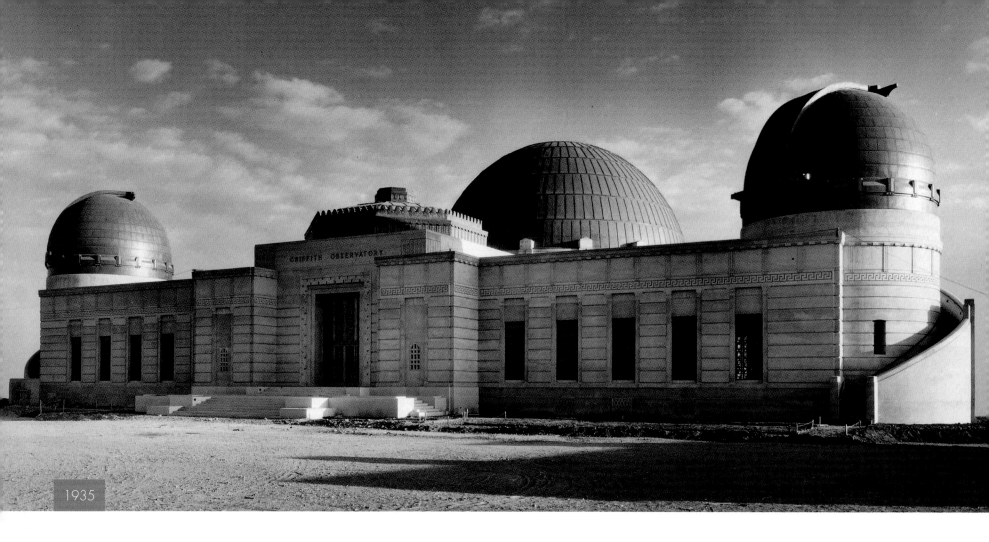

1935

GRIFFITH OBSERVATORY

A major astronomy center offering breathtaking panoramas of Hollywood

ABOVE: In 1896, Welsh-born mining speculator Colonel Griffith Jenkins Griffith gave land to the city in gratitude for his prosperity. Once part of Rancho Los Feliz, this land now became Griffith Park. When he died in 1919, the colonel bequeathed a fund for the construction of an observatory, but because the site was difficult to access, it went undeveloped for years. Finally, Griffith Observatory opened on May 14, 1935. It is divided into three main areas: the Hall of Science museum, the telescopes, and the planetarium theater. Popular attractions include the Foucault Pendulum, Camera Obscura, and the famous Zeiss Planetarium Projector, which shows the sky seen at any time or place for several thousand years in the past or future. It projects about 9,000 stars, the sun, the moon, and the planets. The 1934 Astronomers' Monument was developed as a Federal Public Works of Art Project. The observatory and its grounds have been used for many film locations, most notably *Rebel Without a Cause* (1955), starring James Dean and Natalie Wood.

RIGHT: The Griffith Observatory as seen from Mount Hollywood. One of the most visited landmarks in California, the observatory was also voted one of the ten most romantic places in Los Angeles.

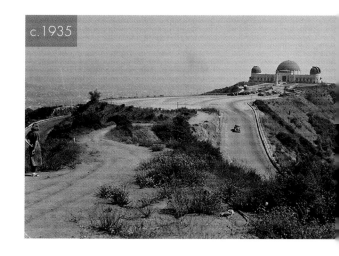

c.1935

26

1935

ABOVE: The immaculate Art Deco structure has been threatened by wildfires in the past, most recently in 2007.

BELOW: A bronze bust of movie actor James Dean sits on the west lawn.

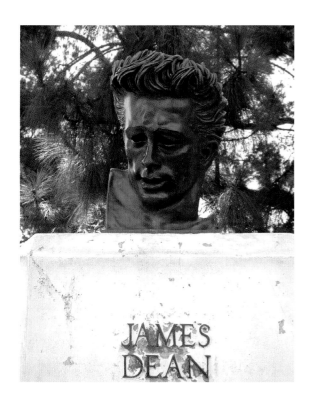

JAMES DEAN

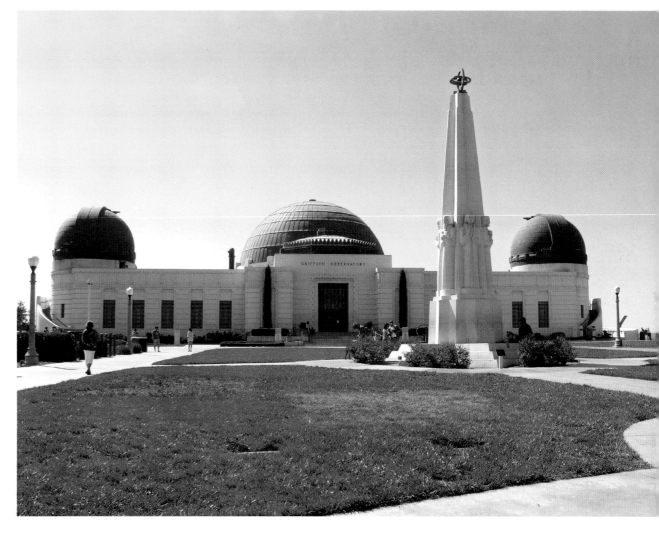

ABOVE: Perched on the eastern slope of Mount Hollywood, the Griffith Observatory overlooks a spectacular panorama of Hollywood. Colonel Griffith mandated that the observatory should be open to the public for free every day and every night of the year. However, after sixty-six years of continuous use and about two million visitors a year, the observatory closed in 2002 for a long-overdue renovation. It was re-opened in 2006. The $93 million renovation included a replacement for the aging planetarium dome.

The building was expanded underground, with completely new exhibits and the new Leonard Nimoy (Mr. Spock from *Star Trek*) Event Horizon Theater. Science fiction is also celebrated elsewhere with an eatery that is an homage to Douglas Adams' book, *The Hitchhiker's Guide to the Galaxy*, the sequel of which was *The Restaurant at the End of the Universe*. Celebrity chef Wolfgang Puck runs a cafe with that name.

HOLLYWOOD HIGH SCHOOL
Educating Hollywood's wealthy and famous since 1904

BELOW: In 1904 Hollywood Union High School was founded at Sunset Boulevard and Highland Avenue, just east of a lemon grove. Students tethered their horses on the athletic field. As offspring of the wealthy and famous, they received an excellent education. The school became Hollywood High and it was completely renovated in the 1930s. A large mural of Rudolph Valentino as "the Sheik" now watches over the football field. Judy Garland, Joel McCrea, John Huston, Mickey Rooney, and Jason Robards were students here, but it was Lana Turner who put the school on the map when she skipped class to visit Tops Café across the street. It was out of bounds because of a recent kidnapping scandal, but that day Lana was "discovered" by the Hollywood Reporter's Billy Wilkerson—and the rest is movie history.

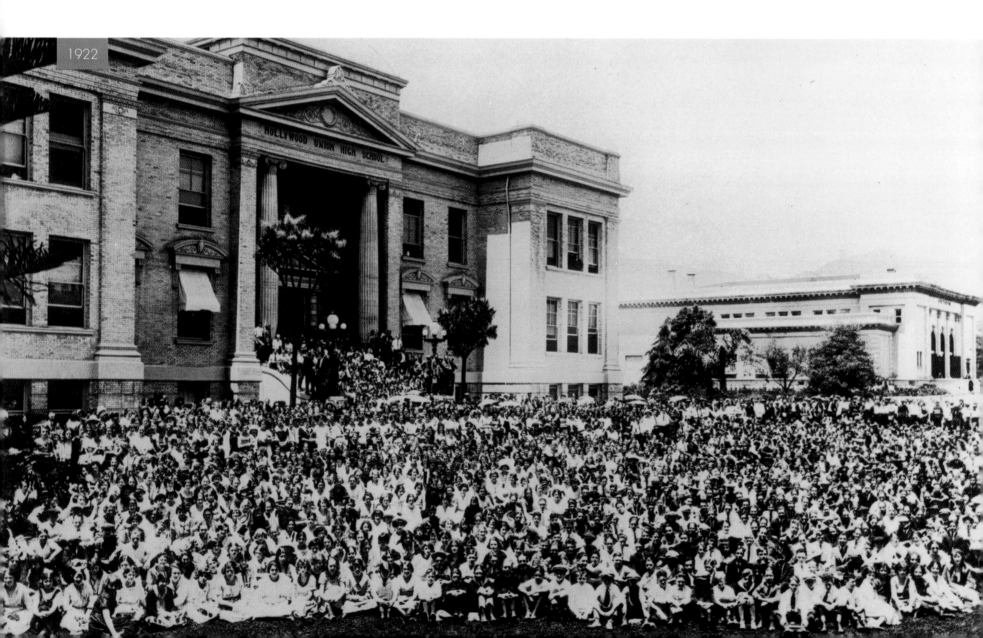

1922

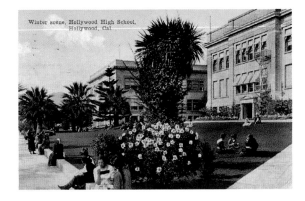

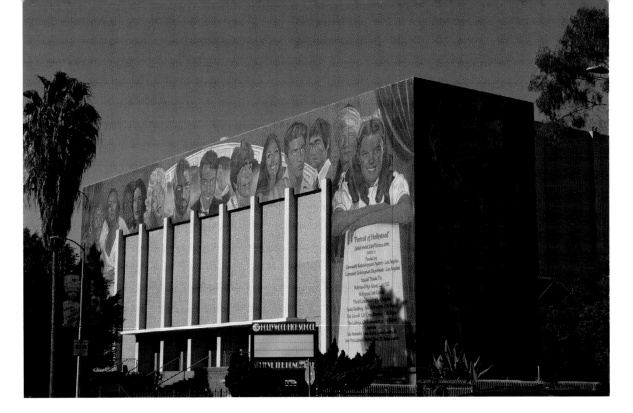

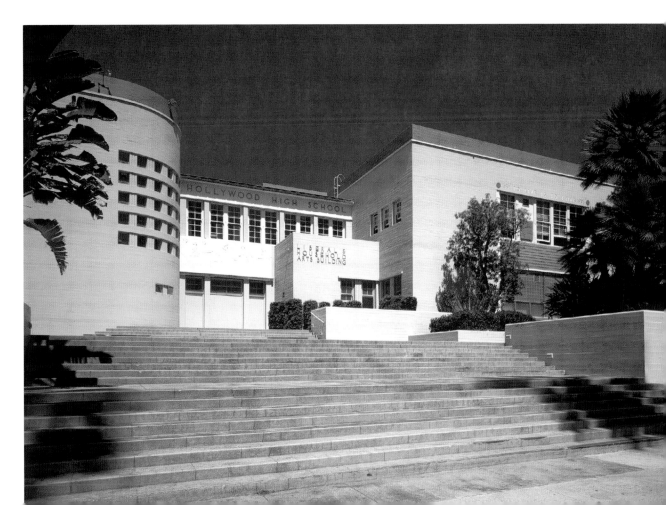

LEFT: Students pose for the annual school photograph on the grounds of Hollywood High School in 1922.

TOP RIGHT: Artist Eloy Torrez painted the mural "Portrait of Hollywood" on the east-facing wall of the auditorium of the school in 2002. The mural is meant to showcase the ethnic diversity in the school attendees. Bruce Lee is pictured but did not attend the school.

RIGHT: The high school is still there today, with its alumni reading more like a *Who's Who* of Hollywood. Stars include Lon Chaney Jr., Alan Ladd, Laurence Fishburne, Stefanie Powers, James Garner, Sharon Tate, Ione Skye, Sarah Jessica Parker, and Tim Burton. The famous Hollywood High School Marching Band still leads the Hollywood Christmas Parade.

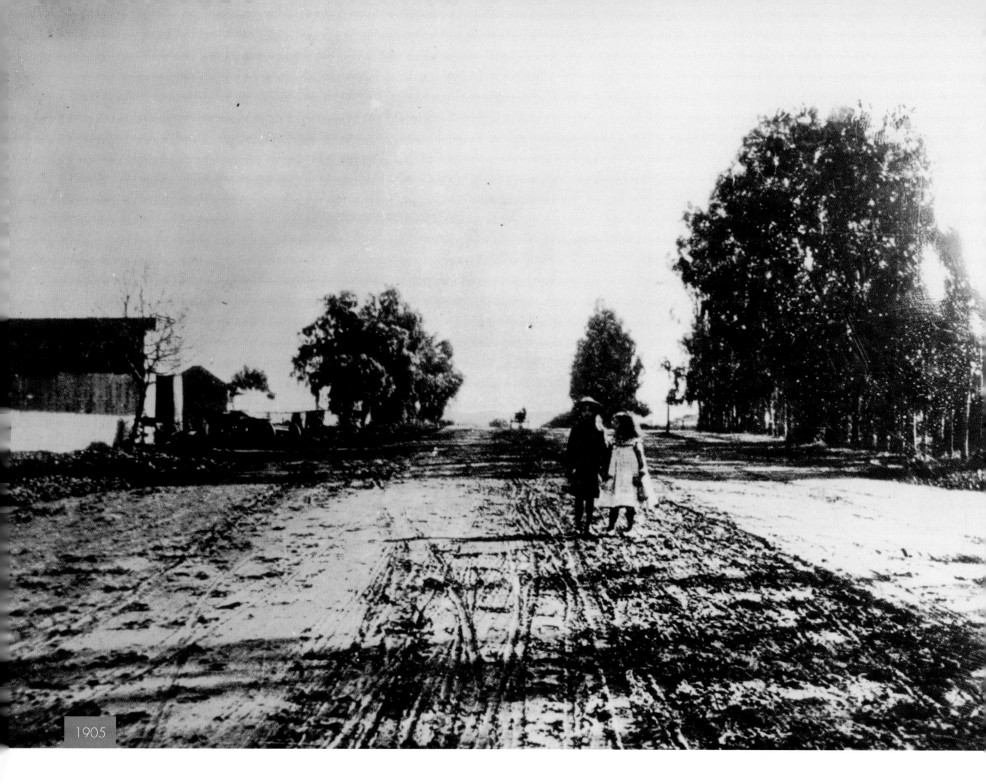

1905

SUNSET BOULEVARD AND GOWER STREET

A long-established gathering point for Hollywood's legion of extras

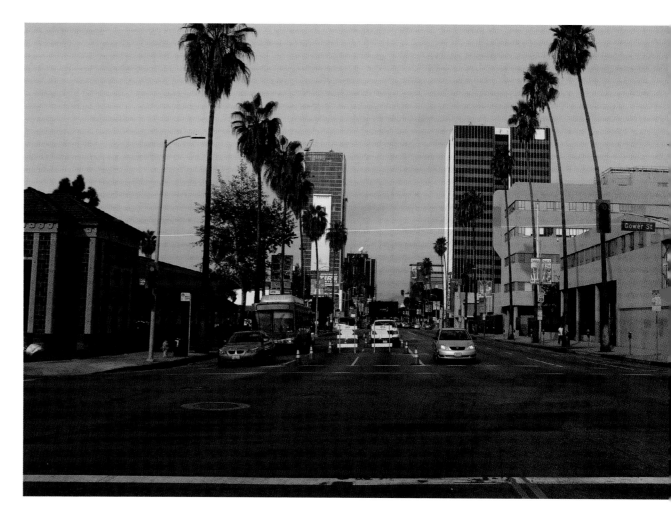

THE MOVIES COME TO TOWN

Cecil B. De Mille is credited for putting Hollywood on the map in 1913. He got off the train from New York at Flagstaff, Arizona, seeking locations for his film *The Squaw Man*. Disappointed with the weather and the scenery, he got back on the train and continued west to California. He then sent the famous telegram to Lasky and Goldfish (later Goldwyn), his producers in New York: "Flagstaff no good. Want authority to rent barn for $75 a month in place called Hollywood." There was a fledgling film industry in the area before De Mille. In 1907 Colonel Selig sent his production company to shoot scenes for *The Count of Monte Cristo* on a Santa Monica beach when bad weather in Chicago halted filming. In 1909 Selig sent director Francis Boggs, actors, and cameramen back to Los Angeles, where they converted an empty Chinese laundry downtown into production offices. Here they filmed *Heart of a Race Horse Tout*, the first picture to be made entirely in Los Angeles. Selig's company made the move permanent and built studios out in Edendale (between Silverlake and Echo Park). Other filmmakers followed: Biograph's D. W. Griffith came west from New York in 1910, bringing young Mary Pickford, her mother Lottie, Lillian Gish, and Mack Sennett along. Charlie Chaplin began filming at the Keystone Studios, and David and William Horsley came from New Jersey with the Nestor Film Company to set up the first Hollywood studio. Other film companies set up shop around Sunset and Gower in the heart of Hollywood and it soon became the permanent seat of the film industry.

LEFT: The scene (far left) from 1905 shows an area of Sunset Boulevard close to Gower Street. The first Hollywood Film Studios were built here and more would follow. These pepper-tree lined streets would soon be awash with small film companies churning out short silent comedies and dramas. The turnover was rapid because so many studios failed to make money and by 1920 the right side of Sunset Boulevard was nicknamed "Poverty Row." One- and two-reel westerns were very popular with the small film studios, and cowboy extras—in full costume and often their own horses in tow—would hang out on the southwest corner, waiting for work. This corner became known as Gower Gulch. On the southeast corner was the Columbia Drug Store and some believe the presence of so many cowboys waiting around, drinking coffee, hoping for that $5-a-day casting spawned the phrase "drugstore cowboy." John Wayne, Gene Autry and Roy Rogers all got their start in this neighborhood, though it's hard to imagine the scene today.

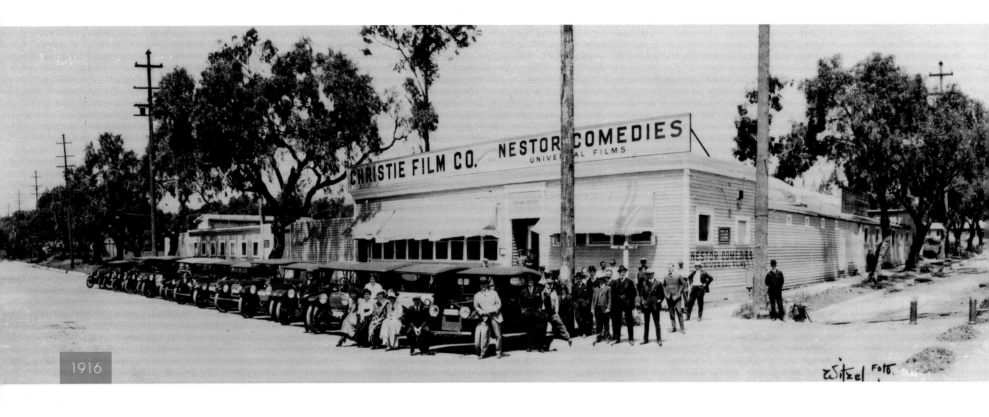

1916

Witzel Foto

BLONDEAU TAVERN / NESTOR FILM CO. / CBS

Local prohibitionists forced the tavern out of business and it became Hollywood's first studio

ABOVE AND RIGHT: In 1889, Mr. Rene Blondeau and his wife Marie bought six acres of land at the northwest corner of Sunset and Gower in the Cahuenga Valley, where they built the Blondeau Tavern. Their establishment had twelve small rooms, a corral, a barn, a five-room bungalow, and offered alcohol, meals, and overnight accommodations. Blondeau Tavern prospered over the years, feeding and quenching the thirst of countless travelers passing through the Cahuenga Valley. In 1903, shortly after of the death of Rene Blondeau, local prohibitionists banned the sale of alcohol, which forced Marie Blondeau to close her establishment. In late October 1911, David Horsley, a film producer of the Nestor Film Company, arrived in Hollywood with his actors

and crew members to work on a new motion pictures. Marie Blondeau rented him her closed-up tavern, which became the first motion picture studio in Hollywood. The bungalow was turned into the production office, the small rooms became dressing rooms, the barn was used for props, and film stages were built in the corral. Under Horsley's supervision the Nestor Film Company made a one-reel western, a single-reel drama, and a comedy each week. Al Christie, Nestor's noted comedy director, would take over the studios.

RIGHT: The Blondeau Tavern before it was taken over by the Nestor Film Company.

c.1903

32

RIGHT: In 1916 the Nestor Film Company became the Christie Film Company, owned by Al Christie and his brother. The two rented facilities from Universal at Sunset Boulevard and Gower Street, which included the site of the former Nestor Film Company. In early 1929, the Christie Film Company began making the first series of talking pictures written and conceived exclusively for African-American performers. In 1933, the Christie brothers Company went into receivership and their studio assets were acquired by CBS Radio. In 1938, the Christie Film Company studios site was integrated in the new CBS Columbia Square Studios, designed by architect William Lescaze and today the studios are occupied by the local CBS affiliate KCBS-TV and CBS radio station KNX. Across Sunset Boulevard and Gower Street from the CBS site is the Sunset Gower studios (pictured right and below). Harry Cohn chose this site for his New York company Cohn-Brandt-Cohn, which later became Columbia Pictures. *On the Waterfront*, *Funny Girl*, and *Lawrence of Arabia* were among Columbia's gifts to the world. In 1972 Columbia Pictures moved to share the Warner Studios lot in Burbank. The studios are now working closely with their sister company Sunset Bronson Studios and remain busy with independent productions and television shows.

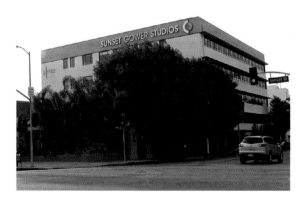

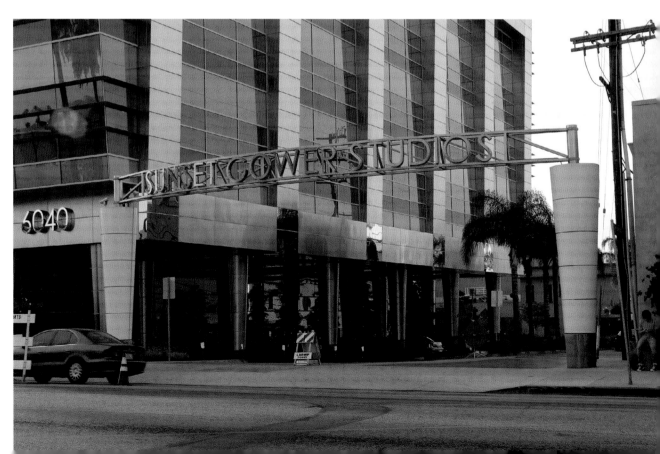

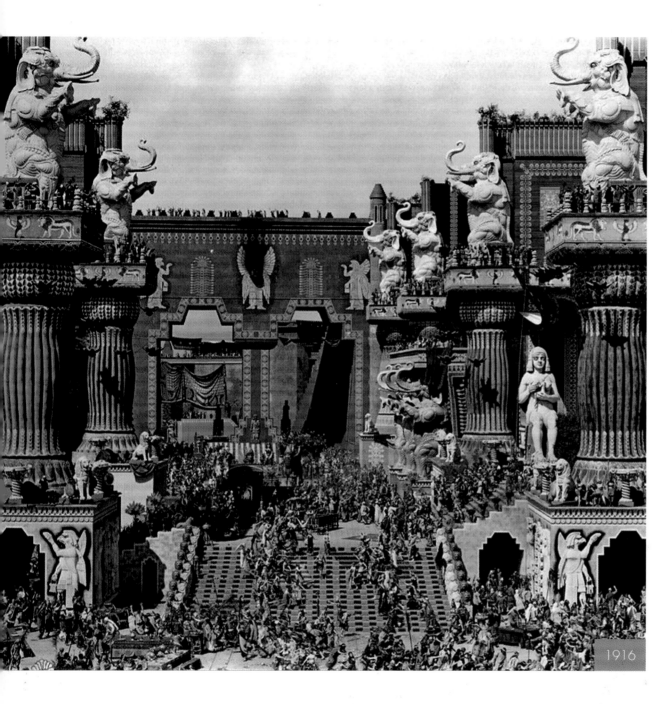

1916

BIOGRAPH COMPANY

The motion picture company that nurtured the talent of D. W. Griffith

Born in La Grange, Kentucky, in 1875, D. W. Griffith directed his first film for the American Mutoscope and Biograph Company, New York, in 1908. He began at Biograph as a five-dollars-a-day actor, appearing in eleven features before directing his first film, *The Adventures of Dollie*. Since that time Griffith has been credited with introducing multiple-camera-angle shots and other pioneering filming techniques. It took a week in those days to produce one ten-minute feature and by the time Griffith left Biograph, he had directed

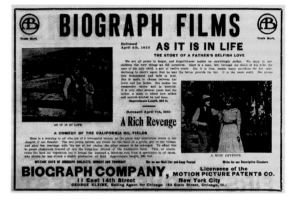

ABOVE A film card for a D. W. Griffith film made in 1910 prior to Biograph's move west.

BELOW: *Intolerance* wove three historical stories with one modern tale, all with the theme of intolerance. Critics saw it as Griffith's response to criticisms of *The Birth of a Nation*.

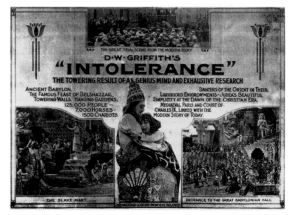

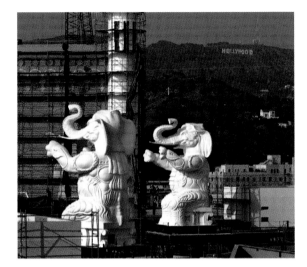

some 400 short films. In 1910, Griffith brought his cameraman, G. W. Bitzer, and his cast of players, including a very young Mary Pickford, Mack Sennett, and Donald Crisp, to California. Installed in Hollywood he completed the commercially successful Civil War tale *The Birth of a Nation*, at that time the most influential and controversial film in cinema's short history. He followed this in 1916 with an even greater challenge *Intolerance* (pictured left). Griffith made this epic at the Fine Arts Studio at 4500 Sunset Boulevard, erecting the largest set yet seen, the Babylon set, on a vacant property across the street. Rumored to have been 300 feet high, it stood for over four years because it was too expensive to demolish. This complex spectacular cost $1 million in 1916. *Intolerance* made a star out of Constance Talmadge but was the only financial failure of Griffith's career. He spent the rest of his life trying to pay off the debts the film had incurred. The set of the Great Wall of Babylon, placed at the corner of Sunset Boulevard and Hollywood Boulevard, was finally taken down in 1919. The courtyard of the Hollywood Highland Center (pictured above and right) featuring two pillars with elephant sculptures, was designed as a tribute to Griffith's masterpiece.

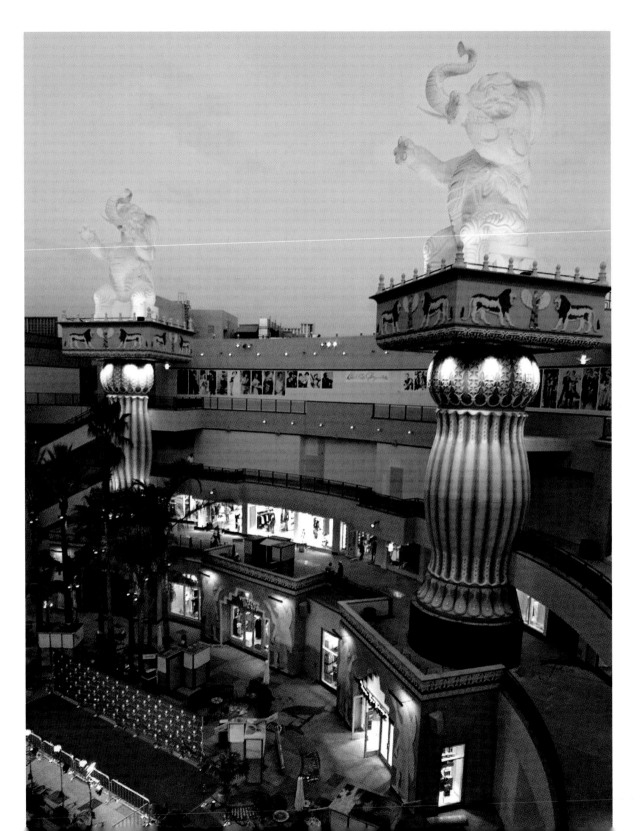

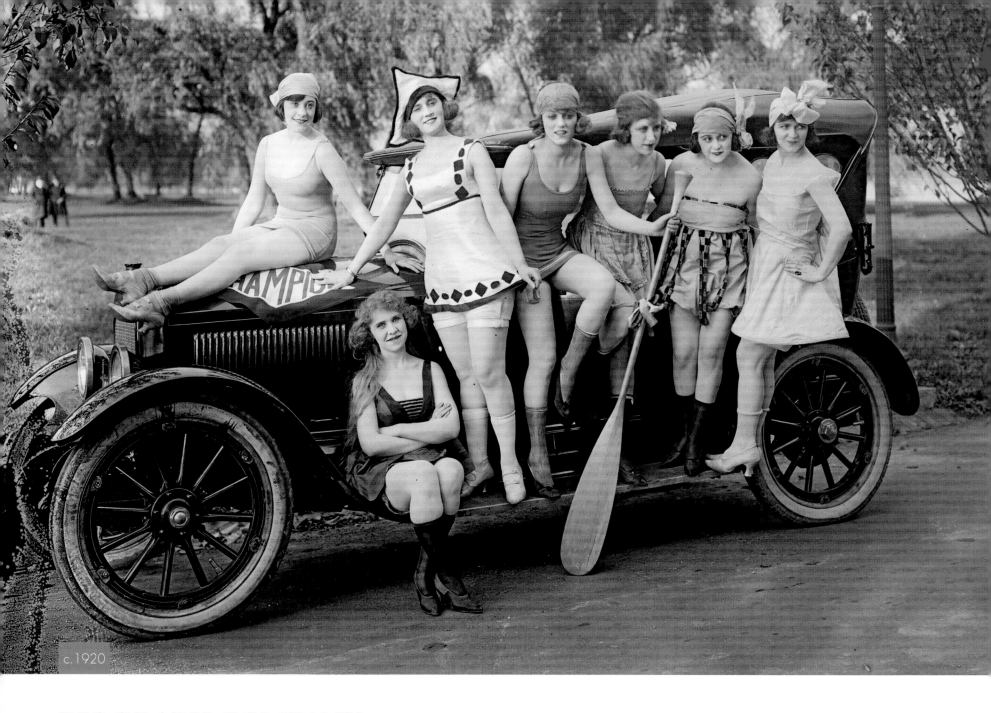

c.1920

BIOGRAPH COMPANY

Mack Sennett knew the formula for success was comedy and bathing beauties

When twenty-nine-year-old Canadian Mack Sennett joined the Biograph Company in 1909, he wrote a film script, *The Lonely Villa*. It was the first film he wrote for fellow Canadian Gladys Smith, better-known under her stage name, Mary Pickford. While at Biograph, Sennett directed comedies and appeared in them. He studied Griffith's directing techniques, gleaning tips from the master. In 1912 he founded his own Keystone Studios, where he developed his own new style of comedy: burlesque, larger-than-life vaudeville, a circus with a bevy of bathing beauties.

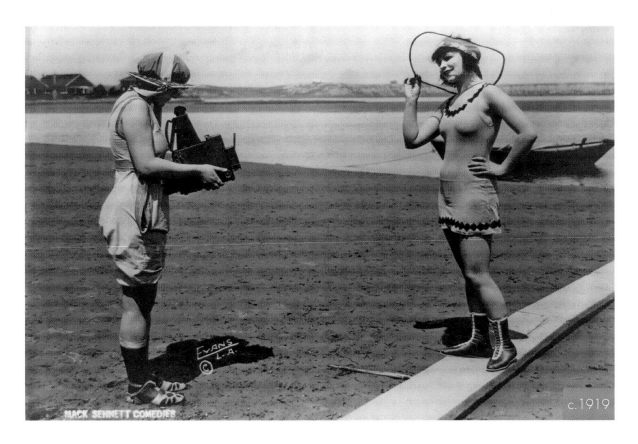

c.1919

MACK SENNETT COMEDIES

EVANS L.A. ©

MABEL NORMAND

Mabel Normand, one of the original Gibson girls, was a leading light of the Vitagraph and Keystone films. Dainty and tomboyish, she was a perfect foil for Charlie Chaplin. She directed his first Keystone comedy. She was also the exuberant star of the Mack Sennett comedies with whom she developed a tumultuous relationship, depicted in the musical *Mack and Mabel*. The comedienne's colorful personality often got her into trouble. She liked to drink and swear and eventually was released from her Goldwyn contract for her abuse of alcohol and cocaine. When director William Desmond Taylor was murdered on February 1, 1922, Mabel was the last one, witnesses said, to see him alive. She was later cleared of any involvement, but these scandals affected her career. The onetime "Queen of Comedy" died of tuberculosis in 1930.

He was the first film director to develop a distinctive comedy style, Sennett produced the first American feature-length comedy *Tillie's Punctured Romance* in 1914. Sennett's comedy discoveries helped make the Keystone trademark world famous and included Fatty Arbuckle, Mabel Normand, Ben Conklin, Ben Turpin, director Frank Capra, and a young Charlie Chaplin. In 1937 Sennett was granted a special award "for his lasting contribution to the comedy technique of the screen" by the Academy of Motion Picture Arts and Sciences.

c.1916

LEFT: Sennett assembled a team of girls known as the Sennett Bathing Beauties who would appear in what were then provocative bathing costumes in short comedy films. The films were sometimes a step-ladder to bigger roles, as was the case with Carole Lombard and the ill-fated Marie Provost.

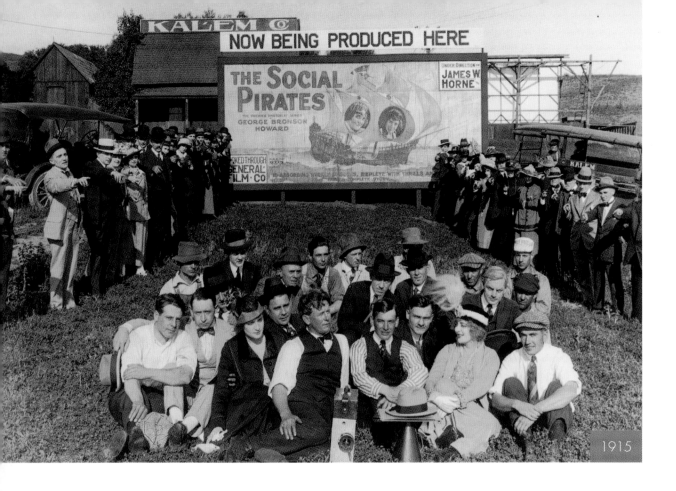

1915

KALEM STUDIOS
Specializing in B movies

LEFT: The Sigmund "Pop" Lubin Company built studios on Sunset Boulevard in 1912 at 1425 Hoover Street. Lubin's tenure was short. That year the Essanay Company made twenty-one westerns there in almost as many weeks. The Kalem Company occupied the studio from 1913 to 1917 with a large company of players who made comedies and swashbuckling dramas. Allied Artists and Monogram were among the more successful companies to produce movies here. Monogram made numerous B movies, including the *Charlie Chan* series, *The Bowery Boys*, and *The Shadow*. *The Babe Ruth Story* was filmed here in 1948 and *The Invasion of the Body Snatchers* in 1956. The studio at 4401 Sunset Boulevard, has been in continuous operation since 1912. Since KCET, a public broadcasting station, bought the facility in 1971, much has been rebuilt, but a few original remnants remain. Steve Martin shot scenes for *L.A. Story* at these studios. In 2011, KCET sold the studio to the Church of Scientology which intends to use the facilities to produce videos, internet content and high definition video transmissions.

BELOW: The crew of *The Squaw Man* in 1914.

THE JESSE LASKY STUDIOS
Makers of the first full-length feature

RIGHT: Founded in New York in 1913 by Jesse Lasky, Cecil B. De Mille, his brother-in-law Samuel Goldfish (later Goldwyn), and Arthur Friend, the Lasky Feature Play Company set out for Flagstaff, Arizona, to shoot the film *The Squaw Man*, starring Dustin Farnum. Finding Arizona unsuitable, they continued on to Hollywood. De Mille and Lasky rented a yellow barn at Selma Avenue and Vine Street, where the owner still kept his horses. De Mille and the actors shared the horse stalls. In 1914 *The Squaw Man* (pictured right) was the first full-length motion picture to be filmed in Hollywood. A year later De Mille and Lasky's company owned the whole block. In 1925 the Lasky Feature Play Company merged with Adolph Zukor's Famous Players to form Famous Players-Lasky Corporation. The original yellow barn was moved—along with the rest of the company—to the massive United Studios on Marathon and Van Ness in 1926. United Studios became Paramount Studios, where the yellow barn remained until 1982, when it was relocated to Highland Avenue, opposite the Hollywood Bowl. It is now used as the Hollywood Heritage Museum, which is dedicated to the early movie era.

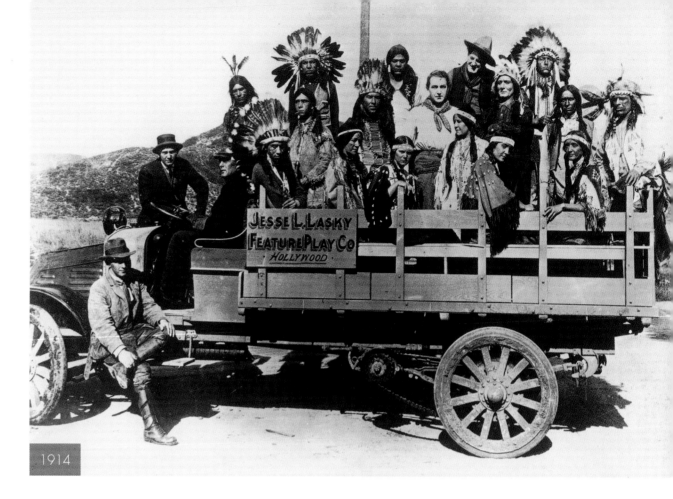

1914

1914

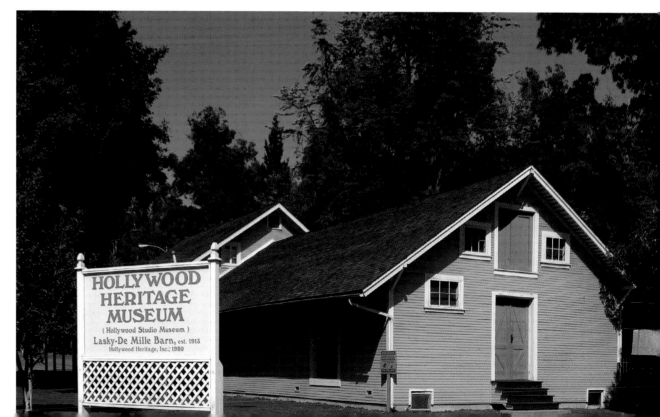

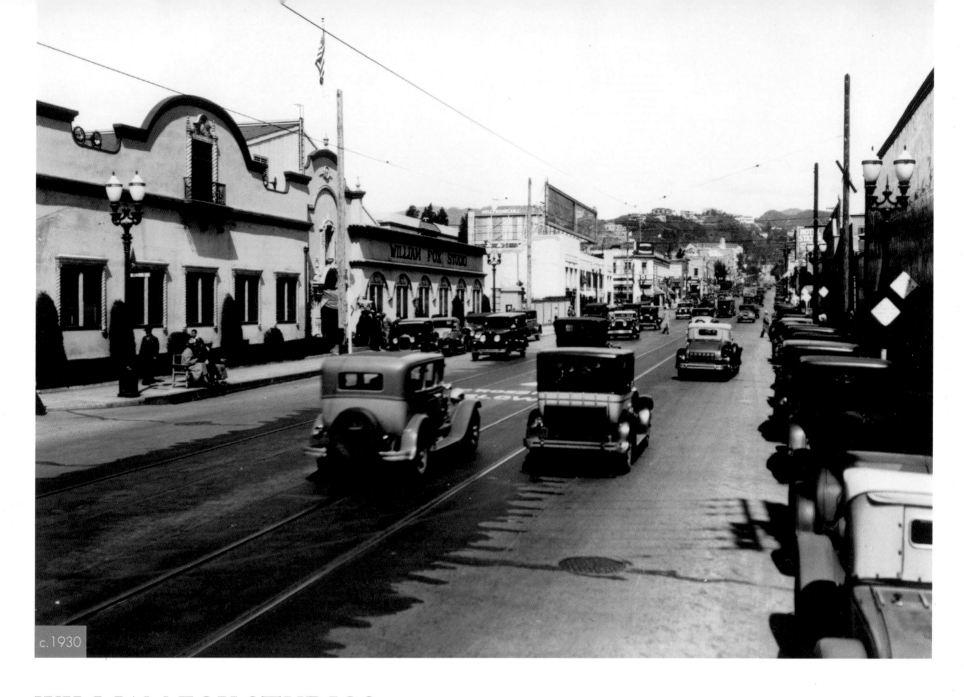

c.1930

WILLIAM FOX STUDIOS

Fox established a base on Western Avenue before moving to Beverly Hills

ABOVE: Hungarian-born William Fox moved to Hollywood from New York in 1916 to make movies. In 1917 he bought the old Dixon Studios on the west side of Western Avenue below Sunset, plus eight additional acres across the road, and

signed vamp Theda Bara and Tom Mix to contracts. By 1923 William Fox needed more room and expanded his production to Beverly Hills; however, the corporate offices (pictured above) remained on Western. By 1925 they had turned

out eighty-three films. Fox merged his company with Darryl Zanuck's Twentieth Century Productions in 1935. Fox died in 1952, but under Zanuck's guidance, Twentieth Century Fox Studios, now at 10201 West Pico Boulevard,

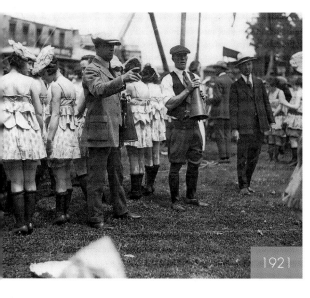

1921

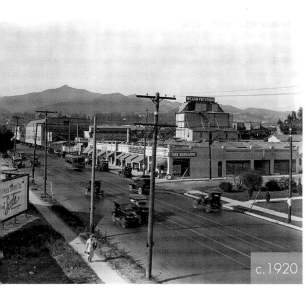

c.1920

LEFT: Coy Watson supervises the bathing beauties next to director Hampton Del Roth on the Fox backlot.

BELOW: Today there is no sign of the Fox business on Western Avenue.

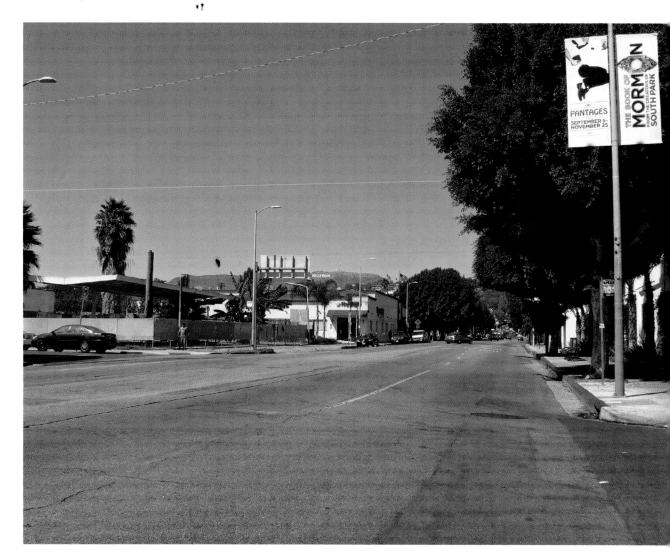

prospered with stars like Tyrone Power, Henry Fonda, and Marilyn Monroe. Fox won Best Picture Oscars for *All About Eve* and *The Sound of Music*, among others. Much of the Pico lot was sold off in 1965 to create Century City. Twentieth Century Fox continues to enjoy success with the *Star Wars*, *Die Hard*, *X-Men* and *Ice Age* series. The company was bought in 1985 by controversial Australian media magnate Rupert Murdoch, who was obliged to take U.S. citizenship to complete the deal. The movie-making arm is part of the Fox Broadcasting empire.

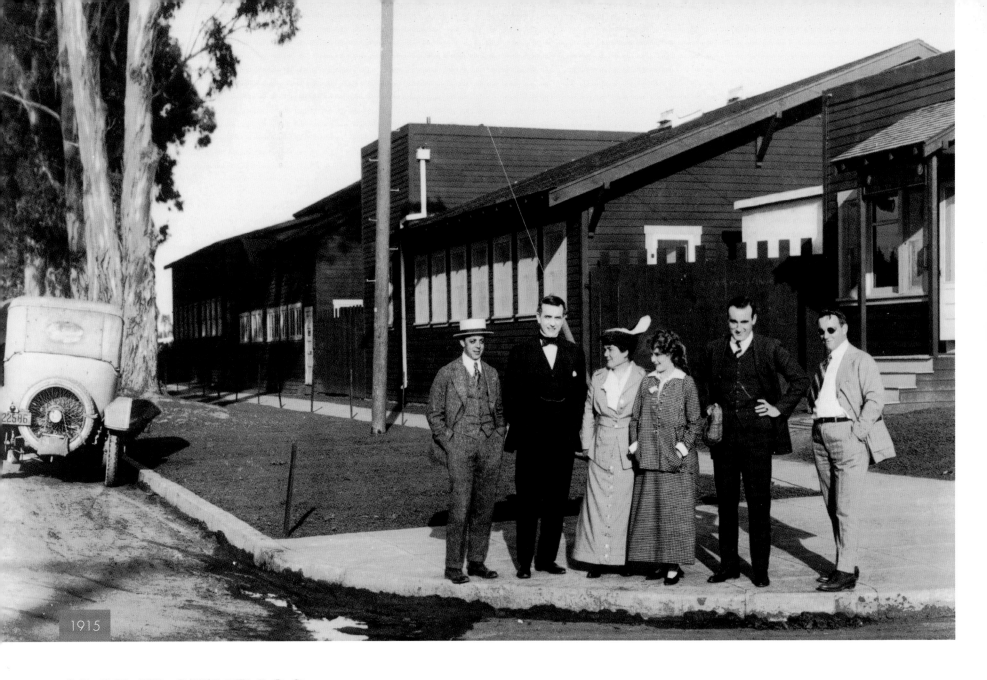

1915

CLUNE STUDIOS

One of the oldest studios in Hollywood, now producing independent films

ABOVE: Built in 1915 by theater magnate William H. Clune, the Clune Studios on the northeast corner of Melrose and Bronson is a neighbor to Paramount Studios. It has lived under many different titles. In the 1930s William Boyd and Gabby Hayes made their popular *Hopalong Cassidy* films here. It was renamed The California Studio, and in 1946 *The Best Years of Our Lives* was shot here, as well as the original *A Star Is Born*. In the 1960s it changed name once again, this time to the Producers Studio. Future U.S. President Ronald Reagan starred in *Death Valley Days*, while interior scenes for the Oscar winner *In the Heat of the Night* were filmed here. In 1979, it became the Raleigh Studios, where independent films are now made, as well as a variety of television series.

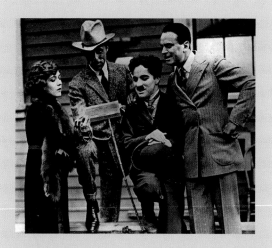

UNITED ARTISTS

The United Artists Corporation was founded in 1919 by Douglas Fairbanks, Mary Pickford, D. W. Griffith, and Charlie Chaplin. They wanted artists to make and distribute their own and other people's quality products. Their early successes include *Pollyanna*, *Broken Blossoms*, and *Way Down East*. In the mid 1920s, they were joined by Joe Schenck, who brought in Rudolph Valentino, Gloria Swanson, Buster Keaton, and Sam Goldwyn. With Howard Hughes, they added *Hell's Angels* and *Scarface*. Everything went splendidly until the late 1940s when, without a studio or contract stars, business slowed down. United Artists regrouped and rose again with successes like *The Magnificent Seven* and *Tom Jones*. United Artists subsequently became part of the MGM organization.

FAR LEFT: From left to right: Albert Kaufman, Harold Lockwood, Mary Pickford's mother, Lottie, Mary Pickford, Donald Crisp, and the director Allan Dwan, in front of the Clune Studios.

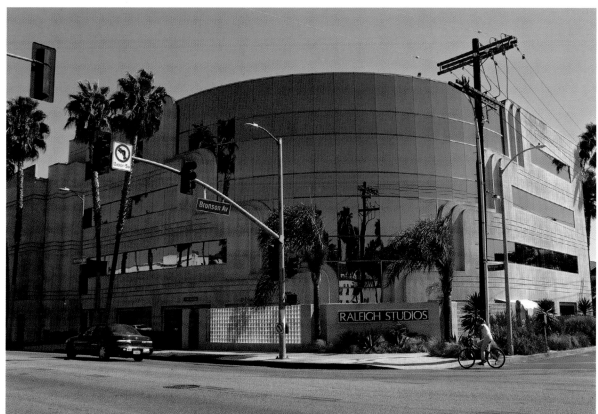

CHARLIE CHAPLIN STUDIOS
A little piece of England on La Brea Avenue

BELOW: Raised in poverty in London, Charlie Chaplin built a Tudor-style home on La Brea Avenue facing Sunset Boulevard where his mother could live in comfort. He built a studio behind it with cottages, chimneys, and green landscaping. The "Little Tramp" now owned his own English village in Hollywood, surrounded by orange groves. His footprints are indelible in the cement outside Sound Stage 3. At his own studios, Chaplin continued committing his comic genius to celluloid with such classics as *The Gold Rush* (1925), *City Lights* (1931), *Modern Times* (1936), and *The Great Dictator* (1940). Chaplin left these studios in 1953, after which several television series were filmed there, including *Superman*, *Perry Mason*, and *The Red Skelton Show*.

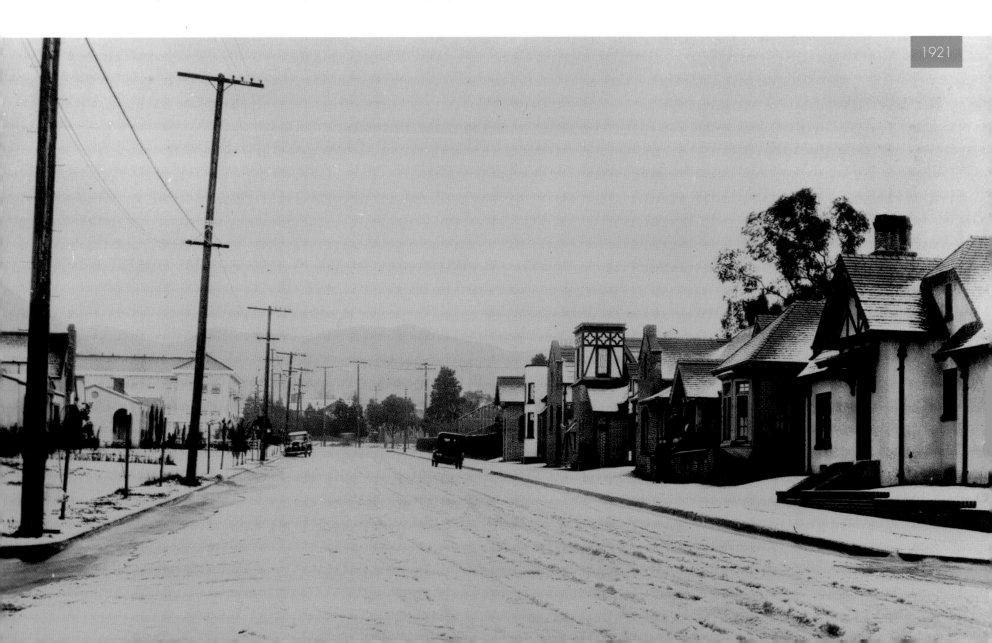

1921

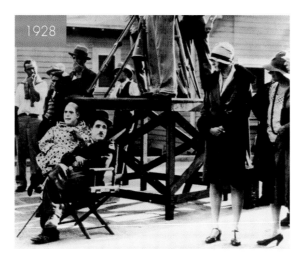

1928

BELOW: Today the studio lot is half the original five-acre size. Until 1999 it was owned by Herb Alpert and Jerry Moss (as A&M Studios), who recorded Alpert's own Tijuana Brass, Quincy Jones, and the Bee Gees. In 1985 the video of *We Are the World* was made here with Bob Dylan, Michael Jackson, Bruce Springsteen, and other singers. Today the studio is owned by Jim Henson Productions and home to Miss Piggy and the Muppets. The studio lot was used for the 2011, Muppets film where the puppet team are reunited to save the old Muppets Theater. Perched on the roof above the main gate is Kermit the Frog dressed as Charlie Chaplin's Little Tramp.

CHAPLIN'S FILM SUCCESS

The comic genius, unmistakable in his battered bowler hat, was actually wearing four hats on his movie *The Circus*. Chaplin had written the script, played the lead, and directed and produced the film. In fact, he did such a brilliant job that at the Academy Awards held in 1929, Chaplin's name was removed from the competitive class and the Academy honored him with a special award not given every year: "To Charles Chaplin for versatility and genius in writing, acting, directing, and producing *The Circus*." Chaplin who used to busk on the streets of London to support his impoverished family, now received the Academy's highest honor. He was the king of Hollywood. Charlie Chaplin was the first actor to grace the cover of *Time* magazine in 1925. In 1972, he was awarded a special Oscar "for incalculable effect in making motion pictures the art form of the century." He was made a Knight Commander of the British Empire in 1975.

TOP RIGHT: Charlie Chaplin has an eye for the extras on the set of *The Circus* in 1928.

LEFT: A fittingly English setting for Chaplin's mock-Tudor architecture, a snowfall on La Brea Avenue in 1921.

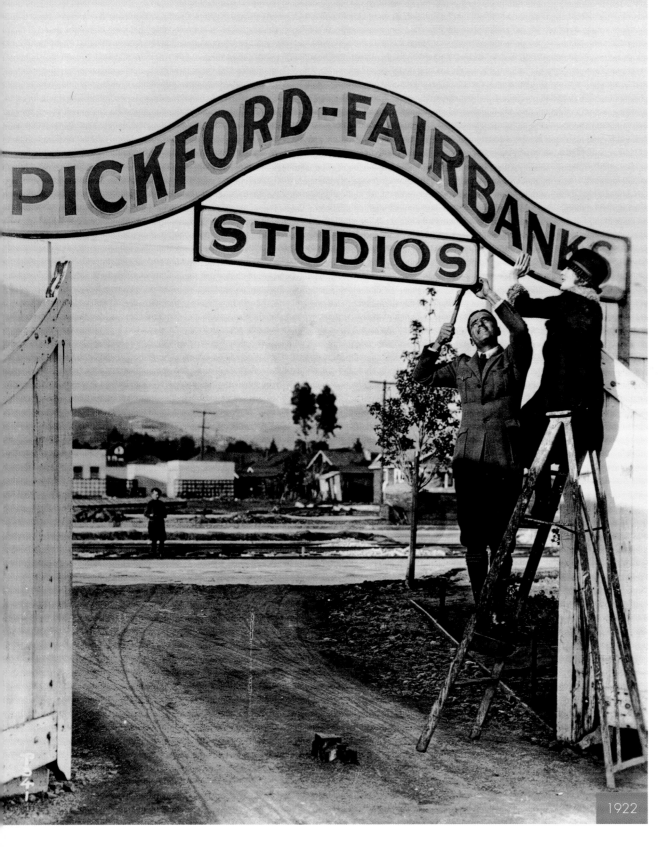

1922

PICKFORD-FAIRBANKS STUDIOS

Like many studios in Hollywood, the name over the gate would soon change

LEFT: The Jesse B. Hampton Studios opened in 1920 on Santa Monica Boulevard and Formosa Avenue. In 1922 Mary Pickford and Douglas Fairbanks purchased the facility and renamed it. They made classics such as *Robin Hood* and *The Thief of Bagdad*. In 1924, after leaving his own company, Samuel Goldwyn rented space here. In 1927, the studio was renamed United Artists, though the famous couple had joined Chaplin and D. W. Griffith in their own enterprise eight years earlier. Eddie Cantor filmed *Roman Scandals* here in 1933. By 1948 another name was over the gate: Samuel Goldwyn Studios (pictured below right). *The Apartment*, *West Side Story*, *Irma La Douce*, and *Some Like It Hot* came under that tenure. Some of *The Alamo* was filmed on the Goldwyn lot, where John Wayne had an office. Natalie Wood, Susan Hayward, and Frank Sinatra were among the many stars signed to this studio.

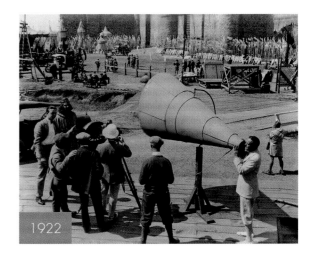

1922

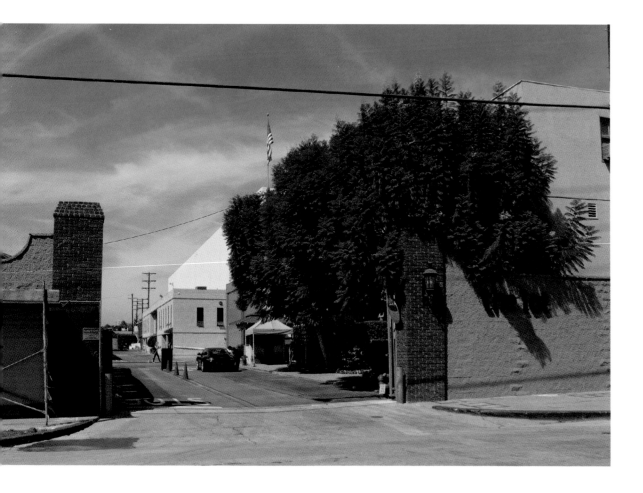

ROBIN HOOD

In 1922, Douglas Fairbanks wrote, produced, and starred in the silent movie version of *Robin Hood* at Pickford-Fairbanks Studios. Wallace Beery played King Richard, and Enid Bennett, Maid Marion. Directed by Allan Dwan (who also directed many Shirley Temple films), the movie was originally titled *The Spirit of Chivalry*. Fairbanks's most elaborately designed production, which included a replica of the mammoth castle and village of Nottingham, brought costs to over $1 million. However, the film made over $2.5 million. The photograph bottom left shows Douglas Fairbanks at the megaphone on the set of *Robin Hood*.

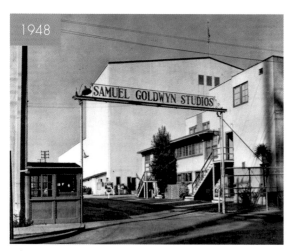

1948

ABOVE: From 1980 it was known as the Warner Hollywood Studios, an addition to the studio in Burbank, where in the 1980s and 1990s, television series such as *The Love Boat*, *Dynasty*, and *The Fugitive* were made. Motion pictures included *Basic Instinct* and *The Green Mile*. But in 1999 this historic landmark changed hands once more. During the 2000s, the studios came to be known as the Lot, with Warner Brothers Productions as the tenant. Redevelopment of the Lot started in April 2012, as developer CIM Group plans to build new offices and soundstages on the property.

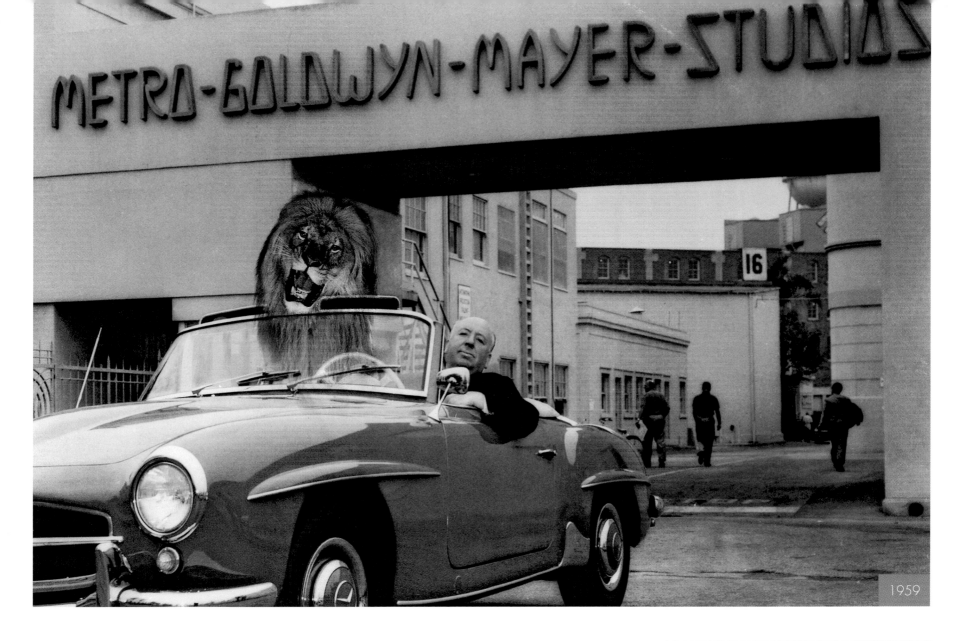

1959

MGM STUDIOS

One of Hollywood's richest ironies—Sam Goldwyn was never part of MGM

The most famous Hollywood movie studio in the world was not actually in Hollywood: MGM Studios began in Culver City, west of Hollywood, in 1924. MGM was founded by Louis B. Mayer in the old 1915 Triangle Pictures Studio, built by D. W. Griffith, Thomas Ince, and Mack Sennett. Sam Goldwyn, having given up ownership of

Goldwyn Pictures in 1922, was never part of the studio that carried his name. MGM claimed it had "more stars than there are in heaven" and was known for its star-studded, glossy productions, such as *The Wizard of Oz*, the *Thin Man* series, *Andy Hardy*, *National Velvet*, *Gone with the Wind*, and musicals like *Singin' in the Rain* and *Easter*

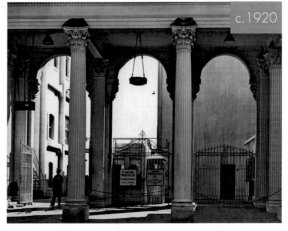

c.1920

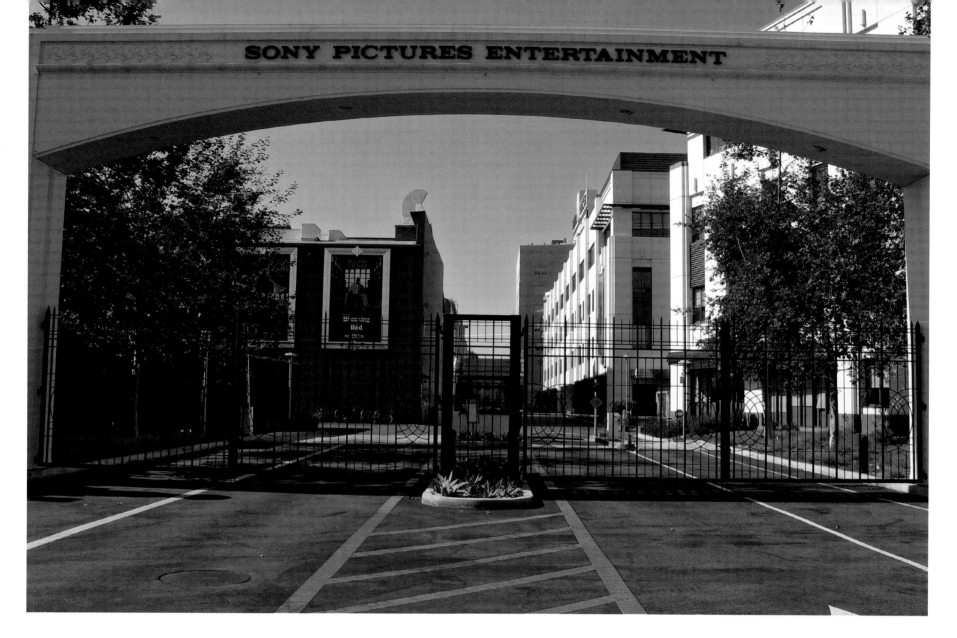

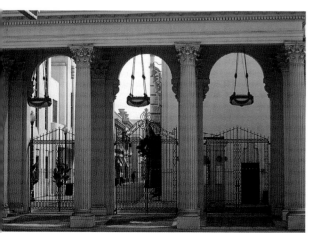

Parade. MGM sold the studio buildings to Lorimar Television in 1980. Owned by Sony Entertainment since 1990, the studio's tenants, Columbia TriStar Films, have produced *A Few Good Men*, *First Knight*, and the *Charlie's Angels* movies. MGM and United Artists are still actively engaged in motion picture production with recent film successes that include the *Legally Blonde* movies, *Die Another Day*, and the 2009 remake of *Fame*. MGM owns the largest film library in the world, with more than 4,000 titles, and has expanded into the home video and interactive media market. The studio has just completed forty years of successful James Bond features.

FAR LEFT AND LEFT: The 1915 colonnade was the original MGM main gate on Washington Boulevard in Culver City.

ABOVE LEFT: Alfred Hitchcock poses in his Mercedes-Benz 190 SL convertible with an illusion of the MGM lion in the passenger seat. "Hitch" was on the studio lot to direct his only MGM film, the classic 1959 thriller *North by Northwest*.

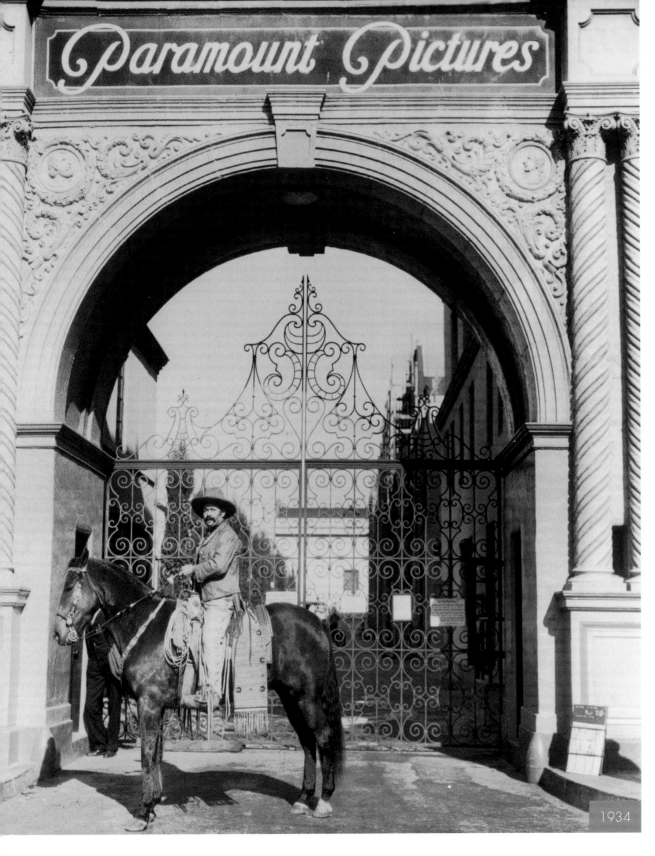

1934

PARAMOUNT PICTURES
The last studio based in Hollywood

LEFT: Paramount Pictures is the only major motion picture studio still operating with its headquarters in Hollywood. Adolph Zukor's Famous Players Company, founded in 1912, merged with the Jesse Lasky Company in 1916 and became Paramount Pictures. Directors Cecil B. De Mille and William S. Hart and stars such as Rudolph Valentino, Mae West, Bob Hope, Bing Crosby, W. C. Fields, Cary Grant, and Katharine Hepburn were here. Gloria Swanson produced a memorable performance as Norma Desmond in *Sunset Boulevard* as she drove up to Paramount's Bronson gate (pictured left in 1934).

BELOW RIGHT: There was an almost insatiable demand for westerns from early Hollywood. Paramount released their silent movie *Open Range* in 1927 starring Lane Chandler. Lobby cards like this will fetch $50 today.

BELOW: A hand-tinted postcard of the Paramount lot.

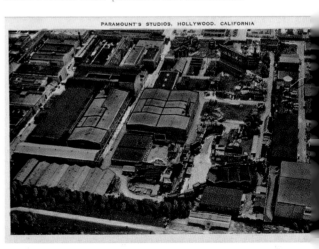

PARAMOUNT'S STUDIOS, HOLLYWOOD, CALIFORNIA

RIGHT: In 1966 Gulf and Western took over Paramount, which had recently produced *Rear Window*, *White Christmas*, and then *Breakfast at Tiffany's*. *Love Story*, *The Godfather*, and *Chinatown* followed under the new regime. Paramount merged with Viacom in 1994. Paramount Television produced such shows as *7th Heaven* and *Frasier*. In 2006, Paramount Television was dismantled to form CBS Television Studios, producers of the *90210* and *Vampire Diaries* series. The Paramount lot backs onto the Hollywood Forever Cemetery.

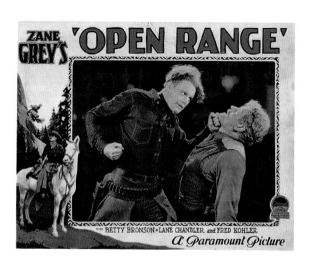

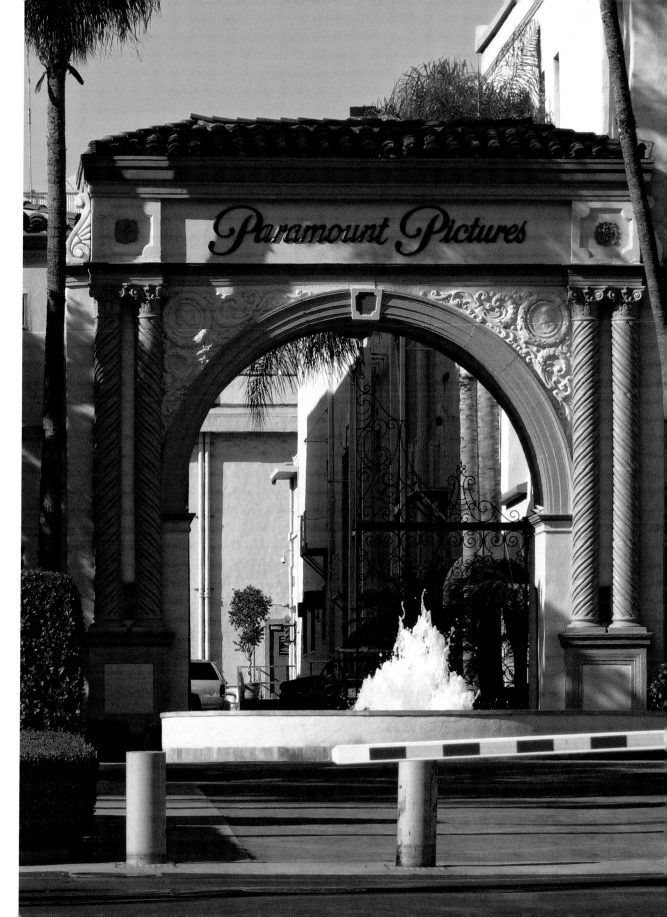

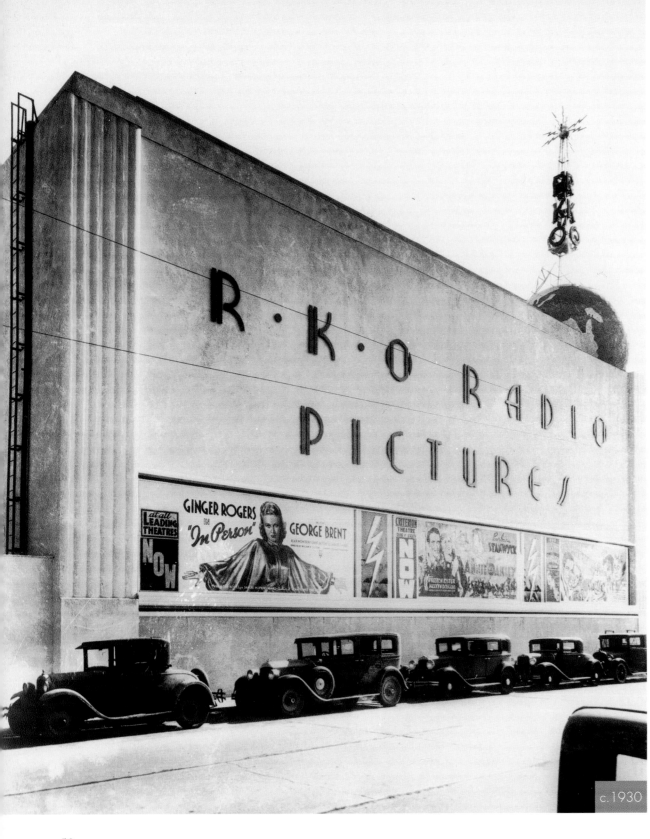

c.1930

RKO RADIO PICTURES
Home to the iconic RKO blue globe

LEFT: Built in 1921 on Gower Street and Melrose, the Robertson-Cole Studios were bought by Joseph Kennedy in 1923. RKO Radio Pictures took over in 1928. Fred Astaire and Ginger Rogers made two musicals a year in the 1930s. Frank Capra's *It's a Wonderful Life* came from RKO, as did the original *King Kong*, *Bringing up Baby*, and Alfred Hitchcock's *Notorious*, while Orson Welles created his masterpiece *Citizen Kane* in 1941 for the company. The eccentric producer Howard Hughes bought RKO in 1948, after which it went into decline. The *I Love Lucy* television series was so successful that in 1953 Lucille Ball and husband Desi Arnaz bought the RKO studio and called it Desilu.

RIGHT: The 1930s Art Deco building housing RKO Radio Pictures was one of the studio's best advertisements. It features the iconic blue RKO globe and broadcast tower that could be seen in the opening credits for each RKO film.

RIGHT: Although they continued to produce their television series there for some years, eventually Desilu was sold to Paramount and became part of that huge complex now owned by Viacom. The blue RKO globe remains on top of the corner of Melrose and Gower but the radio tower is gone. In 1989 RKO Radio Pictures, its few remaining assets, the trademarks, and remake rights to many classic RKO films, were sold to new owners, who now operate the small independent company RKO Pictures LLC.

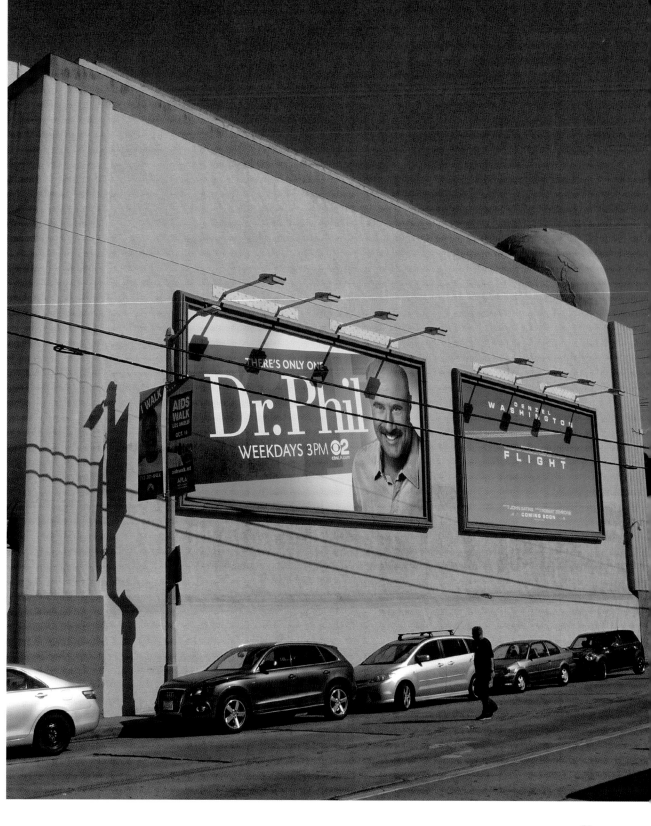

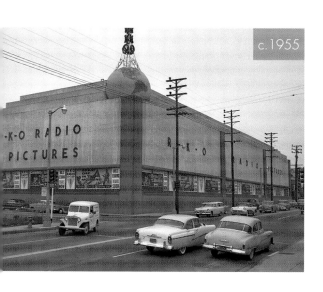

c.1955

SUNSET BOULEVARD
Hollywood's most famous stretch of tarmac

HACIENDA PARK

C.

LEFT: Sunset Boulevard is an icon of Hollywood celebrity culture. Nearly twenty-two miles in length it passes near some of the finest addresses in the Los Angeles area including Echo Park, Silver Lake, Los Feliz, Hollywood, West Hollywood, Beverly Hills, Holmby Hills, Bel-Air, Brentwood, and Pacific Palisades. The boulevard runs along the northern boundary of the UCLA Westwood campus. The best-known section of Sunset Boulevard is probably the Sunset Strip in West Hollywood, a center for area nightlife. At least four lanes in width for all of its length, the road is still treacherous in some areas. Jan and Dean's 1960s hit song *Dead Man's Curve* immortalizes a particularly dangerous section of the road near Bel Air estates just north of UCLA's Drake Stadium. Numerous hairpin curves and blind crests, and the lack of a median in sections yield a shocking number of accidents.

RIGHT: Sunset Boulevard used to extend farther east, but the portion east of Figueroa on the north end of Downtown Los Angeles was renamed César E. Chávez Avenue in honor of the late Mexican-American trade union leader. Sunset Strip in West Hollywood, known as the center of Los Angeles nightlife, is likely the best-known section of Sunset Boulevard. At first, the Sunset Strip lay in unincorporated Los Angeles County, which gave rise to its wilder nature. During Prohibition, clubs served alcohol to movie stars away from the watchful LAPD. The highest concentration of celebrity homes is in the hills above the strip. The boulevard is commemorated in many pop culture creations: Billy Wilder's famous movie of the same name, an Andrew Lloyd Webber musical, and a 1950s television series, *77 Sunset Strip*. While cruising the boulevard, drivers pass the headquarters of the Directors Guild of America, Hollywood High School, the Roxy Theatre, CBS Columbia Square and Will Rogers State Historic Park.

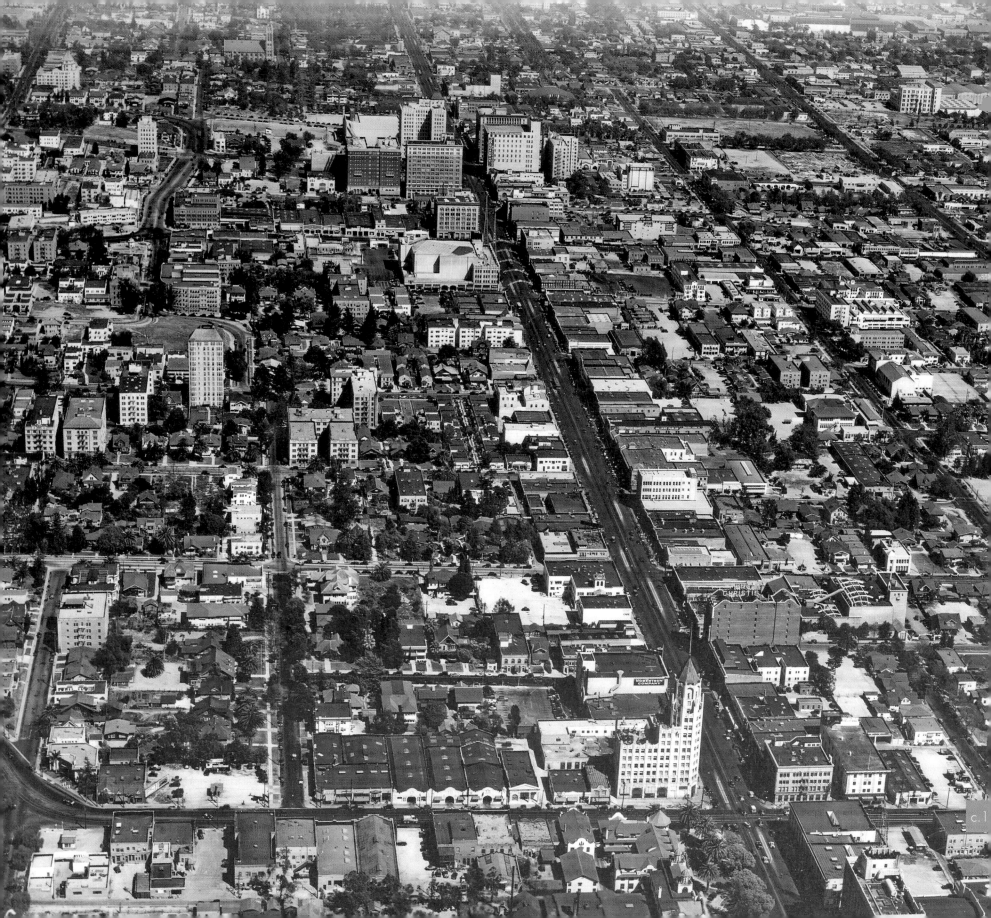

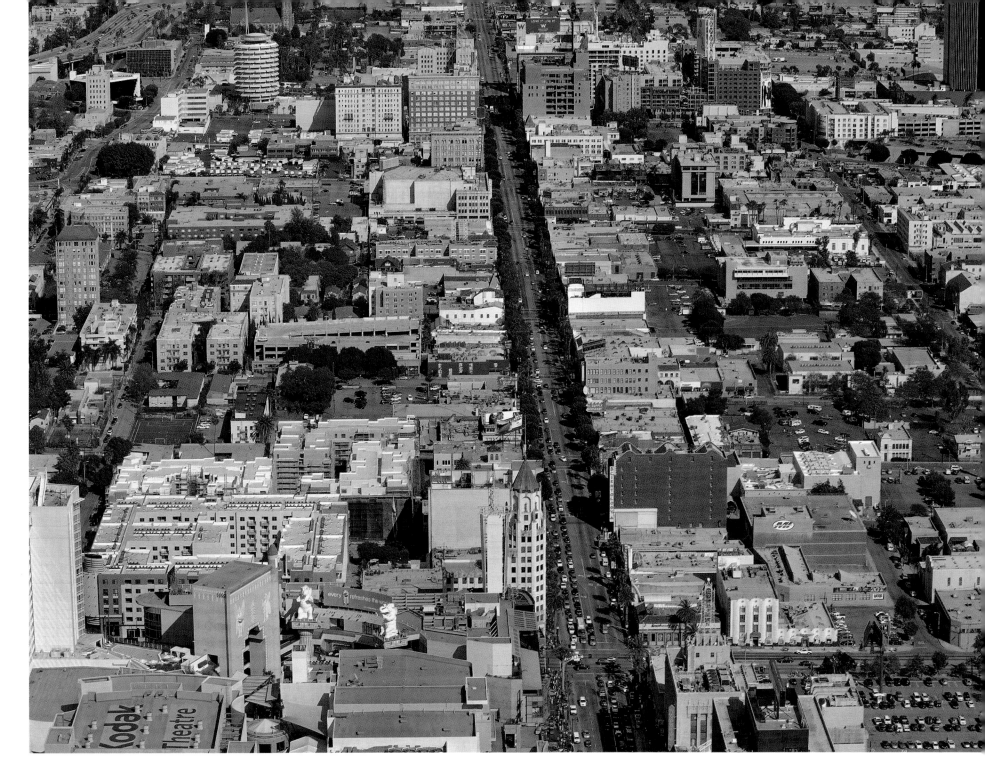

HOLLYWOOD BOULEVARD
The central artery of tinsel town

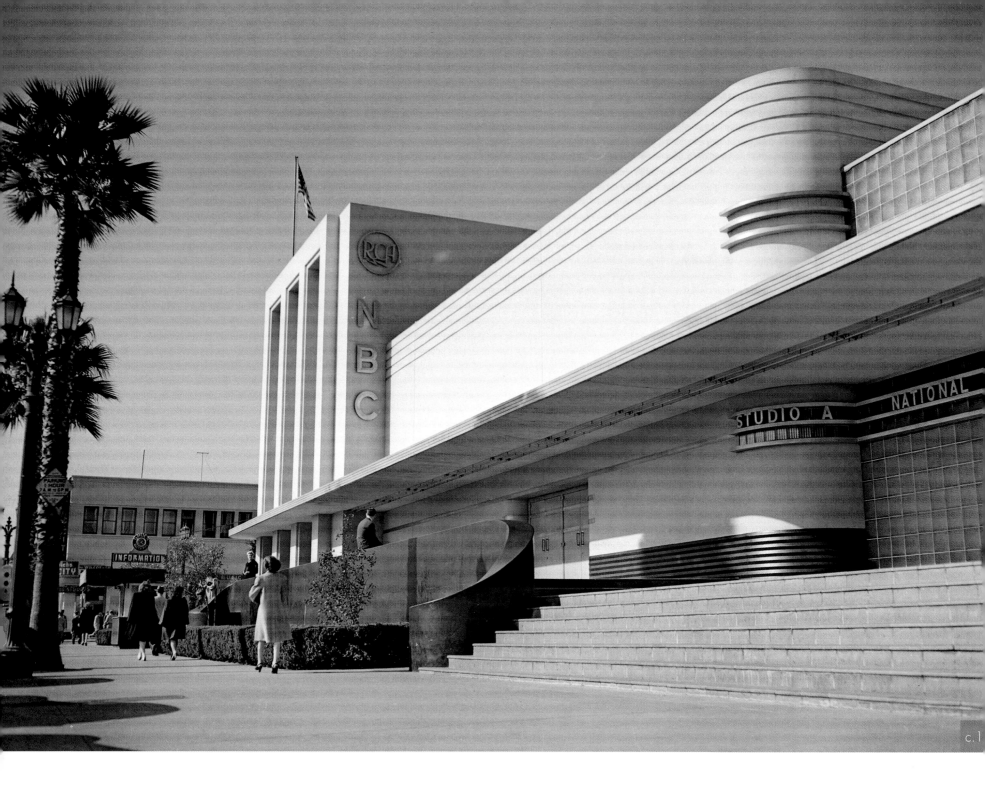

c. 1

NBC BUILDING AT SUNSET AND VINE
One of many beautiful Streamline Moderne buildings lost to the wrecker's ball

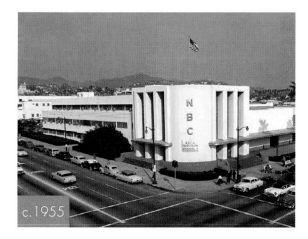

c.1955

LEFT: The National Broadcasting Corporation (NBC) opened their moderne-style Hollywood studios in 1938. In a reference to a nickname from their New York studio, they placed the words "Radio City" on the front of their building between Sunset and Hollywood boulevards at Vine Street. Soon the area was known as Radio City. Many radio studios and radio-themed cocktail lounges and businesses sprung up and for a while, radio vied with celluloid to be king of Hollywood. Radio first brought live entertainment into the homes of Americans across the country. Movie stars, who the listeners had seen on the silver screen in neighborhood theaters, were now invited into their homes. Famous internationally as the home of the movie industry, Hollywood's major radio stations had the benefit of convenient access to stars like Bing Crosby, Jack Benny, Amos and Andy and Bob Hope. A block away, the Columbia Broadcasting System (CBS) opened and the American Broadcasting Corporation (ABC) studios set up shop a few doors north on Vine.

ABOVE: The days of visitors to Radio City touring studios, giant control rooms and other "behind the scenes" features of radio production are gone. The NBC building at Sunset and Vine was demolished in 1963. The last radio program was broadcast from Hollywood in 2005. Newscasters and announcers made the final statement on KNX (1070)—the first and last station to transmit from a city that once hosted sixty-eight stations. New projects are in store for the intersection where NBC studios sat. The site of Radio City has been a bank for many years. But across the street, a 305-room hotel tower with 143 adjoining condominiums was completed near the end of 2009. Recently the area also welcomed 375 new luxury apartments in a building featuring restaurants, a nightclub, stores and a spa.

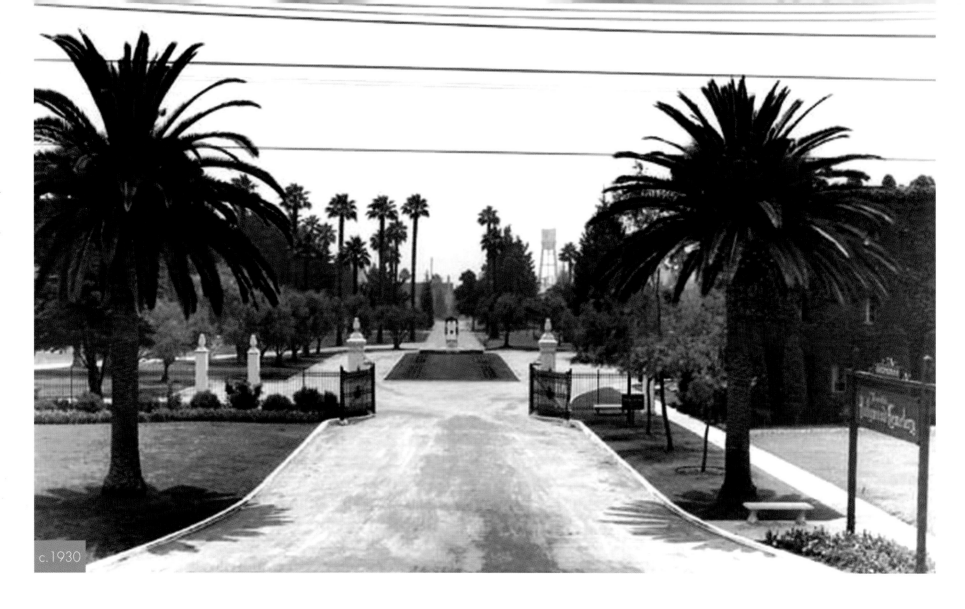

c.1930

HOLLYWOOD FOREVER CEMETERY

Resting place of the good and the great from Hollywood's golden age

ABOVE: The cemetery was founded in 1899 by Isaac Van Nuys when it was known as Hollywood Memorial Park Cemetery. The cemetery was planned long before the movie business came to town but its location next to Paramount studios soon made it the burial site of choice for the stars. Some of the greatest names of the early years of Hollywood are interred here with suitably grand monuments—others have the simplest of plaques. Cecil B. De Mille, Harry Cohn (Columbia),

Douglas Fairbanks, Rudolph Valentino and Jesse L. Lasky (Paramount) rest here. There are also residents with a musical connection such as band leaders Woody Herman and Nelson Riddle, and Johnny Ramone. Beatle George Harrison was cremated here before his ashes were taken to be spread on the river Ganges. Hollywood Forever is a cemetery with a checkered past. After its initial success, larger cemeteries, such as Forest Lawn, began to take its business, despite the cachet of

being buried in the heart of Hollywood along with such prestigious names. A parcel from the original 100 acres was sold off to Paramount (the company started by one of its residents) to stave off some of the debts. In the 1940s it was sold to former fraudster Jules Roth whose company set about asset stripping the business, selling bronze statuary, raiding the endowment fund and putting future maintenance at risk. With limited money for upkeep the cemetery fell into a decline

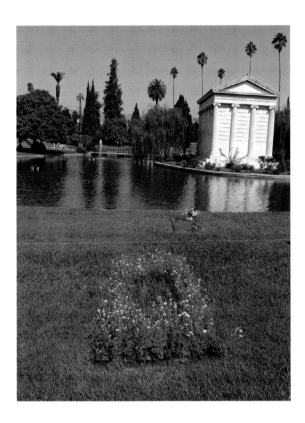

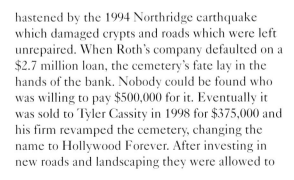

ABOVE: The Greek Revival temple mausoleum of William A. Clark Jr. has its own island and cost $500,000 in 1921.

RIGHT: The band Spirit Cleanse perform down the same avenue featured in the archive photo as part of "Dia de Los Muertos" (Day of the Dead) celebrations on October 30, 2010.

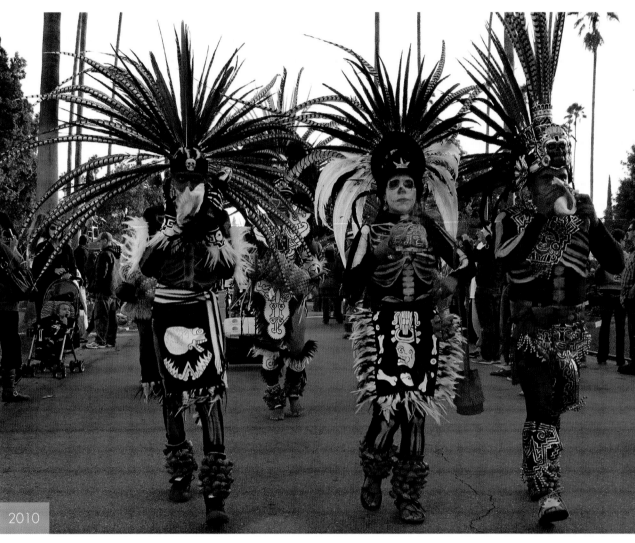

2010

hastened by the 1994 Northridge earthquake which damaged crypts and roads which were left unrepaired. When Roth's company defaulted on a $2.7 million loan, the cemetery's fate lay in the hands of the bank. Nobody could be found who was willing to pay $500,000 for it. Eventually it was sold to Tyler Cassity in 1998 for $375,000 and his firm revamped the cemetery, changing the name to Hollywood Forever. After investing in new roads and landscaping they were allowed to

sell new burial plots. In addition they have started running special events, such as movie screenings and festivals, like the Hispanic celebration of "Dia de Los Muertos" (Day of the Dead). In 2000 the cemetery was entered into the National Register of Historic Places. The Beth Olam Cemetery, in the southwestern section, is a dedicated Jewish burial ground. Famous residents: Mel Blanc (voice actor), Coral Browne (actress), Harry Cohn (movie chief), Cecil B. De Mille (film director) Douglas

Fairbanks (actor), Douglas Fairbanks Jr. (actor), Peter Finch (actor), Estelle Getty (actress, *Golden Girls*), Pauline Pfeiffer Hemingway (widow of Ernest), Woody Herman (bandleader), John Huston (film director), Jesse L. Lasky (movie chief), Peter Lorre (actor), Dee Dee and Johnny Ramone (rock stars).

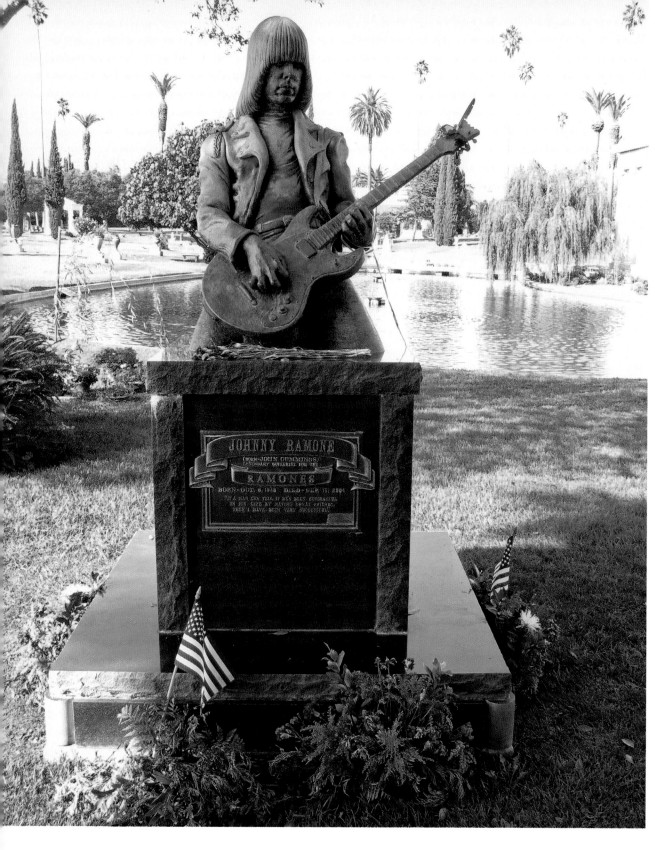

LEFT: The monument to rock star Johnny Ramone who died at age 55 in 2004. There is an annual Johnny Ramone tribute at Hollywood Forever, the eighth was held in 2012, with guest appearances from his contemporaries and a screening of one of Johnny's ten favorite Elvis movies.

BOTTOM RIGHT: This is the monument and reflecting pool for actor Douglas Fairbanks and his son, producer and actor Douglas Fairbanks Jr.

BELOW: Jayne Mansfield, Tyrone Power and Fay Wray.

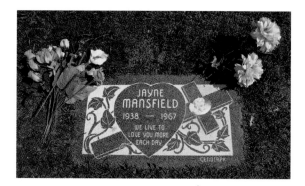

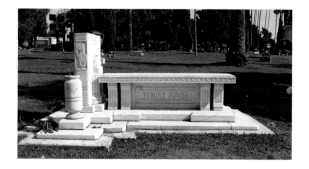

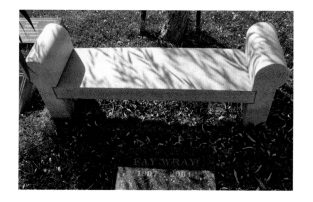

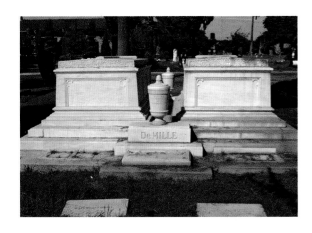

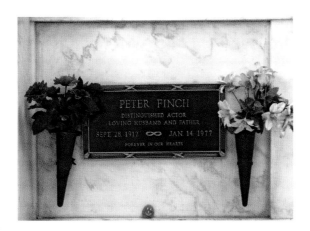

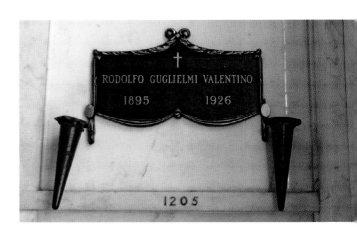

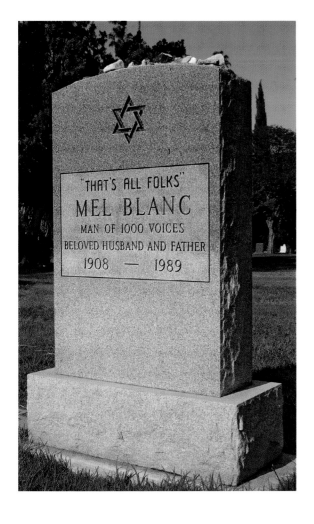

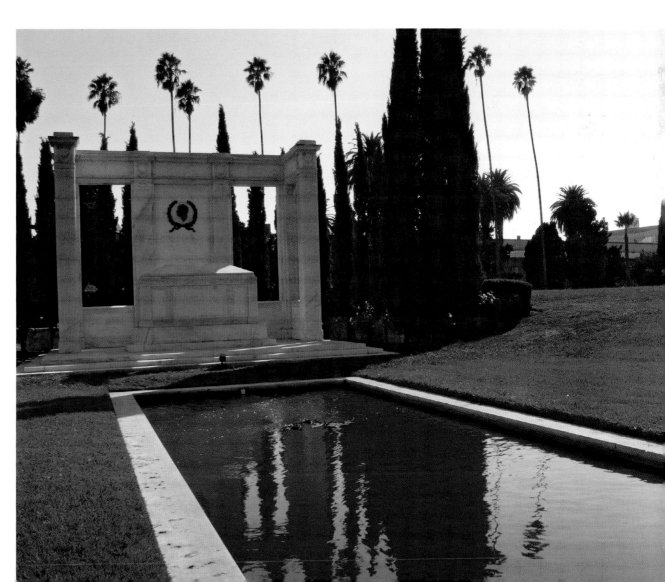

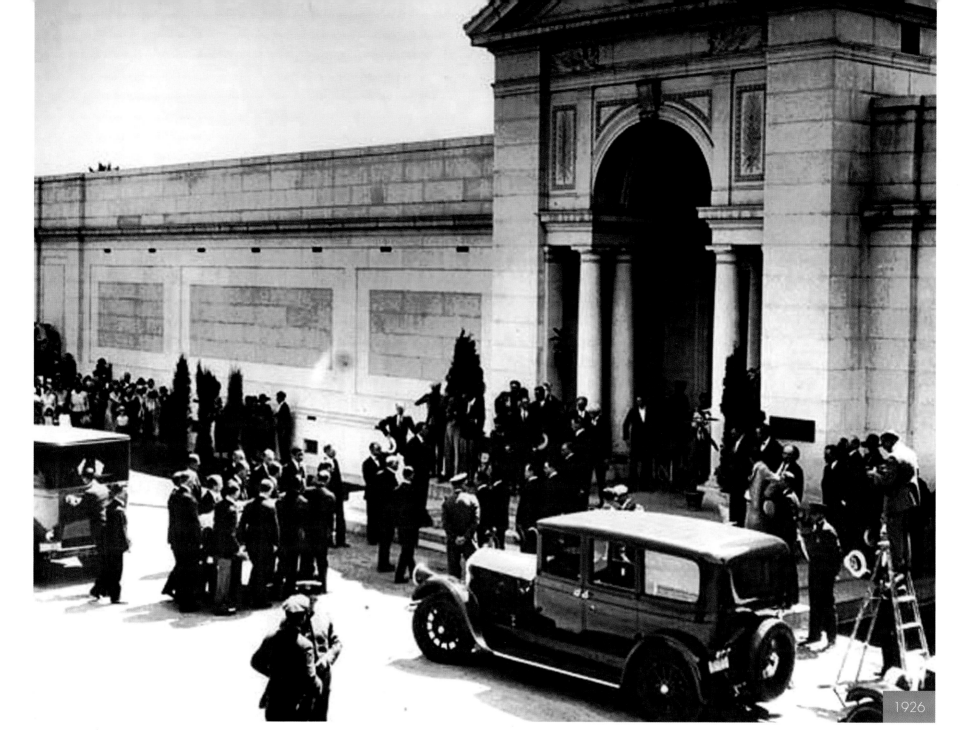

1926

RUDOLPH VALENTINO FUNERAL
The day the world's biggest screen idol was laid to rest

1926

RIGHT: After financial mismanagement of the cemetery its license to conduct funeral services was revoked. Under new management the cemetery has once again open for business.

BELOW RIGHT: The shrine to Valentino as it looks today.

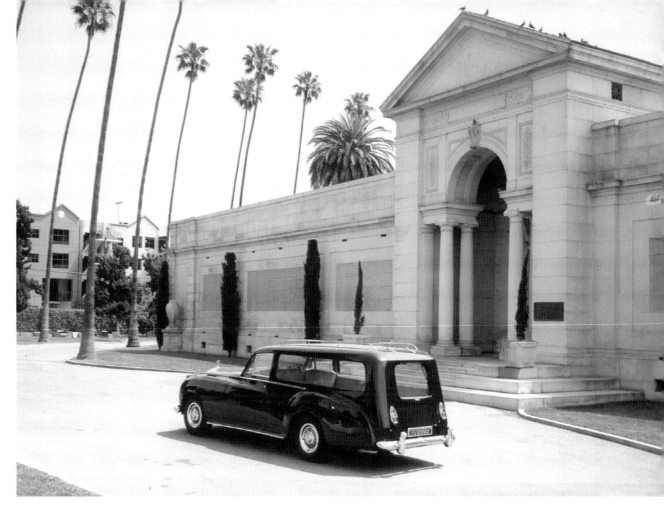

LEFT: August 23, 1926: "The day that Hollywood died." A mobile emergency room was set up to deal with swooning flappers when more than 100,000 mourners paid tribute to Rudolph Valentino, "the World's Greatest Lover," who died in New York at the age of thirty-one. The Sicilian-born Valentino had starred in *Four Horsemen of the Apocalypse* and *The Sheik* and had become the greatest silent screen star of all time. There was mass hysteria at his funeral service at the Church of the Good Shepherd in Beverly Hills, and thousands stood in stunned silence when he was carried to his final resting place at the Hollywood Cemetery. Shortly after his interment, a mysterious lady in black began making silent sojourns to his crypt. Today's "lady in black" Karie Bible carries on the tradition and gives guided tours. A memorial celebration is held at the Valentino crypt every August 23.

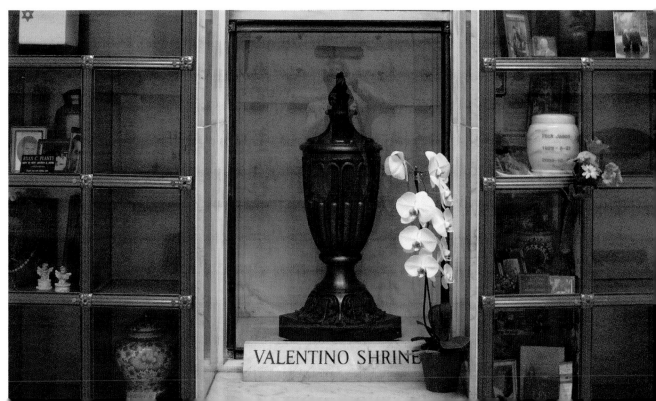

VALENTINO SHRINE

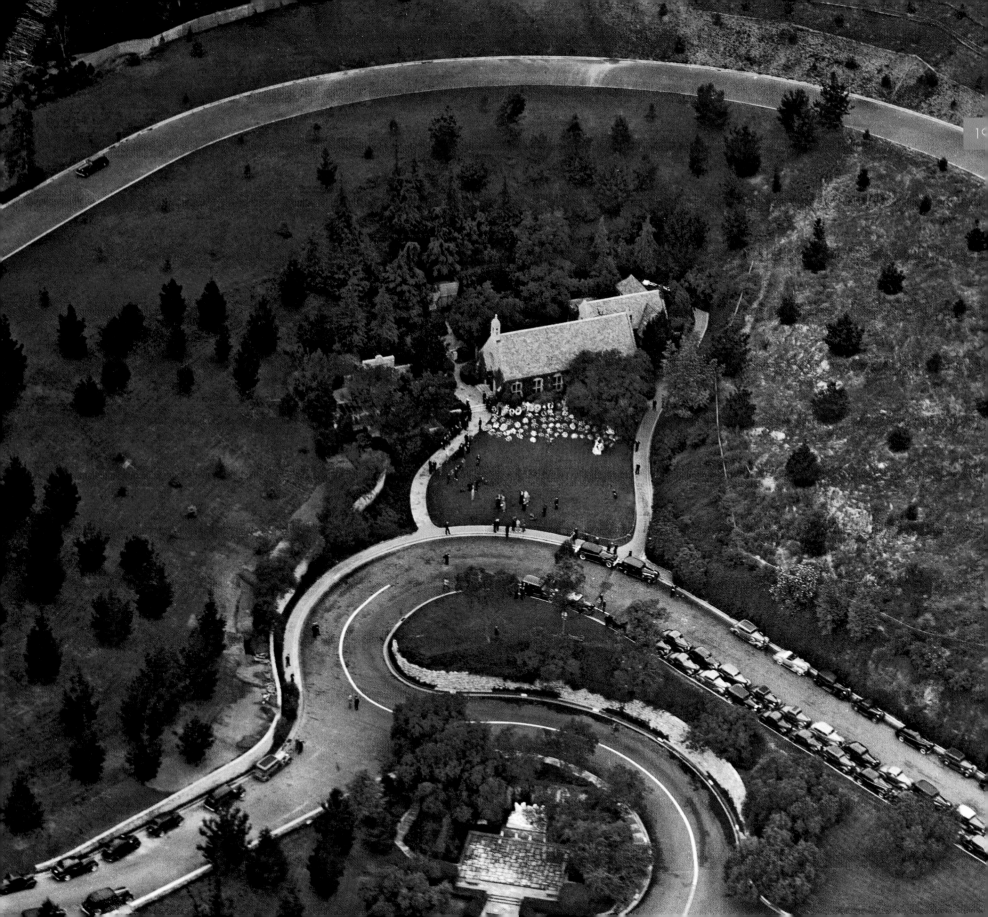

JEAN HARLOW FUNERAL

A spectacular send-off at just twenty-six

LEFT: Actress Jean Harlow started the tradition of blockbuster funerals after her untimely death at age twenty-six. Hollywood's first "blonde bombshell," Harlow's big break came when Howard Hughes cast her in his World War I aviation epic, *Hell's Angels* in 1930. While making *Saratoga* (1937), Harlow collapsed on the set. She was suffering from a number of different medical problems, including kidney problems that may have been the result of scarlet fever she contracted as a teenager. She died of cerebral edema and uremic poisoning, which is caused by a build-up of waste products in the blood. Harlow's funeral, held two days after her death, was the most spectacular funeral service Hollywood had ever seen. More than 250 invited guests attended, including Clark Gable, Spencer Tracy, Lionel Barrymore and the Marx brothers.

RIGHT: Harlow's funeral took place in the Wee Kirk O' The Heather Chapel at Forest Lawn Memorial Park. The chapel is considered an exact replica of the village church at Glencairn, Scotland and has been used for many weddings and christenings as well as funerals. Television star Regis Philbin and his wife, Joy, were married there. Some other church replicas at the cemetery include: Church of our Fathers modeled after Old St. John's Church in Richmond, Virginia; Church of the Hills modeled after the First Parish Church in Portland, Maine; and The Little Church of the Flowers, inspired by a village church at Stoke Poges, England. Michael Jackson was laid to rest at the cemetery's Great Mausoleum designed as a replica of Campo Santo in Genoa, Italy. Forest Lawn is a private cemetery and has long upheld a tradition of preventing gawkers, tourists or die-hard fans from disturbing the stars' restful peace. Limited access to the public is permitted.

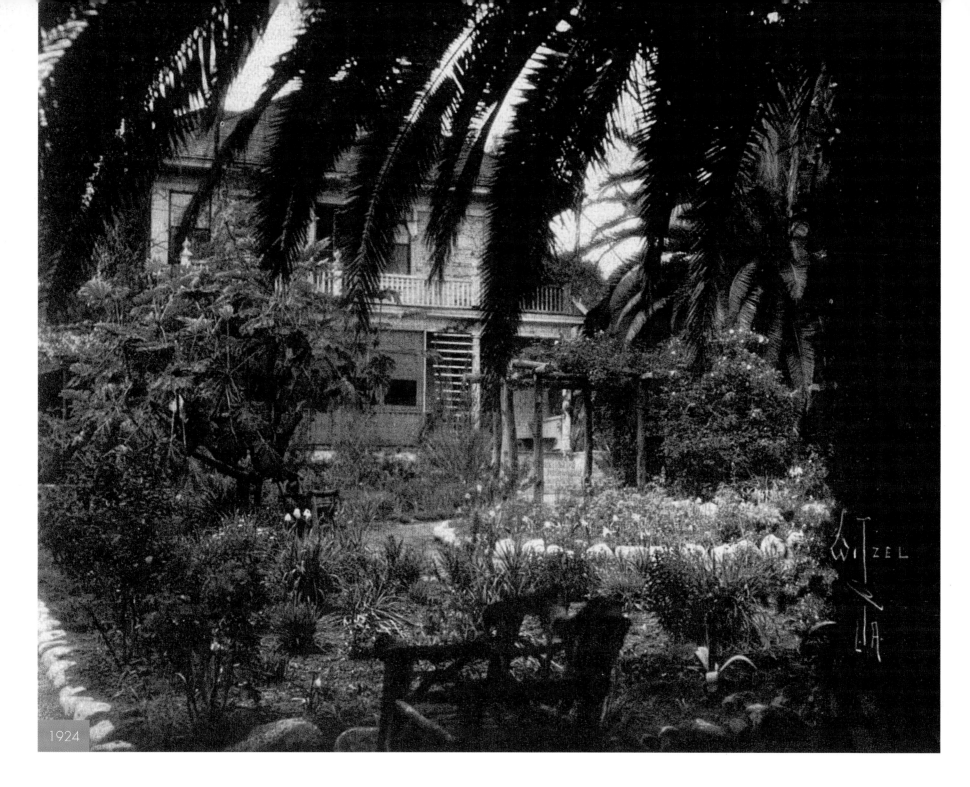

1924

HOLLYWOOD SCHOOL FOR GIRLS
Along with the Woman's Club of Hollywood, it is waiting for preservation

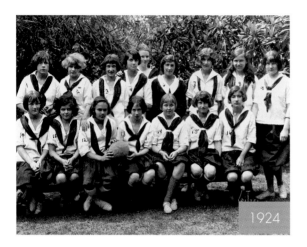

1924

ABOVE: Harlean Carpenter was an eighth-grade pupil of the Hollywood School for Girls in this 1924 team photo. She later took the name Jean Harlow and is second from left in the top row.

BELOW: Jean Harlow puts her handprints and footprints in cement outside Grauman's Chinese Theatre in 1933. She put three pennies in the cement for good luck. She was only to live four more years.

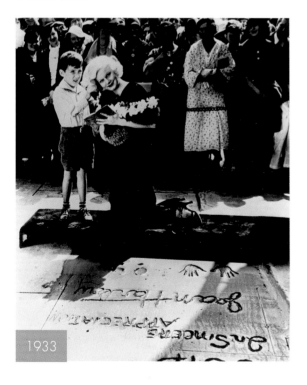

1933

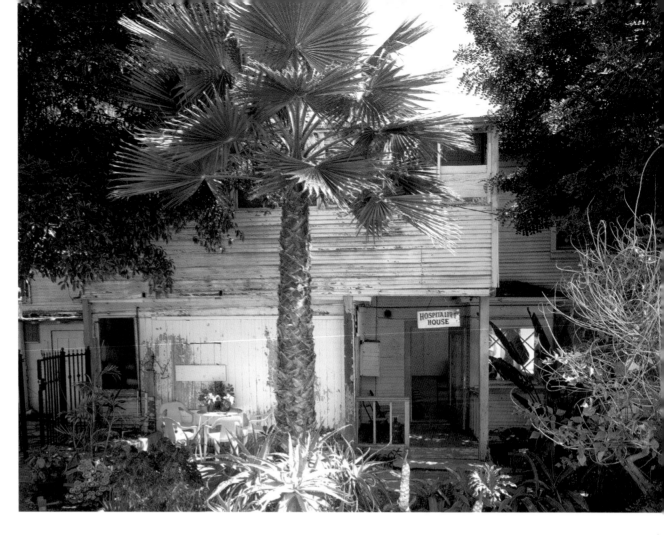

LEFT: The founders of the Hollywood School for Girls, founded in 1908, believed that girls should be as well educated as boys. Initially the only private school in Hollywood, it enrolled many children of celebrities: Cecilia De Mille, L. B. Mayer's daughters Irene and Edith, and Catherine Toberman. It also had pupils who would go on to become celebrities: Agnes De Mille, Douglas Fairbanks Jr. (who was embarrassed at being at a girl's school), Jesse Lasky Jr. (who had been expelled from the Misses Janes School), Mary Anita Loos (the first woman screenwriter), and Jane Peters (later known as Carole Lombard). One of the biggest future stars was Harlean Carpenter, later known as Jean Harlow. One of the early buildings of the Hollywood School For Girls at 1749 La Brea Avenue—then known as the Shakespeare House, because Shakespearean actor Charles Laughton taught here—is all that is left of the school nowadays. It is now called the Hospitality House. The building is located next to the equally historic Hollywood Woman's Club and both buildings are under threat from redevelopment having suffered long periods of neglect. Listed by the Hollywood Heritage website as one of Hollywood's most endangered sites, its fate hangs in the balance. As of June 2012, a receiver was appointed by the Los Angeles Superior Court to take possession of the property of the Woman's Club and so preservation might not be too far away.

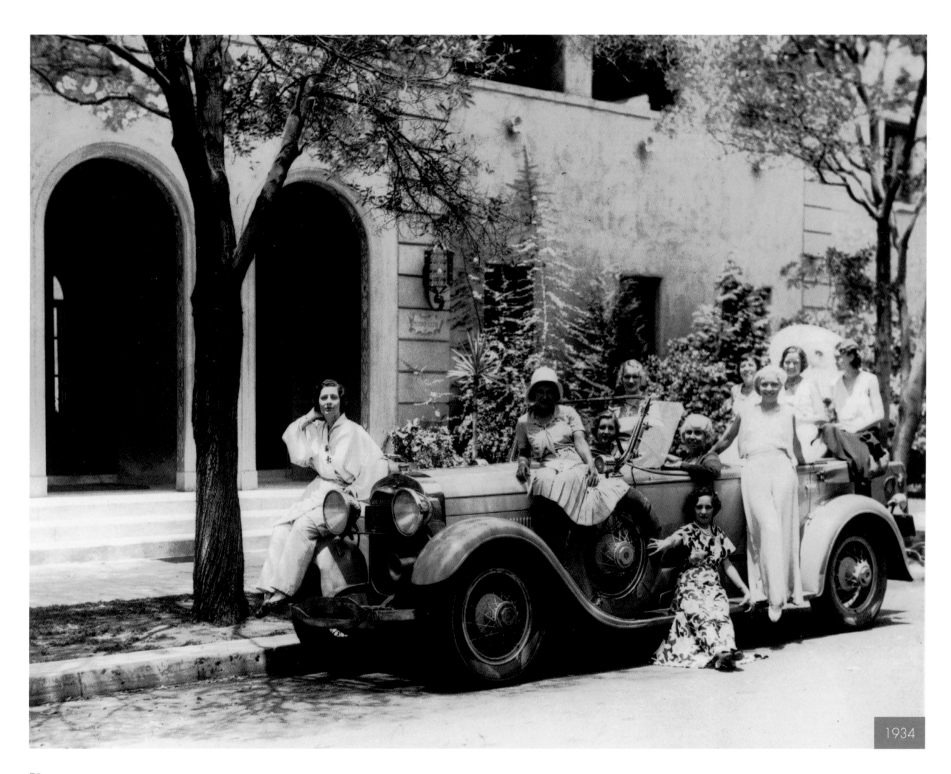

HOLLYWOOD STUDIO CLUB
A dormitory for Hollywood's aspiring actresses until 1975

LEFT: As the movie industry grew, young girls from all over the country came to Hollywood to seek their fame and fortune. Concerned for their welfare, the Hollywood Woman's Club and the YWCA established the Hollywood Studio Club at 6129 Carlos Street in 1916. By 1925, they had their own building at 1215 Lodi Place. Donations came from the major studios and individual stars such as Gloria Swanson, Harold Lloyd, Howard Hughes, and Mary Pickford. The rules were strict, but the atmosphere was homelike and the rent was low and came with two meals a day. Famous alumnae of the Studio Club include Marilyn Monroe, Rita Moreno, Kim Novak, Dorothy Malone, Nancy Kwan,

Zasu Pitts, and Myrna Loy. The Studio Club was a haven for young girls seeking stardom. But with the decline in the large studios and their stables of performers, the need for it waned. Finally in 1975 the Studio Club ceased operation when the city advised the YWCA that the building did not meet new fire-safety standards and could not be used for a residence. Today it is used as a job training center, operated for the Department of Labor by the YWCA until April 2012. It was listed in the National Register of Historic Places in 1979.

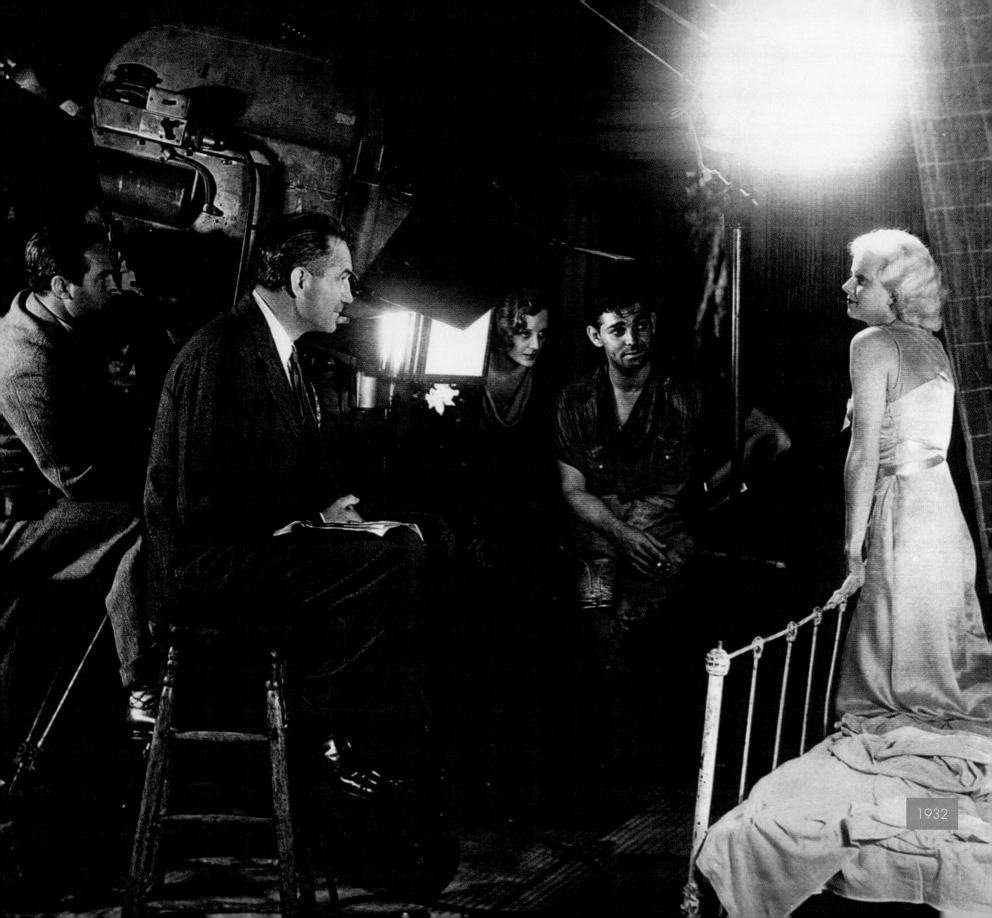

1932

THE STUDIO SYSTEM

Like sports stars signed to a team, the studio system bound actors to their employers

LEFT: As Hollywood's influence grew, the public became fascinated with the film stars. As the smaller studios merged into larger conglomerates, the producers recognized the value of the movie stars—and they wanted to control them. They put all actors and actresses, and some directors and writers, under lengthy exclusive contracts. The hungry young actors, anxious to work, leaped at the chance to have guaranteed work and a paycheck each month. The studio system ruled supreme in Hollywood in the golden era of the 1930s and 1940s. Under the careful and iron-gloved guidance of Jack Warner, Harry Cohn, Louis B. Mayer, and the other big studio bosses, the actors were given acting coaching on the studio lots. They also had diction and voice lessons, makeup and hair styling advice, deportment, and dance and singing instruction. Everything was taken care of. They were told how to dress and behave in public and where they could and could not be seen; thus the public's image of these young stars would never be tarnished. Publicity campaigns were launched to introduce them to the world and their careers were carefully planned and executed. Film roles were specifically written for their screen alter egos. The world saw the glamorous Hollywood stars at premieres, the best parties, restaurants and nightclubs, and charity functions. While some enjoyed the comfort of all this caring attention, others wanted to be free to play different types of roles and to make their own career decisions. Their "owner" was also free to loan the actor out to another studio. If a contract player wanted a different type of part or refused a role, he was put on suspension that extended the length of his contract. Today these long contracts are a thing of the past, it is the stars and their agents who have the power.

1941

ABOVE: Louis B. Mayer's MGM Studios was one of the most powerful players in the studio system. In this image Clark Gable, with the young Mickey Rooney and Judy Garland, welcomes teenager Shirley Temple to MGM after years under contract to Twentieth Century Fox.

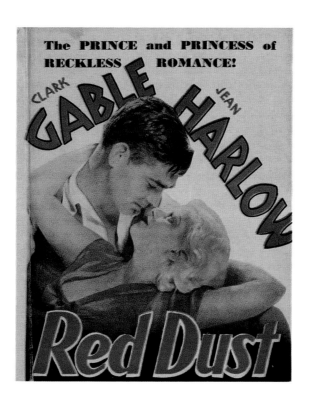

1932

LEFT, FAR LEFT AND MAIN PHOTO : The teaming of stars Jean Harlow and Clark Gable was electric in the 1932 melodrama *Red Dust* set on a rubber plantation. The film was directed by Victor Fleming (seated second left) who went on to direct classic films such as *The Wizard of Oz* and *Gone With The Wind*.

HOMES OF THE STARS

As time has passed, Hollywood mansions have got bigger, better and further away

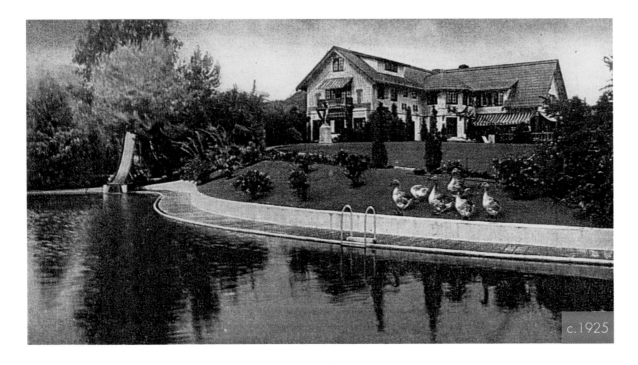

c.1925

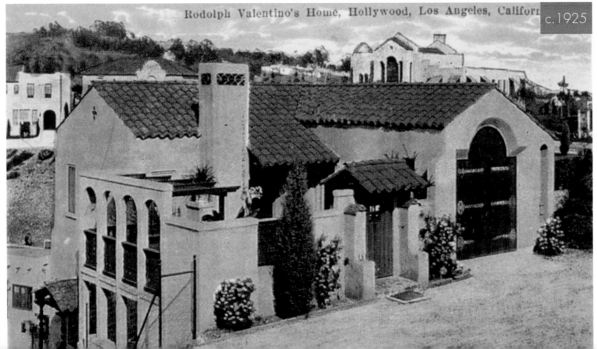

Rodolph Valentino's Home, Hollywood, Los Angeles, Californ

c.1925

LEFT: When America's sweetheart Mary Pickford married Douglas Fairbanks, they bought their dream home in Beverly Hills at 1143 Summit Drive. Pickfair was a 1918 hunting lodge that they remodeled into their perfect palace, complete with swans on the lake and a swimming pool. When the couple divorced in 1936, Mary Pickford remained in the forty-two-room house and her new husband, Buddy Rogers, moved in. After her death in 1971, the house was sold to Jerry Buss, owner of the Los Angeles Lakers. Despite protestations from preservationists, Pickfair was later demolished and a new house was built in its place. Above Hollywood Boulevard, in an area called Whitley Heights, some of the most beautiful Mediterranean-style homes were located. One such home was that of silent screen star Rudolph Valentino at 6776 Wedgewood Place. Bought in 1924, the eight-room house with servants' quarters had a beautifully landscaped, terraced garden with Italian cypress trees and green lawns. When Rudolph and his second wife, Natasha Rambova, moved in, they decided to make some changes. Mrs. Valentino loved shocking pink, so the decor became pink, gray, and black. Valentino loved to tango, so they put a black marble floor down in the foyer. Rudolph loved this house but Natasha wanted to live in Beverly Hills. A year later they bought Falcon's Lair in Beverly Hills. He spent only a few months there before his untimely death. The house was later demolished to make way for the Hollywood Freeway.

ABOVE AND RIGHT: Just as the movie business has spread out from Hollywood, so the homes of the stars have moved far beyond Whitley Heights, to Malibu, Santa Monica, Burbank and the San Fernando Valley. Sandra Bullock is unusual among film stars in that she has mansion built in the 1940s that harks back to the era of the first Hollywood stars. Her $23 million Tudor-style mansion in Beverly Hills is set on four acres and surrounded by an expansive lawn, evoking shades of an English stately home. Brad Pitt and Angelina Jolie use Brad's Los Feliz compound (pictured top right) which he bought in 1994 for a reported $1.7 million. The couple recently enlarged their property by buying an adjoining 1920s two-bedroom house and have invested $4 million making the enlarged residence a children's paradise. Will and Jada Smith's 25,000 square-foot Calabasas house (pictured right) took seven years to be completed. It was designed by architect Stephen Samuelson. The house features a tennis court, basketball court, swimming pool, recording studios—where Willow Smith recorded her single *Whip My Hair* in 2010—and has "commanding views" of the surrounding mountains. Proving that Will is living the life of the Fresh Prince of Bel Air.

c.1930

VILLA CARLOTTA
Home to influemtial columnist Louella Parsons

LEFT: The Villa Carlotta, on Franklin Avenue near Beachwood Canyon, was built in 1927 by Eleanor Ince, widow of pioneer film producer Thomas Ince. The four-story, forty-eight-room Italian Palazzo–style building was originally a hotel for actors. Advanced for its day, the villa had elaborate soundproofing and a ventilation system. Hollywood gossip columnist Louella Parsons lived there and was married in the lobby. Guests at her wedding included Buster Keaton and Norma Talmadge. Marion Davies, Edward G. Robinson, and George Cukor also lived at the Carlotta. Over the years the building has deteriorated, but has not lost any of its charm. The Spanish-style decor in the foyer has survived the years, as has the original furniture, although it's now chained to the floor. Currently it is divided into 105 apartments, and it feels like it's still home to many of the spirits of yesterday.

RAVENSWOOD

Home to screen siren Mae West for almost fifty years

RIGHT: This grand old apartment building in Art Deco style, at 570 North Rossmore was designed by architect Max Maltzman and built by Paramount Pictures in 1930. Mae West moved into Apt #611 shortly after her arrival in Hollywood in 1932, and lived there until her death in 1980. The buxom, blonde, "Come up and see me sometime" star lived here in the penthouse with her pet monkey, Wooly. In 2003, Ravenswood was declared a Historic-Cultural Monument by the City of Los Angeles.

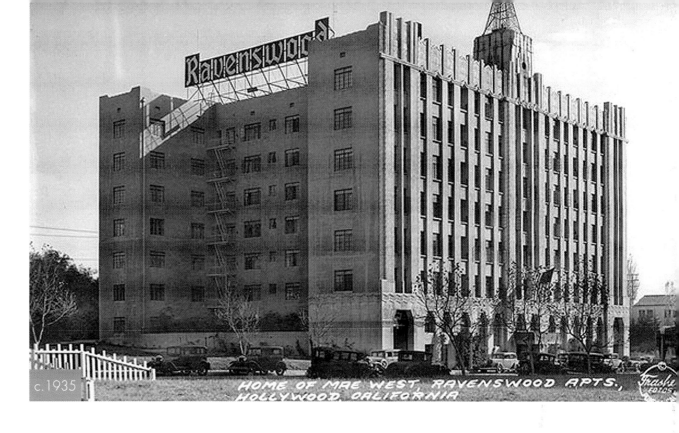

c.1935

HOME OF MAE WEST, RAVENSWOOD APTS., HOLLYWOOD, CALIFORNIA

BELOW: Mae West shows off the living room in her apartment some time in 1933.

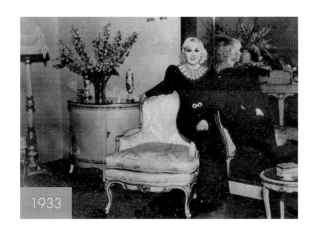

1933

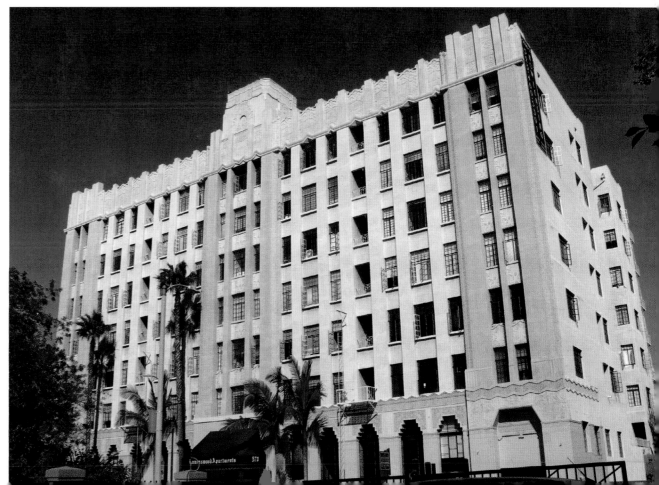

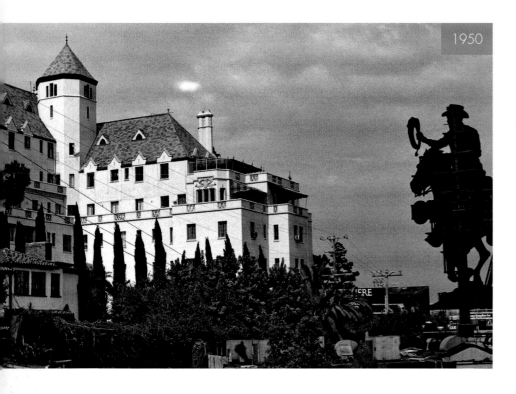

CHATEAU MARMONT HOTEL
A private haven for Hollywood's elite

ABOVE In 1926 Fred Horowitz returned from France with a dream to build his own chateau in Hollywood. On February 2, 1929, his Chateau Marmont apartment house on Sunset Boulevard opened for business just eight months before the Wall Street Crash. Horowitz sold it to British-born Vitagraph producer Albert Smith, who renamed it the Chateau Marmont Hotel in 1931. It was a private haven for Hollywood's elite. Greta Garbo signed in as Harriet Brown—and was left alone. Jean Harlow liaised here with Clark Gable—on her honeymoon with someone else. Humphrey Bogart and Errol Flynn also hung out at the Marmont. Columbia boss Harry Cohn famously told his young stars William Holden and Glenn Ford, "If you must get into trouble, do it at the Marmont." This is where John Belushi died in 1982. Now under new ownership, the Chateau Marmont hums discreetly on. Hunter S. Thompson, photographers Annie Leibovitz and Bruce Weber, Dorothy Parker, F. Scott Fitzgerald and director Tim Burton have all spent time working while resident in the hotel.

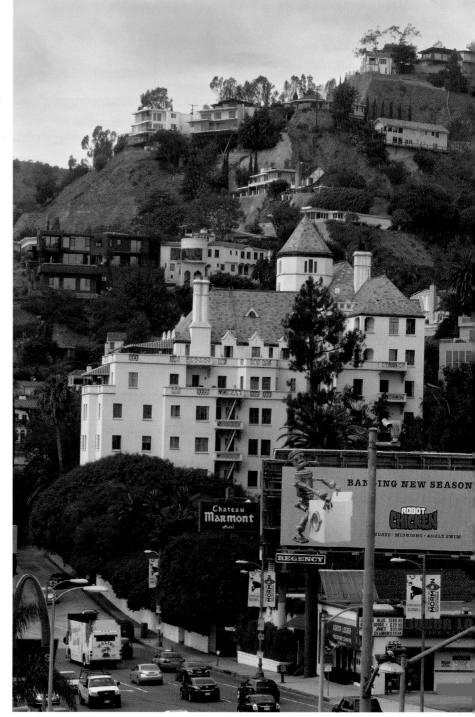

ALTO NIDO APARTMENTS

Where scenes from *Sunset Boulevard* were shot

RIGHT: Right at the end of Ivar Avenue, the Alto Nido at 1851 North Ivar is a beautiful old Spanish-style apartment building. It was opened in 1930 as first-class Hollywood hotel, primarily for actors and actresses. It became famous for being the home of 1947 murder victim Elizabeth Short, the "Black Dahlia," and for being used in the 1950 film *Sunset Boulevard*. Today it has been carefully restored and is still a classic apartment building.

BELOW: A promotional still from Billy Wilder's *Sunset Boulevard*, part of which was shot at the Alto Nido.

WHITLEY HEIGHTS

A precedent to the celebrity neighborhood of Beverly Hills

BELOW: In 1901 real estate speculator Hobart J. Whitley bought land just north of Franklin Avenue and east of Highland Avenue to develop as a residential tract. It became Whitley Heights, an elegant neighborhood designed to look like a Mediterranean-style hilltop village. In the 1920s, Whitley Heights became the first Hollywood celebrity neighborhood. This was where Rudolph Valentino's house stood on Wedgewood Place and where Charlie Chaplin chose to live. Their neighbors included Norma Talmadge, Ethel Barrymore, Bette Davis, Joan Crawford, and Jeanette MacDonald. The Whitley family lived at 1720 Whitley Avenue.

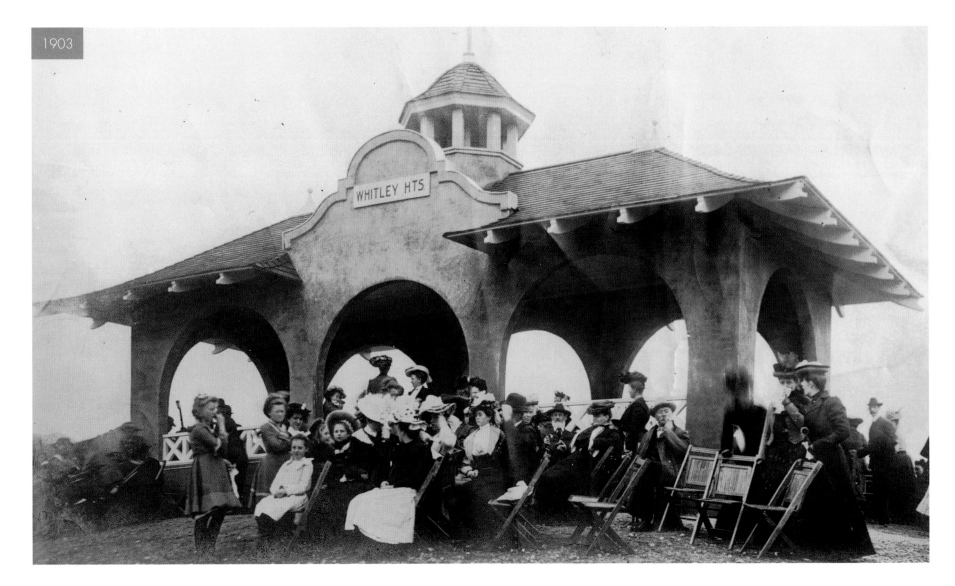

1903

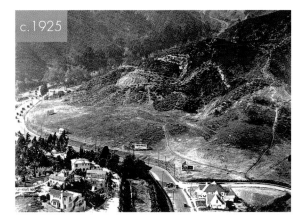

BELOW: Much of this area was lost to the Hollywood Freeway construction, including the Valentino house and the old music pavilion. But there still remains a glimmer of how beautiful old Hollywood was in those days. Whitley Heights was added to the National Register of Historic Places in 1982. The most notable architectural styles found in this area are Spanish Revival, Mediterranean & American Craftsman.

ABOVE: A postcard scan of the Mediterranean-style houses in Whitley Heights. Along with Hollywoodland, it was immediately a stop on the 1920s tourist trail.

ABOVE RIGHT: A view of Whitley Heights in the 1920s. Just visible at bottom left is a sign that reads Whitley Heights Park.

LEFT: The music pavilion at Whitley Heights photographed in 1903. It was demolished to make way for the Hollywood Freeway.

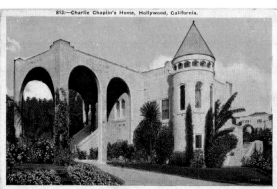

1929

CHATEAU ELYSEE
Luxury apartments now used by the
Church of Scientology

LEFT: Completed in 1929 by the widow of film
pioneer Thomas Ince, the Chateau Elysee was a
secluded hideaway in Hollywood. A classic
Norman–style chateau with seventy-seven luxury
apartments, it was surrounded by beautifully
manicured gardens. The seven-story castle had a
grass moat, drawbridge entrances, and panoramic
views of the city. During Eleanor Ince's
ownership, some of Hollywood's most prominent
citizens were full- or part-time residents who
called it "the manor." Many New York–based
entertainers kept residences at the Elysee: Clark
Gable and Carole Lombard lived here, George
Burns and Gracie Allen had room 609, Ginger
Rogers and her mother were in room 705,
Humphrey Bogart occupied 603, and Edward G.
Robinson was in 216. By the time Ince sold the
property in 1943, most of the celebrity guests had
moved to Beverly Hills and Bel Air. In 1951 it
became Fifield Manor, a home for retired actors.

1929

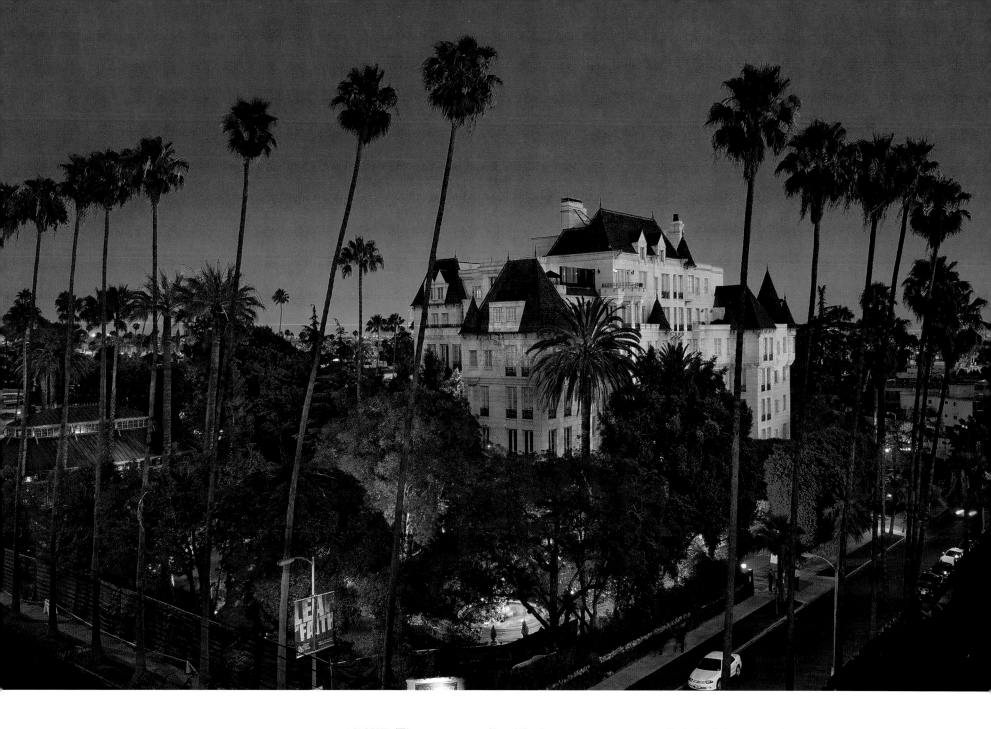

LEFT: Chateau Elysee soon after its opening in 1929.

ABOVE: The property on Franklin Avenue was sold in 1973 to the Church of Scientology. Declared a historical landmark in 1987, nearly one million man-hours went into the careful restoration of this amazing structure. The impressive rococo lobby has been restored to its former glory and the Manor Hotel (also now called the Scientology Celebrity Centre) has been redecorated in rococo and French country styles. More than 7,000 new plants have been added to the beautifully manicured grounds. The ninety-year-old palm trees still tower around the property where some of the other trees have stood for 200 years.

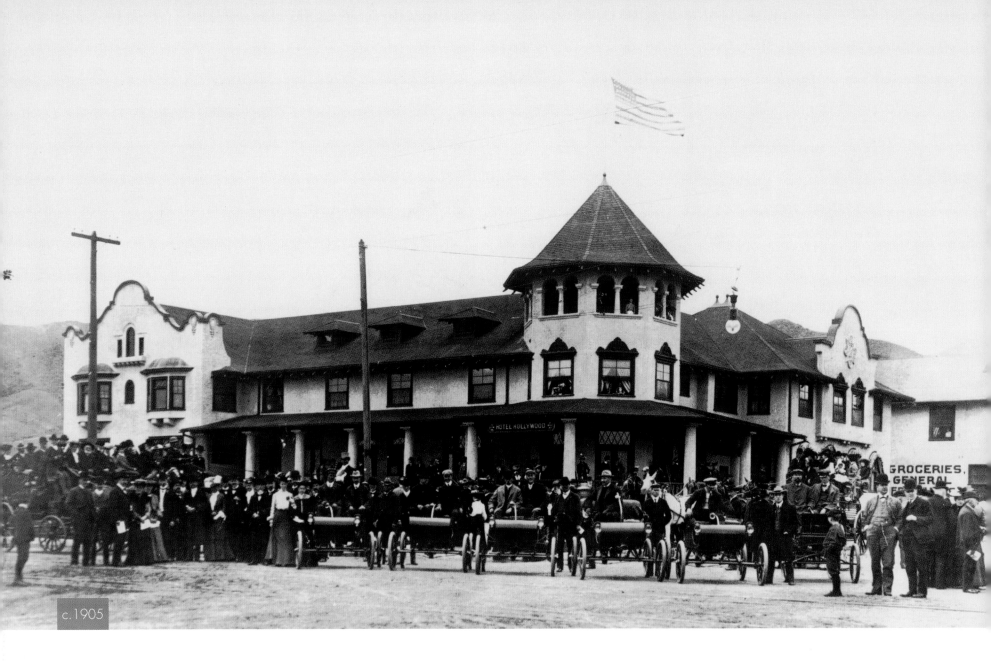

c.1905

THE HOLLYWOOD HOTEL
The hotel that refused Rudolph Valentino a room until he showed them his marriage license

ABOVE: The Hollywood Hotel, on the northwest corner of Hollywood and Highland, was a large, quiet, country resort, nestled amid the lemon groves, when it opened in 1903. George Hoover built it for land prospectors, and in 1907 he sold the 144-room hotel to Mira Hershey of the chocolate family. The movie colony started to flock here. Pola Negri, Douglas Fairbanks, Lon Chaney, and Norma Shearer dined and danced here; Rudolph Valentino married and honeymooned at the Hotel Hollywood—its original name. In the crystal-chandeliered ballroom, the owner painted gold stars on the ceiling with names of the stars who dined there regularly, a practice that would lead to the famous Hollywood Walk of Fame. The hotel was demolished in 1956 and was replaced by a bank.

84

RIGHT: On the site now is the $615 million Hollywood and Highland Center, a development intended to restore this section of Hollywood to its former glory, with stores, restaurants, and a staircase leading to the Babylon Court, designed with replicas of the elephants and motifs from D. W. Griffith's famous *Intolerance* set. The Dolby Theatre (formerly the Kodak Theatre) is the home of the Academy Awards and has twenty-six spectacular Oscar photos on display in the lobby. The theater has hosted many other events, such as the American Ballet Theatre and charity benefits. In September 2011 it launched the long-running Cirque du Soleil show *Iris* which is a journey through the history of the movie business.

BELOW: Postcards of the exterior and the dining room of the Hollywood Hotel.

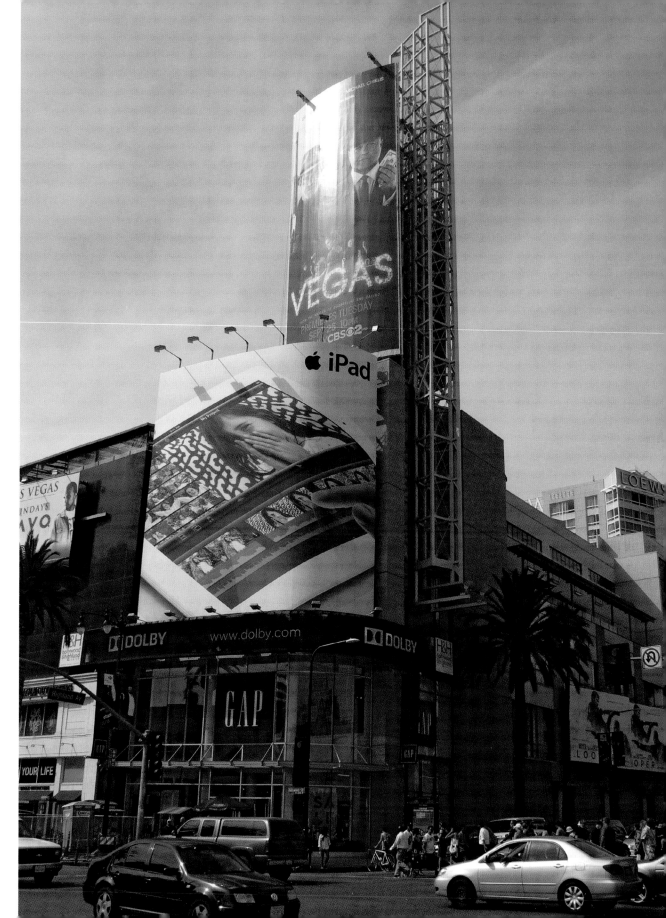

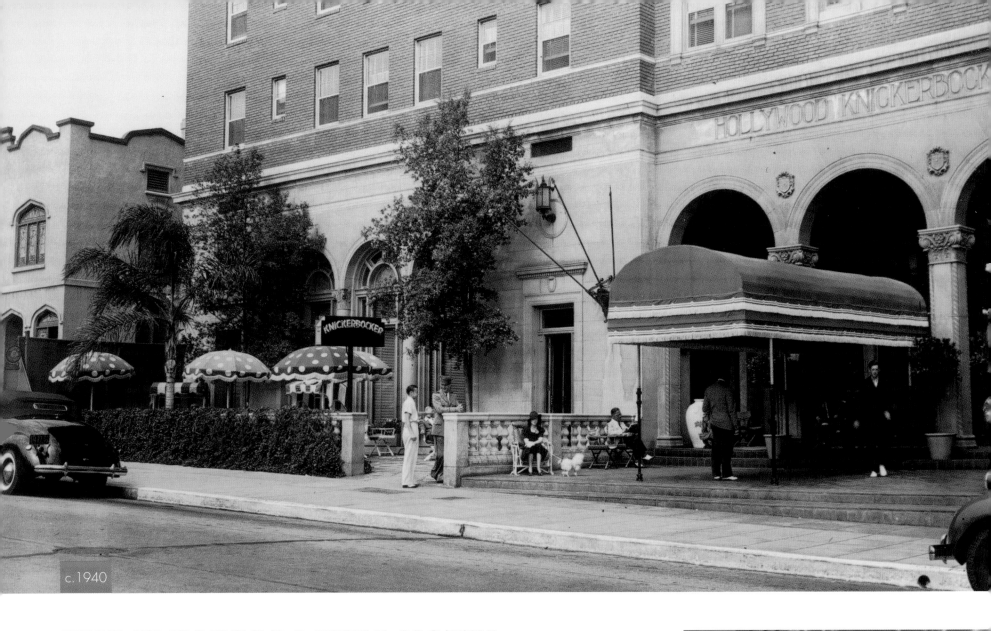

c.1940

THE KNICKERBOCKER HOTEL
A hotel favored by Laurel and Hardy is now a retirement home

ABOVE: Built as a luxury apartment house in 1925, the Knickerbocker Hotel at 1714 North Ivar, played a key role in Hollywood's glory days. Rudolph Valentino tangoed in the Lido Room, and Lana Turner, Laurel and Hardy, and Barbara Stanwyck lived there. D. W. Griffith died of a stroke in the lobby of the Knickerbocker on July 21, 1948. Frances Farmer was arrested here in 1942. Marilyn Monroe and Joe DiMaggio had trysts here. Elvis Presley lived in room 1016, during the filming of *Love Me Tender*, and Houdini's widow, Bess, tried to communicate with him by conducting a séance on the roof.

RIGHT: To the left of the Hotel Knickerbocker is the Capitol Records building from 1956.

c.1960

86

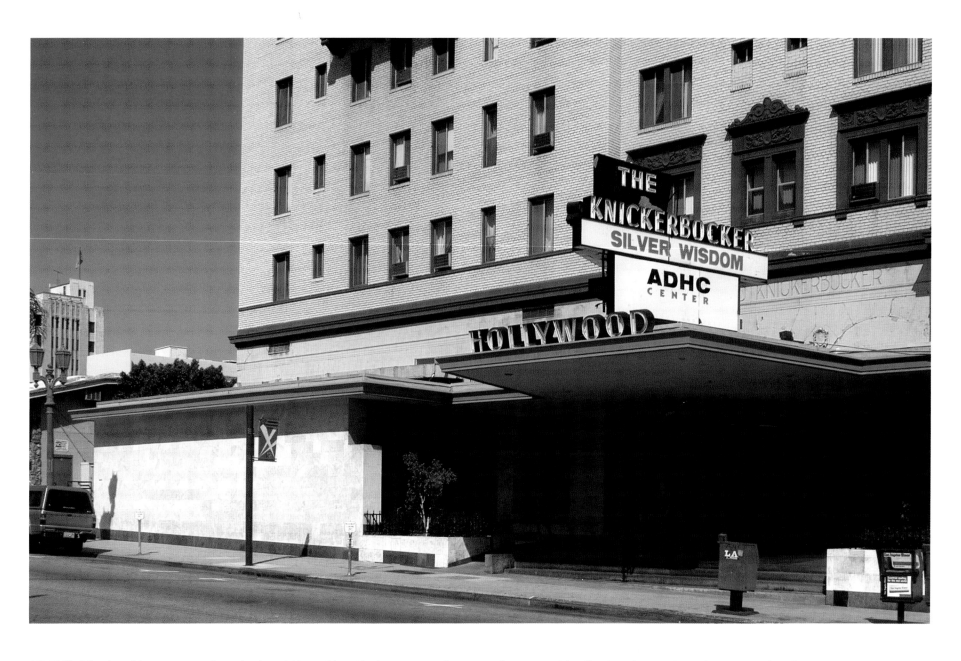

ABOVE: The hotel became run-down in the 1960s and in 1970 it was turned into a retirement home for senior citizens. The ground floor bar area was shuttered for twenty-five years, but in 1993 Max Fisher opened an upscale, nostalgic café called the All-Star Theatre Café and Speakeasy in this famous bar. Bringing back the glamour of the roaring twenties, it was hugely popular with young Hollywood figures such as Leonardo DiCaprio and Sandra Bullock.

It was used for film locations and studio wrap parties. Recently forced to move, the All-Star Café is now located at the Vogue Theatre at 6675 Hollywood Boulevard, next to the Musso & Frank Grill. In 1999, a plaque honoring D. W. Griffith was placed in the lobby.

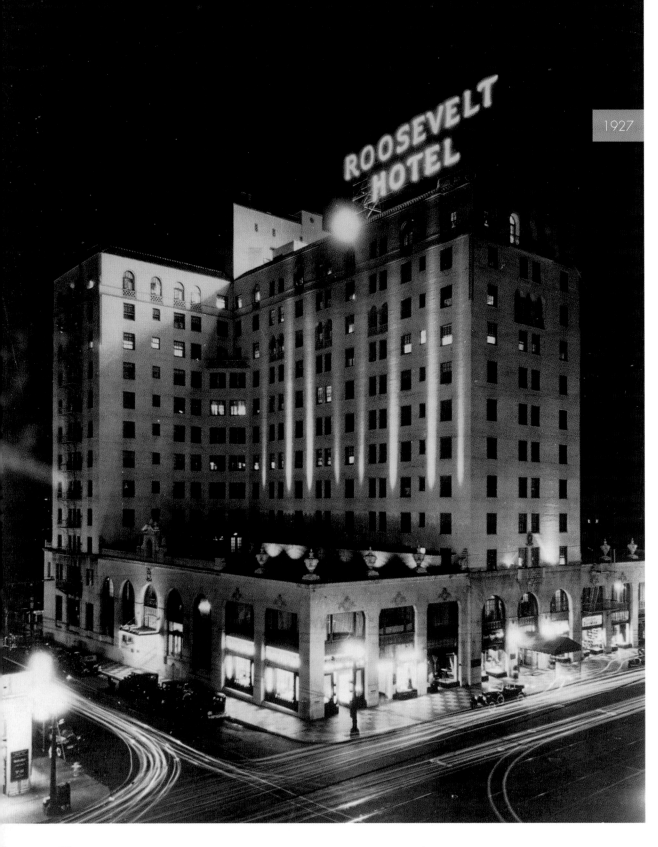

ROOSEVELT HOTEL

A tranquil Mediterranean oasis in the heart of bustling Hollywood

LEFT: This lavish twelve-story Spanish Colonial hotel was built in 1926 by "Mr. Hollywood," the developer C. E. Toberman. It was financed by prominent Hollywood figures such as Mary Pickford, Louis B. Mayer, and Douglas Fairbanks, among others, to house visiting East Coast moviemakers. In his early days a young David Niven lived in the servants' quarters; Mary Martin sang at the hotel's nightclub, Cinegrill. Errol Flynn made hooch in the barbershop during Prohibition. For five dollars a night, Clark Gable and Carole Lombard occupied the penthouse. Shirley Temple and Bill "Bojangles" Robinson practiced tap dancing on the ornately tiled lobby stairs. Marilyn Monroe did her first modeling job by the pool and Montgomery Clift lived in room 928 while making *From Here to Eternity*. The first Academy Awards banquet was held in the Blossom Room on May 16, 1929. It was also the shortest Oscar ceremony ever, lasting just five minutes, as Douglas Fairbanks and Al Jolson helped give away thirteen statuettes. The hotel was the subject of a major renovation in 2005 and now features a lobby in the nightclub called Teddy's. There is a great deal of media attention around supposed hauntings at the hotel including Cabana Suite 229, where a figure resembling Marilyn Monroe has allegedly been seen.

c.1950

ABOVE: Mary Martin, the woman instrumental in bringing the *Sound of Music* to the stage, was a singer in the Roosevelt's nightclub, the Cinegrill.

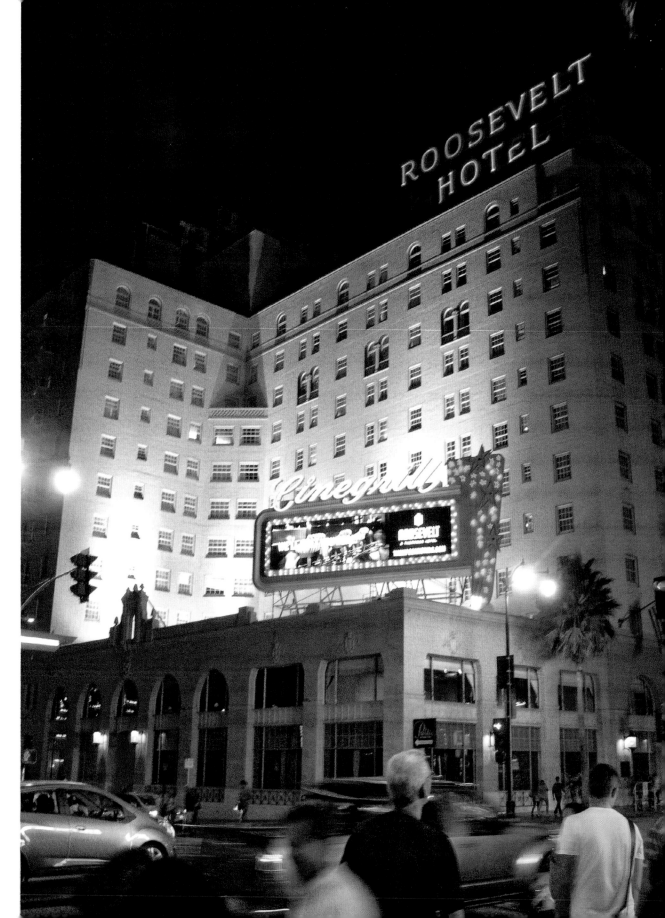

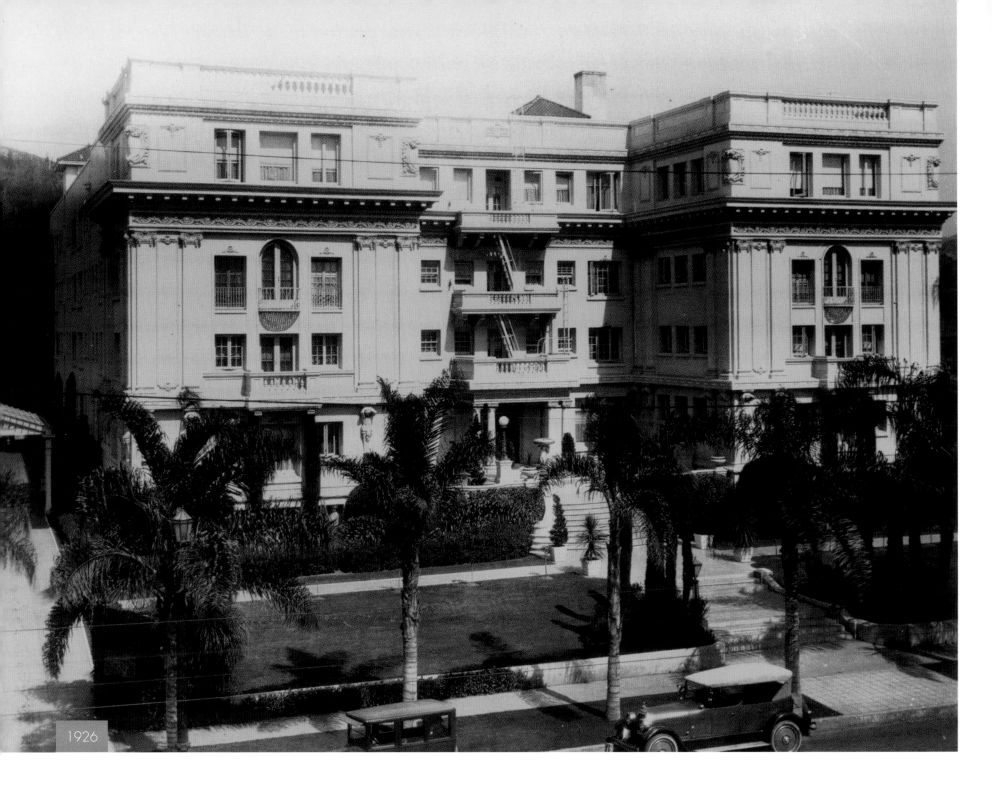

1926

THE GARDEN COURT APARTMENTS

A treasured building lost to development

90

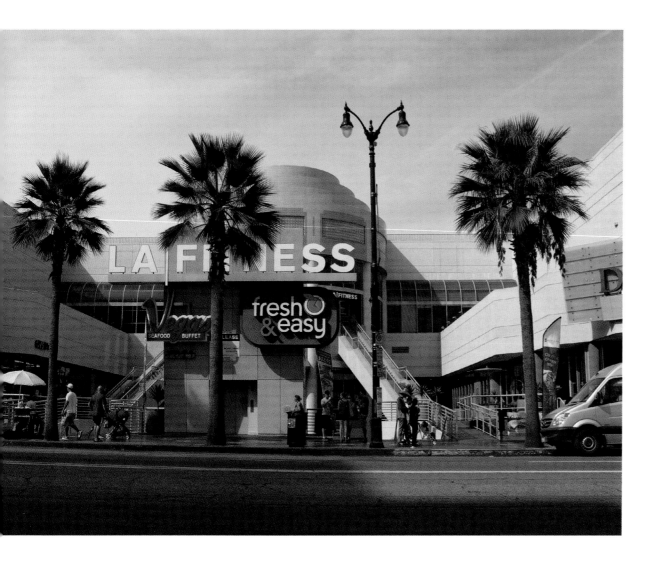

THE GARDEN OF ALLAH

At 8150 Sunset Boulevard, the Garden of Allah filled the block from Crescent Heights to Havenhurst. Built in 1921 by wealthy Russian actress Alla Nazimova, it was a complex of villas surrounding an enormous swimming pool. Nazimova opened the garden with a lavish eighteen-hour party. The center of Hollywood's social life in the 1930s and 1940s, Garden residents included Ava Gardner, Frank Sinatra, Errol Flynn, Clara Bow, David Niven, the Marx brothers, Tallulah Bankhead, and Humphrey Bogart. Nazimova lost all the money she had invested in the Garden in the Depression. After her death in 1945, the Garden continued as a sanctuary for Hollywood celebrities until it fell out of favor. Joni Mitchell wrote the song, *Big Yellow Taxi*, in which she sang about paving paradise and putting up a parking lot. She was referring to the Garden of Allah, which has now become retail units and a parking lot.

LEFT: Built in 1919, the Garden Court Apartments at 7021 Hollywood Boulevard were built in Italian Renaissance style. It was the first modern luxury residential hotel built to accommodate the burgeoning film industry. Boasting Oriental rugs and baby grand pianos in every suite, the Garden Court had two lavish ballrooms, tennis courts, a pool, and a fountain in front. Hollywood luminaries who lived there included Mack Sennett, Louis B. Mayer, Lillian Gish, Mae Murray and John Barrymore.

ABOVE: As the local area declined, so did the Garden Court Apartments. In its last years, it was home to the American School of Dance. Finally abandoned, it was taken over by squatters and became known as "Hotel Hell." Movie legend Debbie Reynolds led a fierce battle to preserve the grand old building, but commerce won. It was demolished in 1985 and replaced with the Hollywood Galaxy movie theater complex. It has subsequently been repurposed for multiple tenants principally LA Fitness.

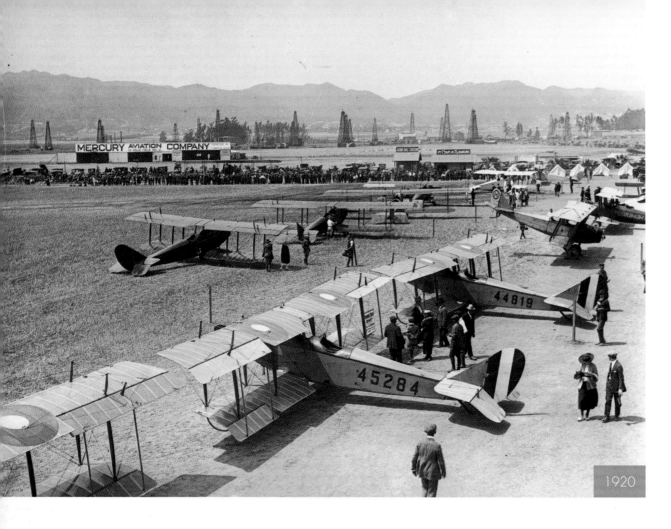

1920

CHAPLIN AIRFIELD

Chaplin invested his movie wealth in his family aircraft corporation

LEFT: Charlie Chaplin enjoyed the fruits of his success in Hollywood. He also built his mother a house, helped his family establish businesses, and invested in airplanes. The Chaplin Aircraft Corporation was founded in 1919 by Charlie's brother Syd Chaplin. On the southwest corner of Wilshire Boulevard and Crescent Avenue (now Fairfax), the Chaplin Airfield had a fleet of the newest two-passenger airplanes, advertising short observation flights: a fifty-mile run over beach, harbor, and city. They offered a course "in flying tutelage by expert pilots." Syd Chaplin pioneered the first air services from Los Angeles to Catalina Island. The photograph, left, shows just how close Chaplin Airfield was to the De Mille field with the same oil wells visible in both archive shots.

DE MILLE AIRFIELD

Home to one of the first American commercial airlines,

RIGHT: In 1919 celebrated movie director Cecil B. De Mille founded the Mercury Aviation Company and the de Mille Airfield on the northwest corner of Wilshire and Fairfax Boulevards, right next to the Chaplin Airfield. Groundworkers rush to anchor the approaching dirigible in this archive photograph. The sign on the roof of the single airport building announces that this is Mercury Aviation Co., De Mille Airfield No.2. Mercury was one of the first American airlines to carry air freight and commercial passengers on scheduled runs. They proudly boasted that they never had one injury. In August 1920, Mercury Aviation's first Junkers JL-6 plane was delivered by World War I flying ace Eddie Rickenbacker to De Mille Airfield. De Mille discontinued operations of Mercury Aviation in 1921 and sold the assets to Rogers Airport Corporation.

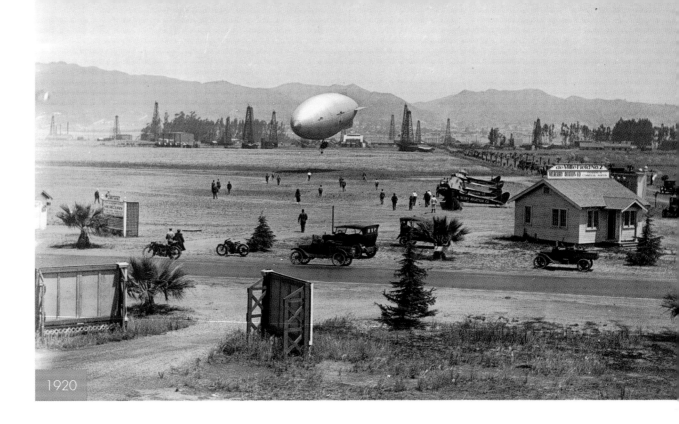

1920

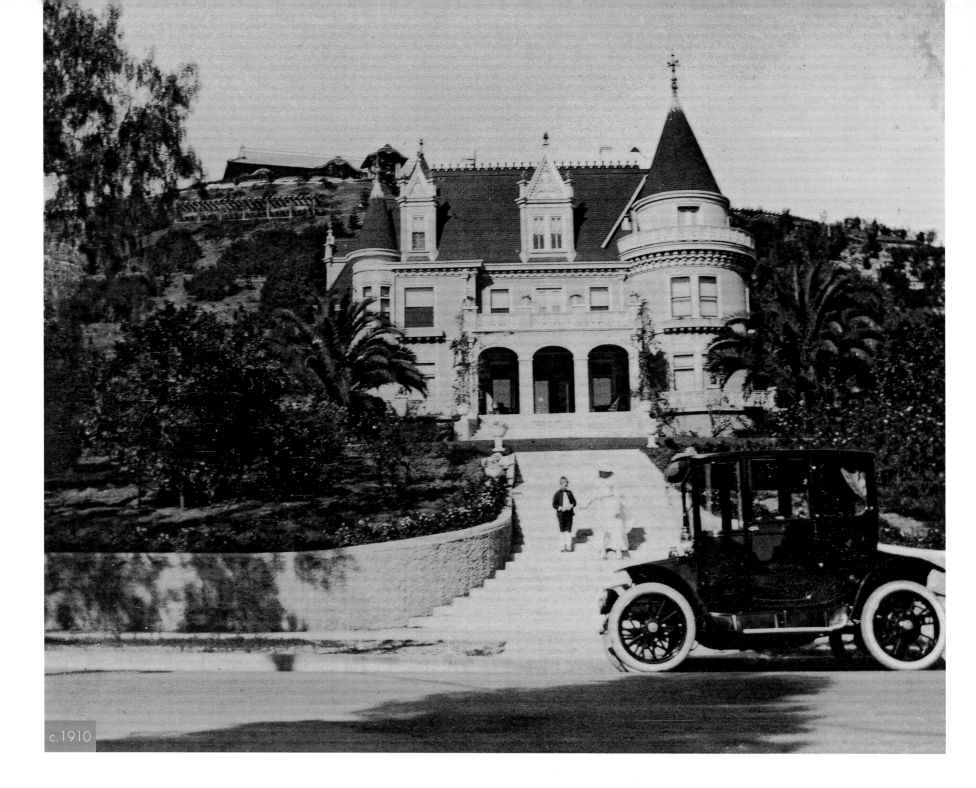

c.1910

MAGIC CASTLE

Encouraging and promoting the art of magic

94

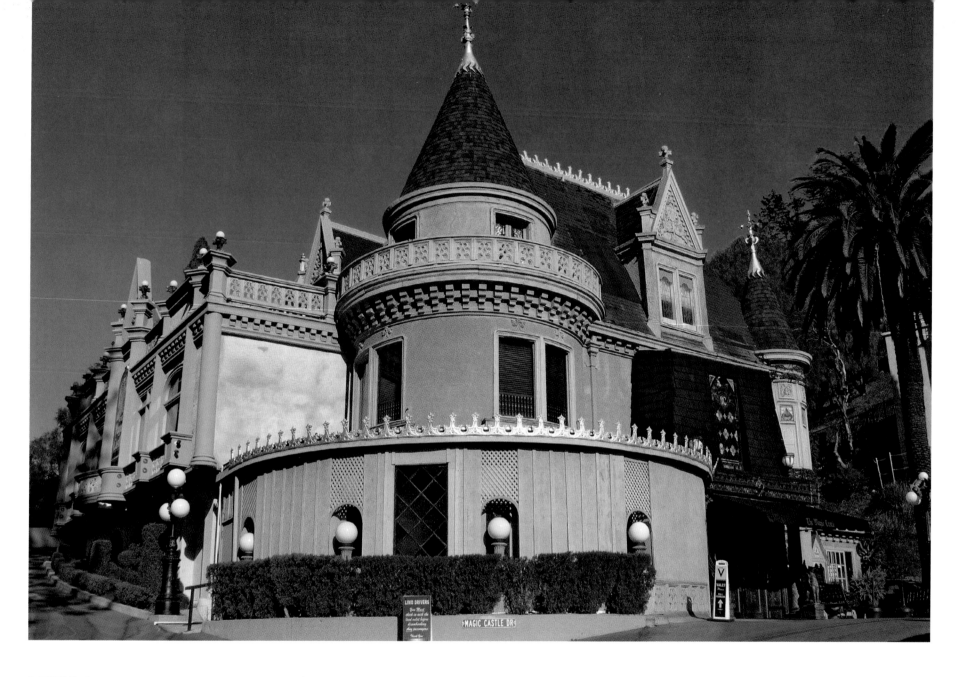

LEFT: Built by philanthropist Rollin B. Lane for $12,000 in 1909 in the midst of orange groves, the three-story, seventeen-room Victorian Gothic house at 7001 Franklin Avenue at the head of Orange Drive was christened Holly Chateau by Mrs. Lane, who spent the rest of her life there. Tom Glover then bought it and leased it to brothers Milt and Bill Larson in 1961. They restored and renovated this intriguing house, then opened it as the Magic Castle. Cary Grant was on the board of directors. This is the world headquarters of the Academy of Magical Arts, founded by Milt Larson. The promise was "to encourage and promote interest in the art of magic."

ABOVE: Today, the Magic Castle is as busy as ever. Once inside the mysterious house, members enjoy the Parlor of Prestidigitation, the Palace of Mystery, the Close Up gallery, and a gourmet restaurant. In keeping with the elegant Victorian decor, there is a strict dress code and reservations are essential. Guests can enjoy "The Houdini Séance" an evening which recreates the elegance and mystery of a classic Victorian séance, and celebrates the life of Harry Houdini. The séance is held for a small private group of guests in the historic Houdini Séance Room. The Academy of Magical Arts also offers a basic magic class for adult beginners. Reputedly there is a resident ghost.

GILMORE ISLAND
Once home to Gilmore Field, Gilmore Stadium and the Farmers Market

BELOW: When Illinois farmer Arthur Fremont Gilmore was drilling for water for his cattle in 1900, he struck oil on his land at Third and Fairfax. In 1905, the dairy was gone and Gilmore oil was gushing. By 1914, Gilmore's corner of California was known as "Gilmore Island." Arthur's son Earl created a vast gasoline and oil distribution network and invented "gas-a-terias," self-service stations. Meanwhile, in 1934, a group of farmers pulled their trucks onto empty land at the corner of Third and Fairfax and displayed their produce from their trucks. The idea caught on, the crowds came and strolled around the displays, and the Farmers Market became an institution with its own buildings.

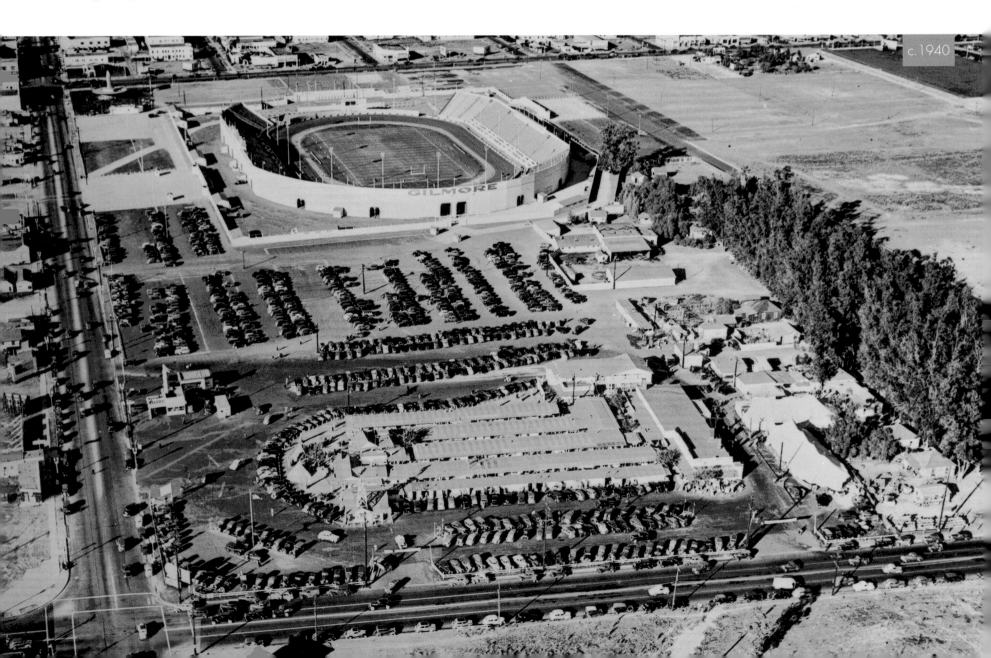

c.1940

c.1955

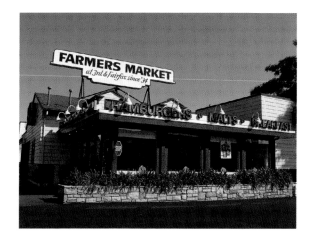

BELOW: The old Farmers Market on Gilmore Island recently had a massive four-year renovation, which transformed the property into an elegant shopping center called the Grove. Stylish restaurants and stores surround the quaint "town square," which features a fishpond and a luxurious new theater complex, complete with 1920s-style uniformed staff wearing pillbox hats and white gloves. This is just steps away from the site of the old Gilmore drive-in theater. A vintage trolley takes visitors around the new Grove. The original Farmers Market still stands where it always has and linking the two is the famous 1941 clock tower (visible in the archive picture left), which is inscribed with a tribute to Gilmore Island founders.

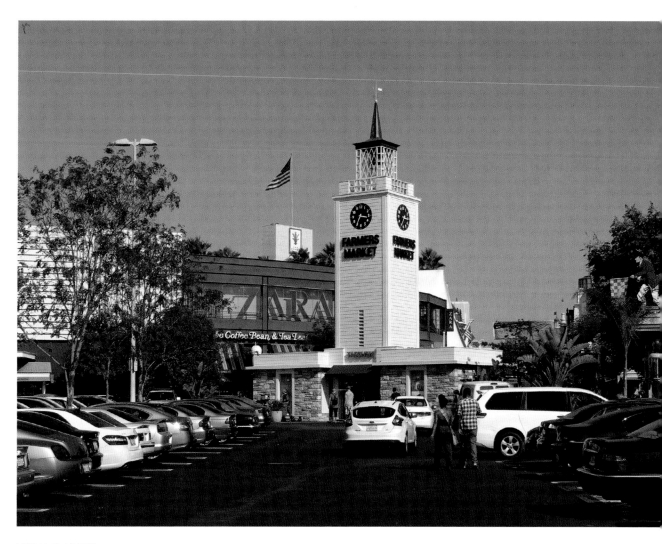

LEFT AND ABOVE: Part theme park, part mall, the Farmers Market combines the old with the new to present a unique shopping experience.

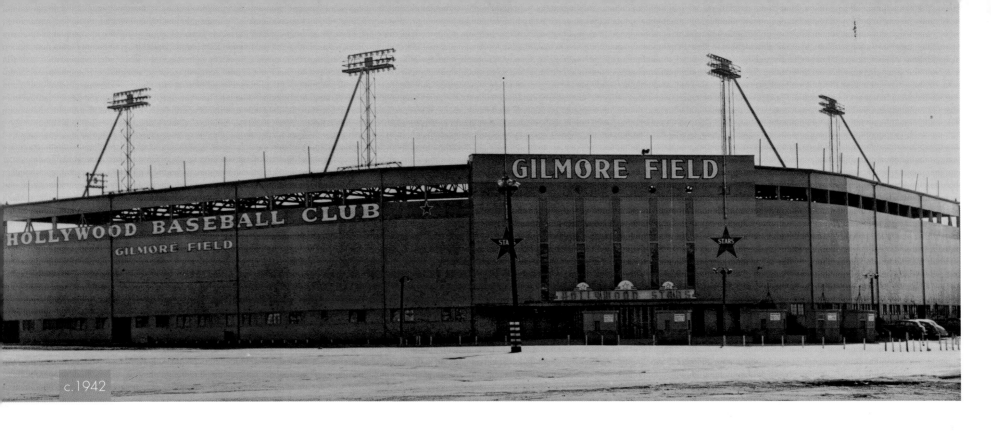

c.1942

GILMORE FIELD

The Hollywood Stars baseball team were going places. Until the Dodgers arrived...

ABOVE: Sports-loving Arthur Fremont Gilmore built Gilmore Stadium just north of the Farmers Market. The 18,000-seat stadium was home to the Bulldogs, L.A.'s first professional football team. The stadium was also used for boxing matches, dog shows, an Esther Williams aquatic show, circuses, rodeos, and midget car racing. Arthur's son Earl built a racetrack on Gilmore Island. His love of cars would lead him later to sponsor winning cars at the Indianapolis 500. In 1987, E. B. Gilmore was elected to the Indianapolis Motor Speedway Hall of Fame. Gilmore Field was constructed in 1938 in the northeast part of Gilmore Island to accommodate the Hollywood Stars, a Pacific Coast League baseball team brought to the city by Herb Fleischhacker. After one poor season at Wrigley Field (in south Los Angeles) the team was sold to new owners, among them Robert H. Cobb, co-owner of the Brown Derby restaurant. Cobb realized the team needed Hollywood backing to

succeed and encouraged the movers and shakers of the film world to invest. Bing Crosby, Gary Cooper, Walt Disney, Gene Autry, (who went to own a major league franchise), all bought stock. Most importantly the team secured the use of Gilmore Field starting in the 1939 season, so it became a Hollywood team playing in Hollywood. The new Stars won three pennants before 1958. Jayne Mansfield was named Miss Hollywood Star in 1955, but two events conspired to end the "Twinks" tenure in Hollywood. CBS had bought Gilmore Stadium and in 1952 announced they wanted to raze it to build a television center. Then in 1957 the Brooklyn Dodgers moved west to offer Major League Baseball nearby and the Stars couldn't compete. They were sold back to Salt Lake City where they had spent eleven seasons from 1915 to 1926 and became the Salt Lake Bees.

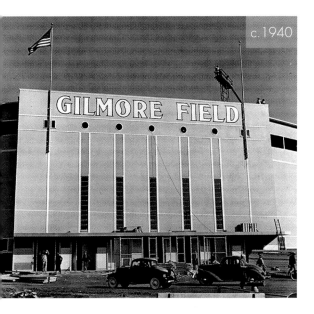

c.1940

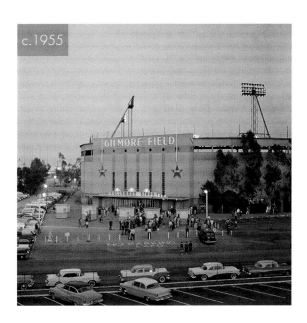

c.1955

BELOW: In 1957, the ballpark site was abandoned and Gilmore Field was razed in 1958. Today the CBS Television City site occupies both the Gilmore Stadium and Gilmore Field sites with the baseball park now being used as a parking lot. Since 1952 CBS has filmed a myriad of television shows here, including *The Twilight Zone*, *The Merv Griffin Show*, *The Carol Burnett Show*, *The Young and the Restless*, and *Hollywood Squares*. Other CBS shows include *The Guardian* and *Everybody Loves Raymond*. In 1999 Viacom (Paramount's parent company) bought the CBS network in, what was then, the largest merger in the media industry. In September 1997, CBS, the Pacific Coast League Historical Society and the A. F. Gilmore Company dedicated a bronze plaque in commemoration of Gilmore Field on a wall outside CBS Studio 46.

ABOVE: The Stars created a genuine local rivalry with the Angels. A brawl between the two teams in August 1953 lasted thirty minutes and fifty riot police had to be sent in.

ABOVE: The ballpark was located on the south side of Beverly Boulevard, about two hundred yards to the west of Gilmore Stadium.

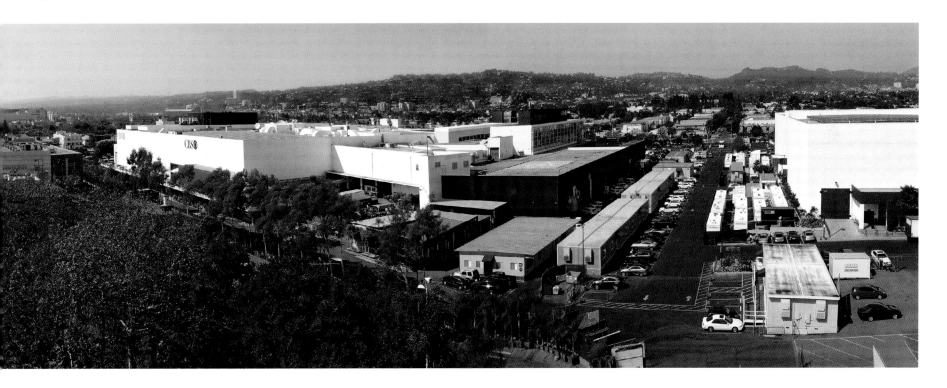

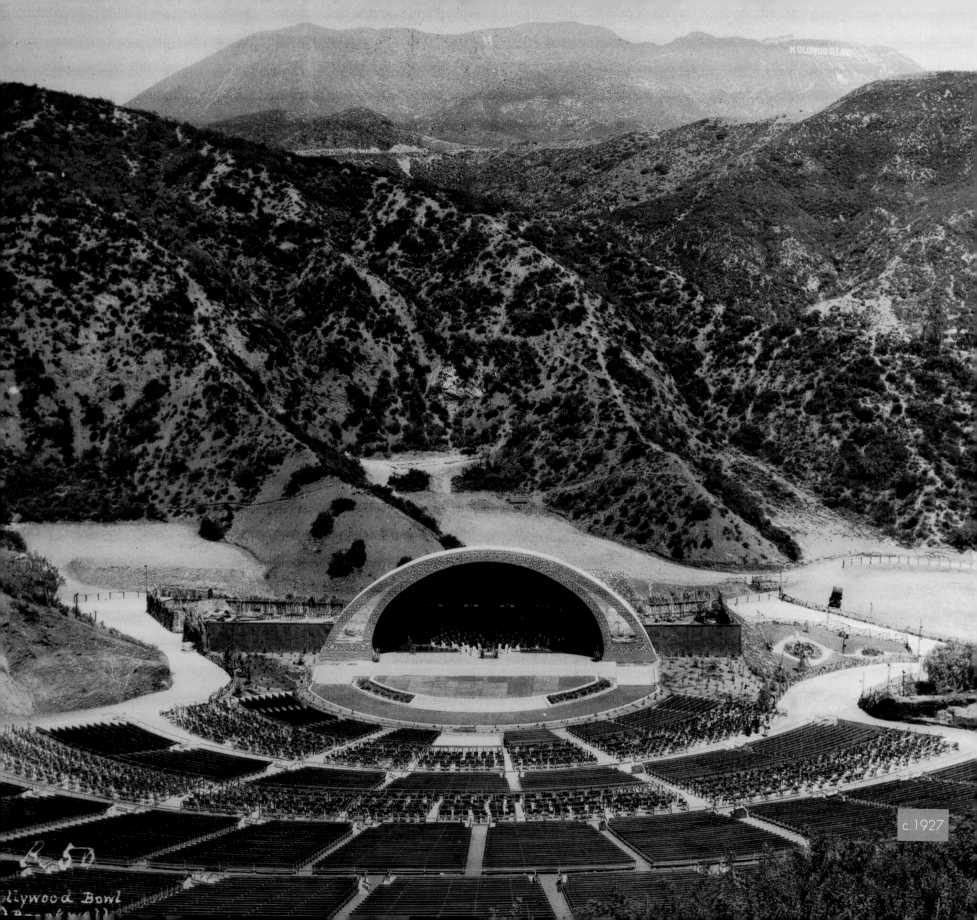

c.1927

Hollywood Bowl

HOLLYWOOD BOWL

Live at Daisy Dell doesn't have the same ring as *Live at the Hollywood Bowl*!

LEFT: When Christine Stevenson, heiress to the Pittsburgh Paint fortune, arrived in Hollywood in 1918, she wanted to present religious plays and outdoor theatrical performances. She chose the natural amphitheatre of Daisy Dell. Stevenson established the Theater Alliance, and with developer C. E. Toberman's help, she bought the land for $49,000 in 1919. In 1920 it was bought by the Community Park and Art Association. Artie Mason Carter, the "arch-dreamer and master-builder of the Hollywood Bowl," who was supervising musical performances in the Dell, created fund-raising schemes. She told whomever would listen of "this outdoor gathering place where people can hear symphonies under the stars." The name came in 1920 when conductor Hugo Kirchhofer declared: "It's like a big bowl—a Hollywood bowl!" The Bowl's first Easter sunrise service was March 21, 1921. The "Symphonies Under the Stars" concerts cost twenty-five cents. In 1926 a large "shell" was erected. Lloyd Wright (son of Frank Lloyd Wright) designed shells for the Hollywood Bowl in 1927, which were then replaced in 1929 by a sturdier steel shell.

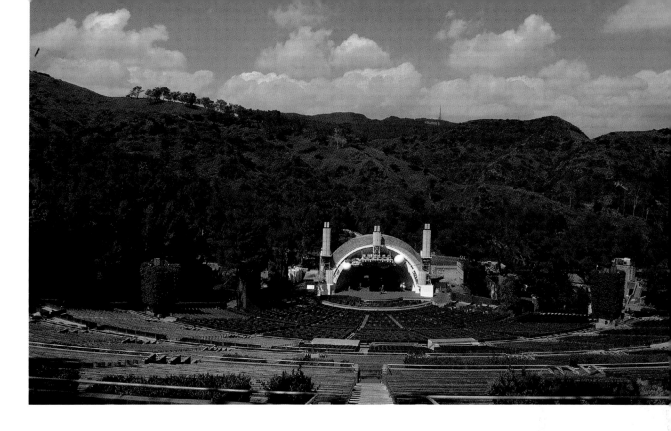

ABOVE: The Hollywood Bowl was featured in the 1937 version of *A Star is Born* with Janet Gaynor and Frederic March, and in many other films and TV movies since then. The great artists that have graced the famous stage include Igor Stravinksy, Frank Sinatra, Barbra Streisand, Luciano Pavarotti, Ella Fitzgerald, the Beatles, the Beach Boys and Judy Garland. The Hollywood Bowl today looks much as it did in the beginning. Careful maintenance keeps its architectural integrity, and much has been done to renovate the facilities and the grounds. From Leonard Bernstein to Bobby McFerrin, from the Monty Python team to Paul McCartney, such is the rich assortment of wonderful music and entertainment that emanates from the Hollywood Bowl.

BELOW: A selection of postcards showing the Hollywood Bowl in various stages of development.

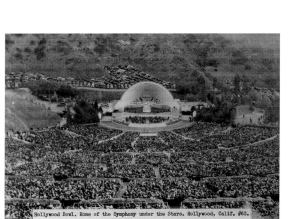

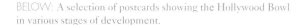
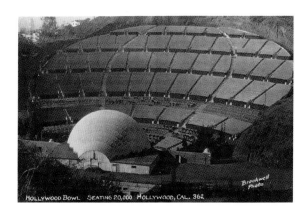

c.1925

HOLLYWOOD AND HIGHLAND

One of the busiest crossroads in Hollywood

LEFT: In the mid 1920s, the intersection at Hollywood Boulevard and Highland Avenue was the hub of the area, and one of the reasons was the presence of the Hollywood Hotel. The oldest theater in Hollywood was also located here. Built in 1913 as the Idle Hour Theatre, it was remodeled and renamed the Hollywood Theatre. This photograph was taken from the Hollywood Hotel in the mid 1920s and shows the intersection at Hollywood Boulevard and Highland Avenue. The building behind the traffic policeman is the C. E. Toberman Building and to the left of that is the Hollywood Theatre. Hollywood and Highland is still one of the busiest crossroads in the city. The former Hollywood Theatre is now the Guinness World of Records Museum pictured left with the theater's blue marquee still in place, and to the right, with the dinosaur emerging from the roof, is the Ripley's Believe It or Not Museum.

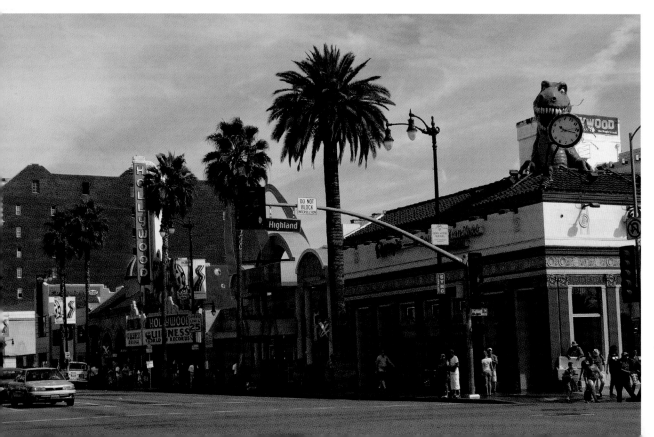

THE MUSIC BOX THEATRE

A veteran of revues, plays, radio drama, movies and concerts

RIGHT: In October 1926 the Hollywood Music Box Theatre opened at 6126 Hollywood Boulevard. Backed by investors such as John Barrymore and King Vidor it ran elaborate shows with Fanny Brice and other musical stars. A year later, legitimate theater replaced the revues, with *Dracula*, starring Bela Lugosi, and *Chicago*, (not the musical) featuring Clark Gable. In 1936 the Music Box Theatre was home to radio broadcasts of popular live radio dramas featuring Marlene Dietrich, Joan Crawford, James Cagney, and Al Jolson. Returning to traditional stage productions, *Life with Father* played here in 1942. The name of the theater was changed to the Guild in 1945 and then to the Fox, as motion pictures proved more popular at this theater. In 1985 it became the Henry Fonda Theatre as a tribute to the actor who enjoyed success on stage with productions of *Mister Roberts* and *The Caine Mutiny Court Martial*, as well as his better-known career in film, with movies such as *12 Angry Men*. The People's Choice awards, Country Music Awards, and the Grammy nominee parties have all been held here. The venue has also been host to concerts by Stevie Wonder, Katie Perry and Radiohead.

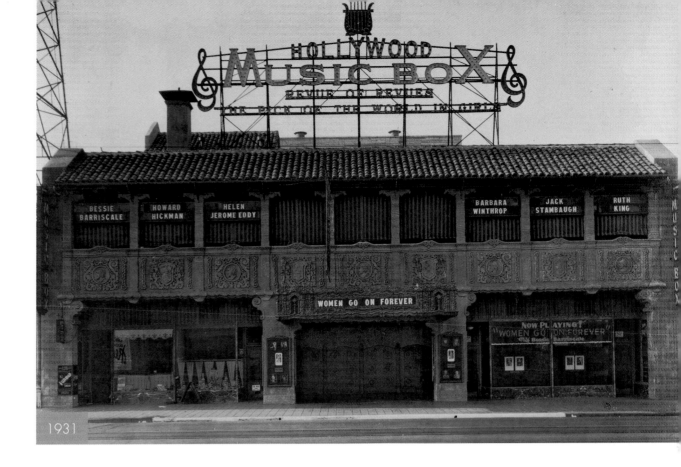

1931

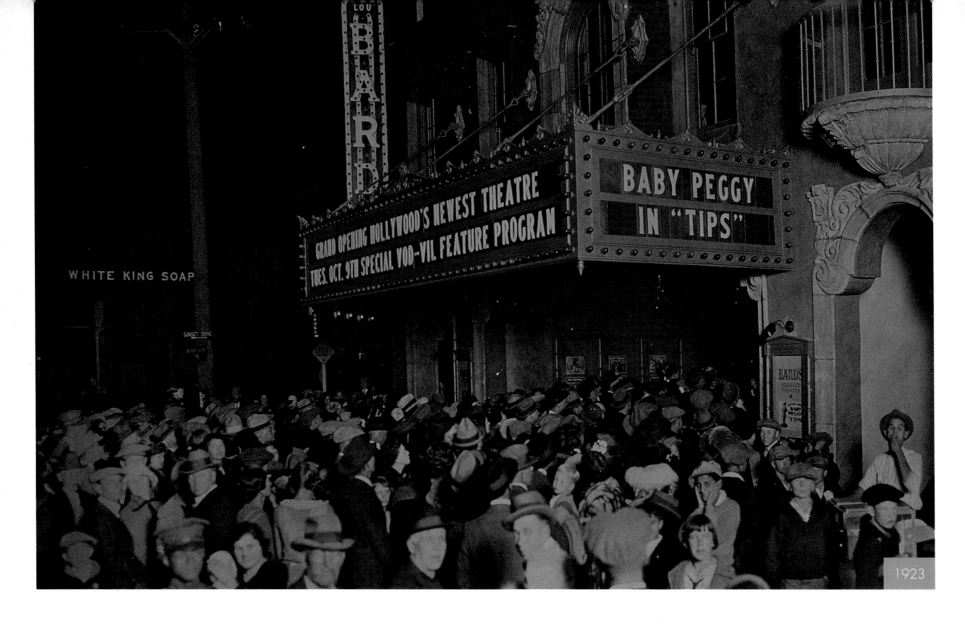

1923

THE VISTA THEATRE
A theater built on the site of D. W. Griffith's Babylonian set for *Intolerance*

ABOVE: The Vista Theatre was built in 1923 as a vaudeville house called the Lou Bard Playhouse, taking its name from a local showman who built four theaters with exotic Egyptian themes. It stands on the site of the towering Babylon set from D. W. Griffith's 1916 epic *Intolerance*. In October 1923, it debuted as a movie house with the premiere of *Tips*, starring child star Baby Peggy. The movie cost ten cents and candy was five cents. On Sunday there were four vaudeville acts before the movie. Eccentric film director Ed Wood had an office upstairs at the Vista.

FAR RIGHT: In the 1950s the building, as with the surrounding neighborhood, became run down. In the 1960s and 1970s the Vista ran adult movies. Film enthusiasts realized the historical importance of this bijou cinema and the single screen theatre was restored between 1997 and 2000. The project cost nearly $1.5 million. The Vista shows classic and first-runs films. It remains a favorite with some of the biggest show-business names, who enjoy anonymity (and extra leg room after many rows of seats were removed). It is now operated by Vintage Cinemas, a company specializing in preserving traditional movie theaters.

ABOVE: Baby Peggy, star of the film that christened the Vista Theatre's movie run.

BELOW: The Vista has been beautifully renovated and is one of the few remaining in Hollywood in its 1920s form.

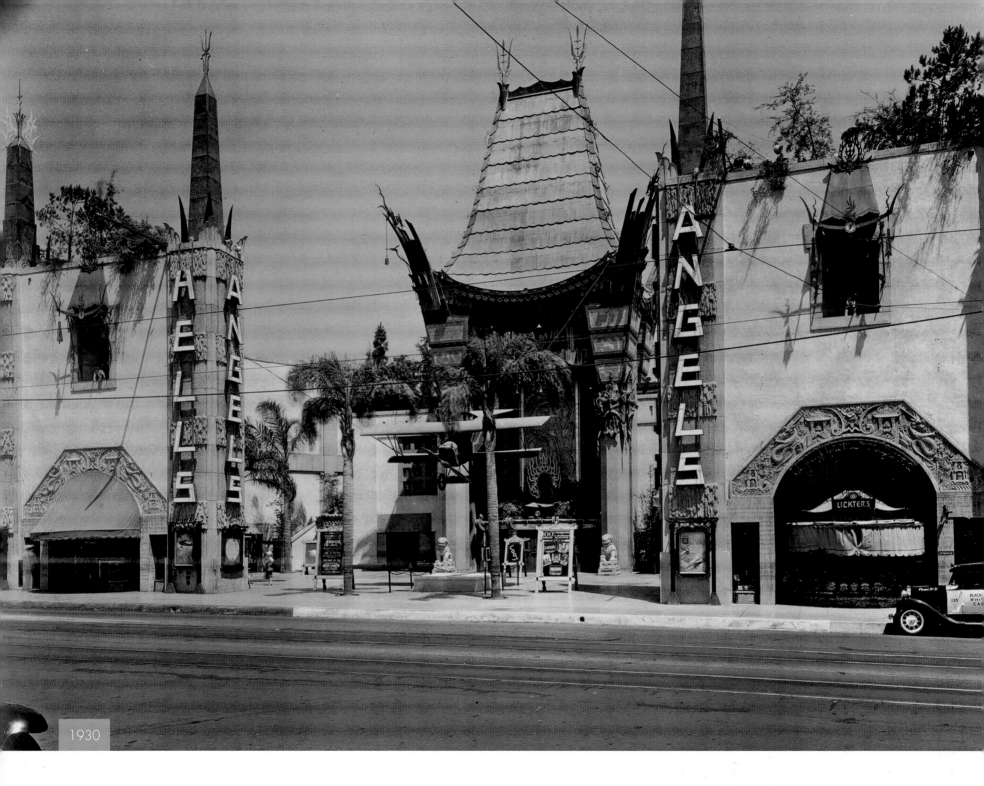

1930

GRAUMAN'S CHINESE THEATRE
The most remarkable movie theater in Hollywood

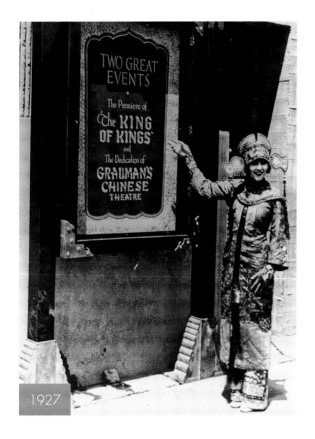

1927

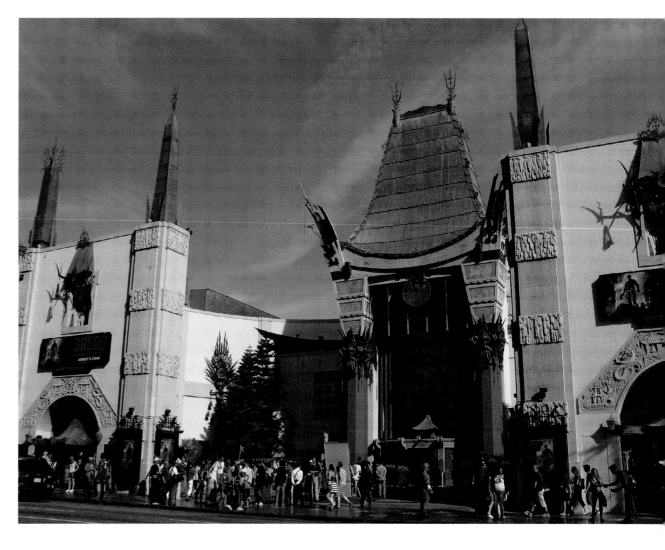

LEFT: Once developer C. E. Toberman had persuaded Sid Grauman and his father to relocate to Hollywood, they built some of Hollywood's most notable landmarks together. Grauman's Chinese Theatre—the most famous and instantly recognizable—opened on May 18, 1927, with the premiere of Cecil B. De Mille's *The King of Kings*. It was said to be the grandest opening ever, with hundreds of fans clamoring for autographs from the stars. Grauman and Toberman had produced the most exotic theater; the Chinese front is ninety feet high and the bronze roof is held aloft by two gigantic columns, between which is a carved stone dragon. Giant Foo dogs guard the entrance. Grauman was an expert publicist and dressed usherettes in Chinese costume for his grand opening (pictured above). Three years later for the opening of Howard Hughes' film about World War I flying aces, *Hells Angels*, he mounted a biplane on cables across the front (pictured left).

ABOVE: On November 9, 2001, Grauman's Chinese Theatre reopened after an extensive $2 million renovation and upgrade. Almost eighty years after it opened, it now has some of the most technologically advanced projection and sound equipment. The large, dramatic lobby boasts ornate Chinese murals and chandeliers. The projection booth was moved back upstairs to its original location after it was moved downstairs in 1958. It was renamed Mann's Chinese after Ted Mann purchased it in 1973, but when the theater was acquired by a partnership of Warner Brothers and Paramount in 2000, they restored its original name. Grauman's Chinese Theatre reopened with the premiere of *Harry Potter and the Sorcerer's Stone*. It was declared a historic-cultural landmark in 1968, and continues to be a preferred location for the cinema industry's most prestigious premieres.

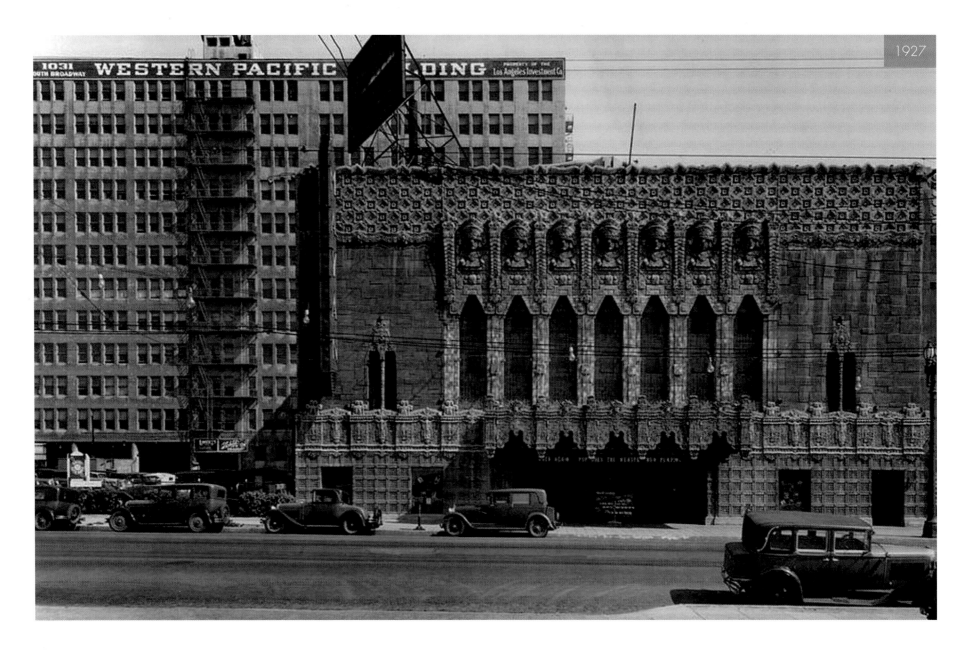

MAYAN AND BELASCO THEATRES

Two similar theaters built near each other, but only one continues in its original role

ABOVE: The Mayan and Belasco Theatres were designed by the architectural firm of Morgan, Walls, and Clements and opened as conventional theaters in 1927 and 1926 respectively. The owners were hoping to establish a new theater district west of Broadway with the Mayan at 1040 South Hill and the Belasco at 1050 South Hill. The Belasco's opening production was the comedy *Gentlemen*

Prefer Blondes (with an advert still visible on the side of the building until it was repainted in 2006) while the Mayan (pictured above) opened with the musical *Oh Kay!* By 1929 the Mayan had started showing movies and in 1931 it was being billed as Grauman's Mayan.

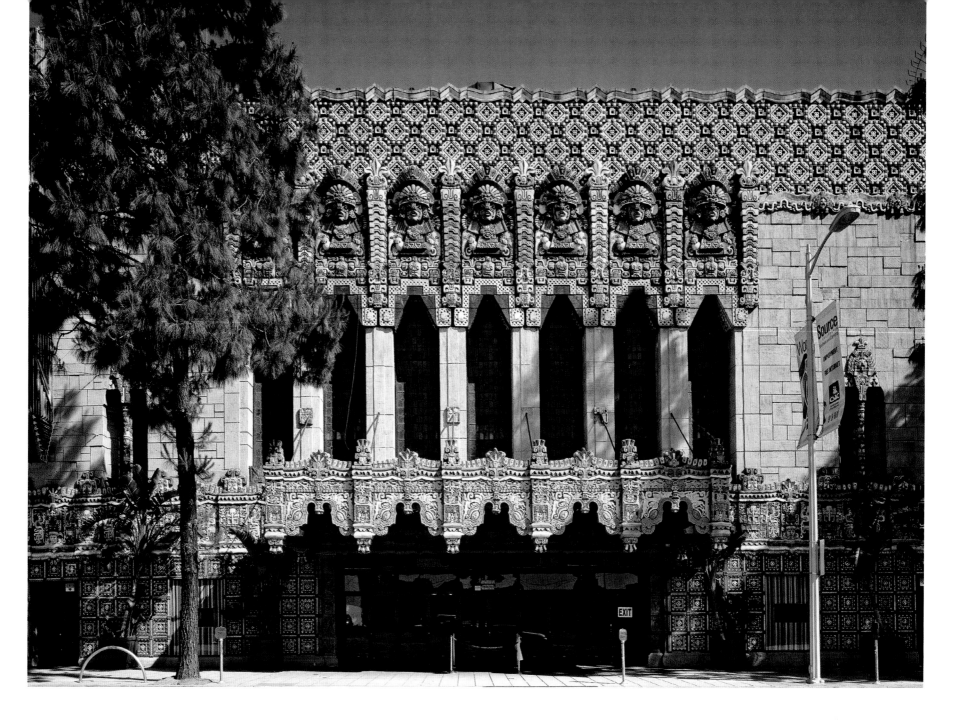

ABOVE: Legitimate theater wasn't abandoned at the Mayan and as part of the WPA Federal Theater Project in the 1930s it put on shows such as *Follow The Parade* and *Volpone*. It switched between stage shows and Spanish language films in the 1940s and 1950s. Duke Ellington played 101 shows to an unsegregated audience here starting from 1941, a time when audiences were segregated downtown. Like many cinemas, the 1960s and 1970s proved to be hard times and in the early 1970s it started to show adult movies (some of which were shot in the basement). In 1977 the auditorium was split into three screens—still showing adult movies—until 1990 when the venue became The Mayan nightclub, its role today. The neighboring Belasco was closed in 1952 and subsequently used as a community church. There were plans to convert it into a nightclub but after a $10 million renovation it re-opened as a theater in 2011.

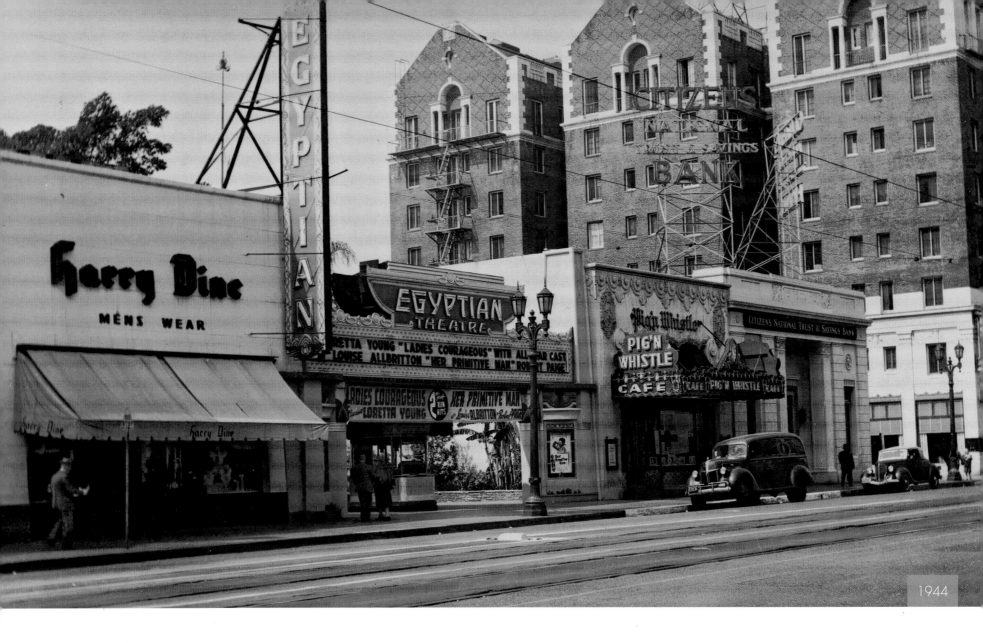

1944

EGYPTIAN THEATRE AND PIG'N WHISTLE
One of the many themed movie theaters of the 1920s

ABOVE: Charles Toberman developed the Egyptian Theatre with impresario Sid Grauman. Tutankhamen's tomb had just been discovered in Egypt, and an Egyptian craze was sweeping America. The theater, at 6712 Hollywood Boulevard, cost $800,000 to build. Props from the current movie would be displayed in the forecourt. Four massive columns marked the entry and an actor in Egyptian costume marched back and forth on the roof announcing the next showing. Girls in harem costumes showed patrons to their seats.

ABOVE RIGHT: Closed in 1992, the Egyptian reopened in 1998 following a $15 million renovation. The American Cinematheque (a nonprofit arts organization) purchased the theater from the city for a dollar with the provision that it be restored to its former grandeur as a movie theater and add programs on filmmaking. Behind-the-scenes tours are available and a documentary, *Forever Hollywood*, was made about the theater. The rehabilitation of the Egyptian Theatre earned the American Cinematheque a 2000 National Preservation Honor Award.

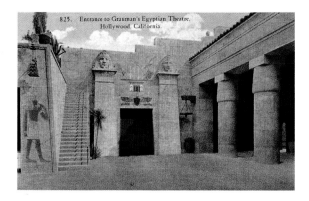

ABOVE: Postcards showing the Egyptian's original decor.

LEFT: The movie announced on the marquee. *Her Primitive Man*, dates this photo to 1944.

1946

TILL THE CLOUDS ROLL BY PREMIERE AT THE EGYPTIAN THEATRE

Till the Clouds Roll By premiered at the Egyptian Theatre in 1946. Major theaters would set up bleacher seats for the comfort of the waiting fans. When the Egyptian Theatre opened in October 1922, it was to be the host of the very first movie premiere—*Robin Hood*, starring Douglas Fairbanks. Sid Grauman staged an elaborate gala with red carpet, bright lights, and lots of movie stars. The Hollywood Egyptian Orchestra played *Aida* as the overture. Today much of the formality has gone from premieres, but the glamour remains.

ABOVE: The Pig'n Whistle opened in July 1927 next to the Egyptian Theatre. Theaters in those days did not have concession stands, so the family-style restaurant, with a soda fountain and candy counter in the front, became very popular with moviegoers. Shirley Temple, Spencer Tracy, and a young Judy Garland were among the celebrities who enjoyed the atmosphere and the sundaes. The restaurant closed in 1949, but reopened in March 2001 on the same site with much of the interior faithfully restored. The soda fountain is gone, but there is a patio café on the boulevard.

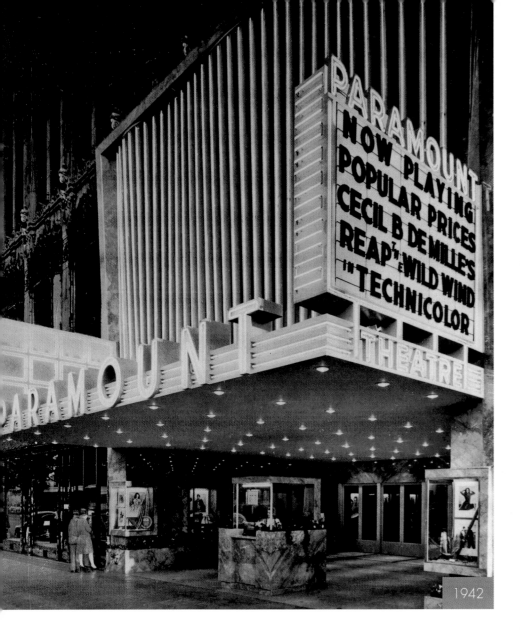

1942

EL CAPITAN
Beautifully restored by the Disney Corporation

ABOVE: The El Capitan on Hollywood Boulevard, west of Highland, opened on May 3, 1926. This was the second collaboration between Charles "Mr. Hollywood" Toberman and Sid Grauman. Opened one year before Grauman's Chinese Theatre, the El Capitan was a live theater and its first show was the French *Charlot's Revue*, starring Gertrude Lawrence and Jack Buchanan. In the next decade, over 120 live shows were presented at the El Capitan, with stars such as Clark Gable, Buster Keaton, and Joan Fontaine. Switching to the movies, the El Capitan premiered Orson Welles's masterpiece *Citizen Kane* in

1942. The El Capitan closed shortly afterward and reopened as the Hollywood Paramount. Despite its success, the Paramount changed hands often in the next few years. In 1989, the Walt Disney Company joined with Pacific Theatres to restore this historical theater. They returned the El Capitan to its former East Indian and Spanish Colonial decor and restored its original name. Today Disney films are premiered here, preceded by live Disney stage shows.

1942

THE HOLLYWOOD PALLADIUM
The place in Hollywood that hosted the biggest of the big bands

ABOVE: The Hollywood Palladium opened on Sunset Boulevard, between Argyle and El Centro, October 31, 1940, and was a huge success from the beginning. On the opening night, Tommy Dorsey and a young Frank Sinatra entertained several thousand in the enormous ballroom. During its reign, the Hollywood Palladium has entertained more than fifty-eight million guests. Stars like Doris Day, Betty Grable, Rita Hayworth, and Martha Raye were Palladium regulars and were often seen dancing with soldiers in uniform. The Hollywood Palladium allowed uniformed servicemen entrance for fifty cents. Between the Hollywood Canteen and the Palladium, it was a great time to be a soldier on leave. Glenn Miller, Artie Shaw, and Harry James often provided the entertainment. After producer Don Fedder took over management of the Hollywood Palladium in 1961, bandleader Lawrence Welk broadcast his popular weekly television show from there. The Hollywood Palladium is currently owned by Palladium Investments, Inc., who have renovated and updated this famous venue. Award shows such as the Grammys, the Emmys, and the Country Music Awards have been held here, and the theater has also been used as a film location for movies such as *The Bodyguard*, and *The Frank Sinatra Story*. The Hollywood Palladium was closed for a year's renovation project and re-opened with a Jay-Z concert in 2008. The original Palladium neon sign design has been brought back.

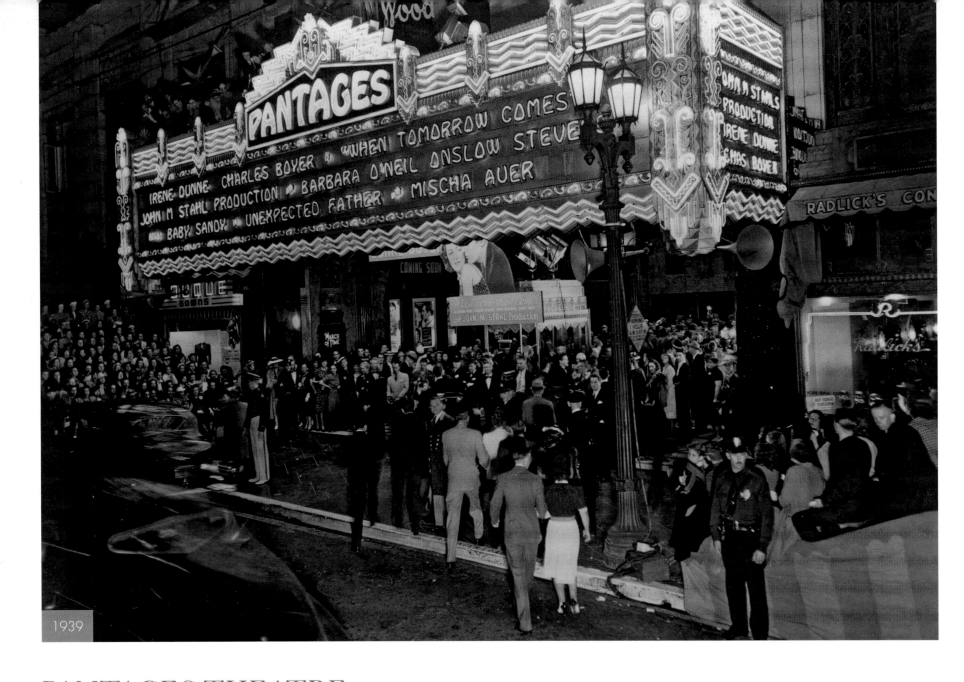

1939

PANTAGES THEATRE

An Art Deco masterpiece that continues to showcase the very best musicals

ABOVE: The Pantages Theatre, at 6233 Hollywood Boulevard, opened in 1930 as a movie theater with the premiere of *Florodora Girl*, starring Marion Davies. Designed by Marcus Priteca, this Art Deco theater has a lavish marble and bronze entrance, an elaborate ceiling, and ornate twin staircases. The most ornate of Hollywood's movie houses, with almost 3,000 seats, this was the fourth theater built by impresario Alexander Pantages, at a cost of $1.25 million. The ensuing years saw both live presentations and movies at the Pantages: Leopold Stokowski conducted the Los Angeles Philharmonic for an entire season here in 1940. The Academy Awards ceremony was held here from 1949 to 1959.

1954

ABOVE: The Pantages Theatre hosted eleven Academy Awards ceremonies including the twenty-sixth in March, 1954.

RIGHT: In 1977 Pacific Theatres joined with the Nederlander Organization as new owners of the Pantages. Starting with the Broadway hit *Bubbling Brown Sugar*, the Pantages has continued to present world-class stage productions, many fresh from Broadway and London. Shows have included *La Cage Aux Folles*, *Damn Yankees*, *Riverdance*, *The Lion King*, *Wicked*, *Evita*, *Annie*, *Cats* and *Phantom of the Opera*. The full run-down reads like a list of the Tony award for the Best Musical for the last twenty-five years. In 2000 nearly $10 million was spent to restore this magnificent place. Mel Brooks's smash *The Producers* opened in 2003 to great critical and popular acclaim. Showing in 2012 was *The Book of Mormon* a transfer from Broadway where it had won nine Tony awards in 2011. The theatre has also occasionally hosted music performances and was the venue for the Talking Heads concert film *Stop Making Sense*, which was shot here in 1984.

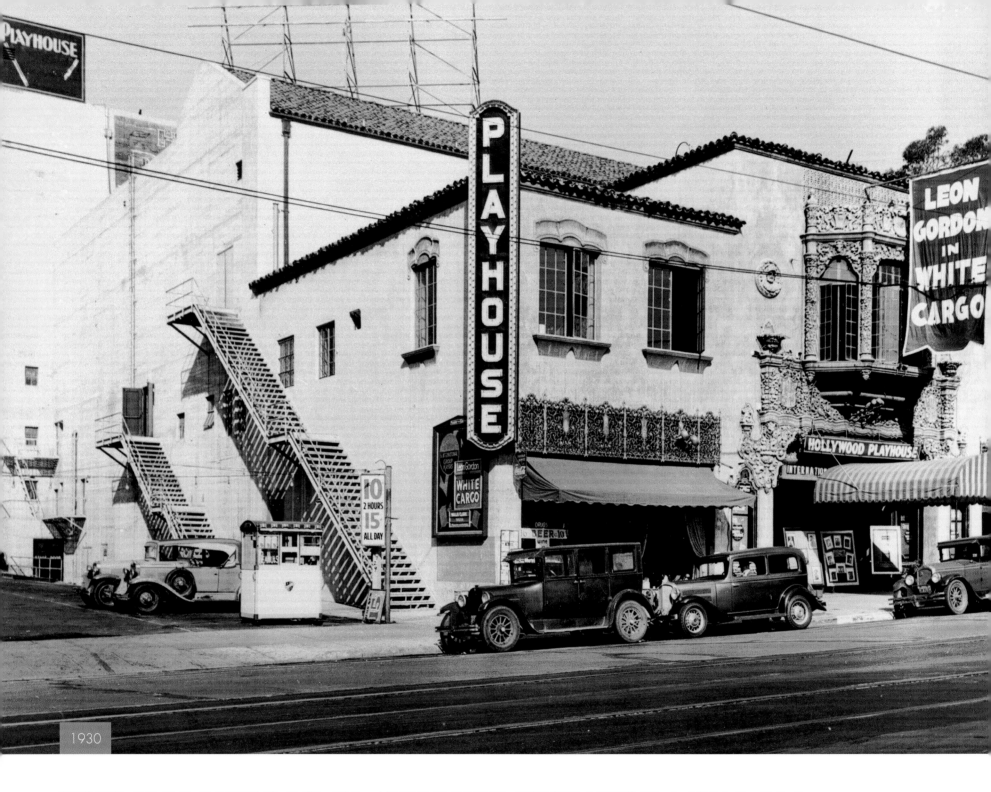

1930

THE HOLLYWOOD PLAYHOUSE THEATRE / AVALON

Like many Hollywood theaters it has had a variety of different titles in the past

LEFT: The Hollywood Playhouse Theatre opened in 1927 at 735 Vine Street. S. H. Woodruff and partners, from the nearby Vine Street Theatre presented lavish dramatic productions with star-studded casts that included Fanny Brice and Lucille Ball. In the 1940s, this theater became the El Capitan (the original El Capitan ran as the Paramount). Under this guise it was home to the classic *Ken Murray's Blackouts*, a live burlesque show that ran a record 3,844 performances. In the 1950s, as an NBC television facility, popular shows such as *You Bet Your Life* with Groucho Marx, *Queen for a Day*, and *The Colgate Comedy Hour*, as well as telethons, were broadcast from here. The theater was renamed the Hollywood Palace, and in 1964 the ABC television show of the same name featured celebrated guests such as Judy Garland, Bing Crosby, George Burns, and Fred Astaire. Merv Griffin televised his own talk show from here until he moved to his own theater.

ABOVE: The theater was sold by ABC in 1978 and resumed as a music venue—the Palace. It was used as a prominent location in the movie *Against All Odds*. The Ramones played their final concert here in 1996. The Palace was in turn purchased by Hollywood Entertainment Partners in 2002, renamed as Avalon and re-opened as a nightclub. Since 2004 the venue has been open to the public on Friday and Saturday nights playing dubstep and trance music.

ABOVE: The Hollywood Playhouse Theatre has had a number of titles over the years. Chronologically it has been: The Hollywood Playhouse, The WPA Federal Theatre, The El Capitan Theatre, The Jerry Lewis Theatre, The Hollywood Palace, The Palace and Avalon.

TOP LEFT: A typical Playhouse poster from 1938.

1938

THE VINE STREET THEATRE

Today named for one of Mexico's finest actors

LEFT: In 1926, the Wilkes Vine Street Theatre opened at 1615 North Vine Street. Known simply as the Vine Street Theatre, it became the CBS Radio Playhouse in the 1930s and broadcast such hugely popular shows as the Lux Radio Theatre. The Lux Radio Theatre brought movie stars such as William Holden, Gloria Swanson, and George Raft to radio dramas, complete with full orchestras. In 1954 the theater reverted to stage productions and was renamed the Huntingdon Hartford. This theater has had, like so many others in Hollywood, many identities. Next it became the James Doolittle Theatre for stage productions. More recently, it was taken over by the Nosotros company who bought the theatre from UCLA and renamed it the Ricardo Montalban Theatre, after the great Mexican actor who was badly injured when he was thrown from his horse while filming *Across The Wide Missouri* in 1951 and later confined to a wheelchair. The Ricardo Montalban Foundation premiered the musical biography *Selena* here in 2001 and today there is a mixture of uses including a *Hola Mexico* film festival, live bands, and, at the time of writing, Nike were offering a free training session on the rooftop. CBS radio station KNX-1070 in Los Angeles has rebroadcast many of the original radio dramas that were recorded here.

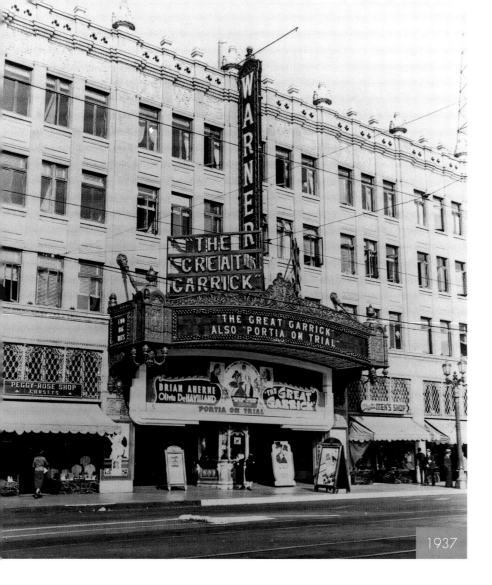

1937

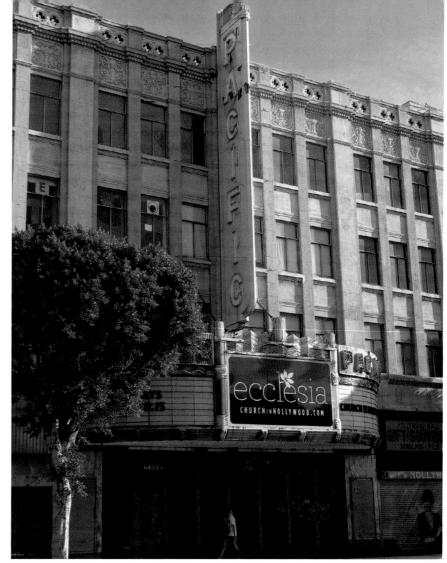

THE WARNER / PACIFIC THEATRE
Hollywood's largest movie house

ABOVE: The Warner Theatre, at 6423 Hollywood Boulevard, opened on April 26, 1928, with *Glorious Betsy*, starring Delores Costello and Conrad Nagel. The Warner Theatre was designed by the prominent theatrical architect G. Albert Landsburgh. A four-story Italianate beaux-arts building, this was the largest theater in Hollywood, with 2,700 seats. It was one of the few Hollywood theaters large enough to convert to Cinerama (a widescreen process introduced in 1956 that used three cameras to create a single image on a specially curved screen that gave moviegoers the illusion of vastness). In 1968 it was purchased by Pacific Theatres and renamed the Pacific Theatre. In the early 1970s, A *Clockwork Orange* played here to packed houses, and *2001: A Space Odyssey* ran for thirty-seven weeks. The theater then underwent a $1 million rehabilitation. The Pacific Theatre has been closed for several years. It only opens for local Sunday Ecclesia church services at 9:30am and 11:15am, for special events, and for use as a filming location.

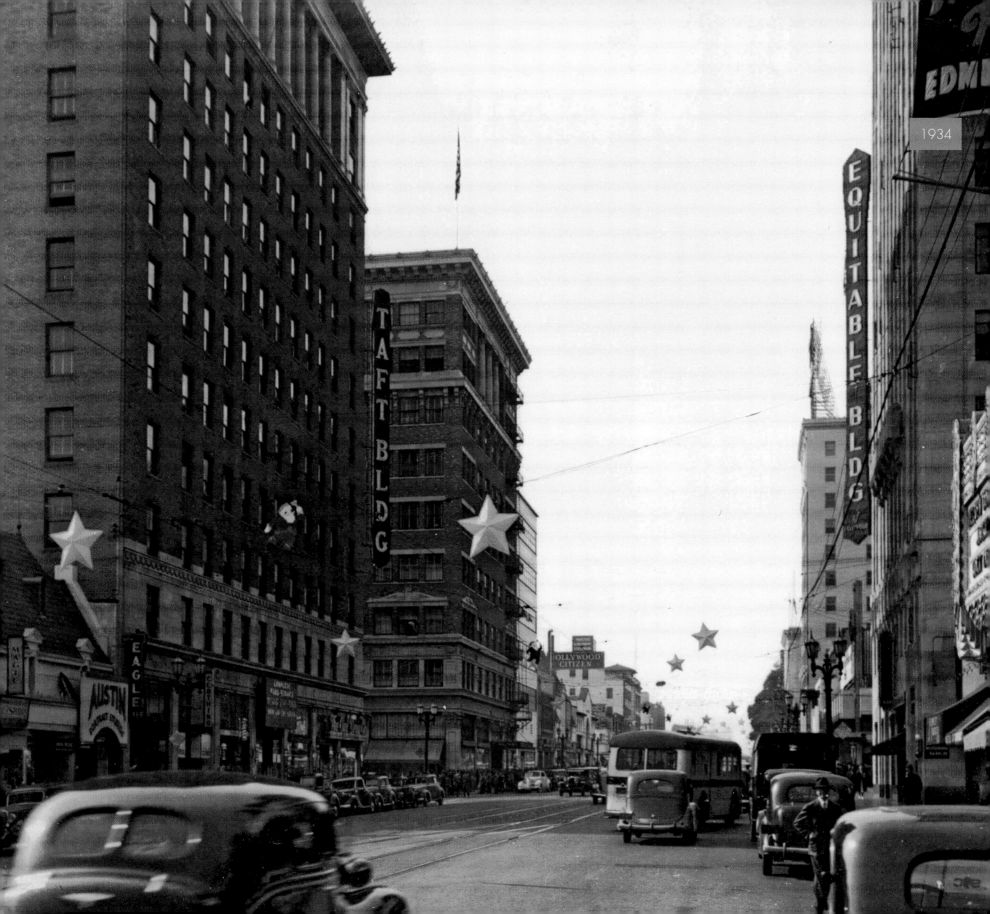

HOLLYWOOD AND VINE

Site of the Taft Building where Will Rogers kept an office

LEFT: In 1910, in the final act of incorporation back into Los Angeles, Prospect Avenue became Hollywood Boulevard—an effort to preserve the name of the now-lost city for posterity. Vine Street was so named because it was a street that ran through Senator Cornelius Cole's vineyard. The Taft Building on the southeast corner (site of the former Methodist Episcopal Church) was built in 1924 by Hollywood pioneers the Taft family. Providing office space for celebrities such as Will Rogers and Clark Gable, from 1935 to 1945 the Taft housed the Academy of Motion Picture Arts and Sciences. The Gothic Art Deco–style Equitable Building on the northeast corner was built in 1929 and was popular with financial institutions. The Dyas department store was built on the southwest corner in 1927. It was later replaced by the Broadway store. No one knows why Hollywood and Vine has become such a world-famous symbol of movie glamour. To local residents, it's just another intersection. Except that, on May 29, 2003, this was named Bob Hope Square, honoring the legendary entertainer's one hundredth birthday, two months before his death. The Taft Building still has its prominent sign and was sold for $28 million in 2011 with a plan to update the facilities and market the space as "cool and creative" entertainment business offices.

c. 1925

HOLLYWOOD DINING, MUSSO & FRANK GRILL

The longest serving restaurant in Hollywood

ABOVE: During Prohibition, which ran from 1920 to 1933, Hollywood built some of its grandest palaces of entertainment. This was also a time when many of the popular restaurants and dance spots opened. The Hollywood elite dined at the Brown Derby or the Musso & Frank Grill, and danced at the Montmartre Café and the Cocoanut Grove. The Musso & Frank Grill was opened in 1919 by John Musso and Frank Toulet at 6667 Hollywood Boulevard. They sold it six years later to Joseph Carissimi and John Mosso, who added the building next door in 1937. It is now the oldest running restaurant in Hollywood. The literati, including William Faulkner, Dashiell Hammett, and Ernest Hemingway, would rendezvous here at what they called the "Algonquin Round Table West." Raymond Burr, Charlie Chaplin, Humphrey Bogart, and a host of celebrities through the ages occupied the red leather booths, while notorious gossip columnists Louella Parsons and Hedda Hopper conducted interviews here. After more than eighty years in operation, the interior of Musso & Frank Grill appears to have hardly changed. The decor is dark wood, with red-leather booths, much like an old gentlemen's club, and the food is as good as ever. It is still as busy as it must have been in Hollywood's heyday.

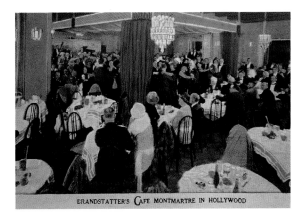

ABOVE: The height of sophistication in the 1920s, film stars would need a "special delivery" brought to their table if they wanted to drink alcohol during Prohibition.

THE MONTMARTRE

Bing Crosby moonlighted here early
in his career

RIGHT: Eddie Brandstatter opened the Montmartre Café in December 1922. Located on the second floor of the C. E. Toberman Building, at 6757 Hollywood Boulevard, the supper club offered entertainment, dancing, and fine cuisine. Joan Crawford is rumored to have won a Charleston contest here and an unknown Bing Crosby was hired to sing. The stars flocked to the Montmartre night and day; the luncheon was very popular, especially on Wednesdays, when it was set up specifically for the film folks. Fans would line up on the street and in the lobby to catch a glimpse. Bebe Daniels, Marion Davies, Mabel Normand, John Barrymore, Winston Churchill, and Fatty Arbuckle all signed the guest books. The café closed in 1929 and in the 1970s the Lee Strasberg Theatre Institute was housed here. Today there is no sign of the glamorous life of the Montmartre, just an office block.

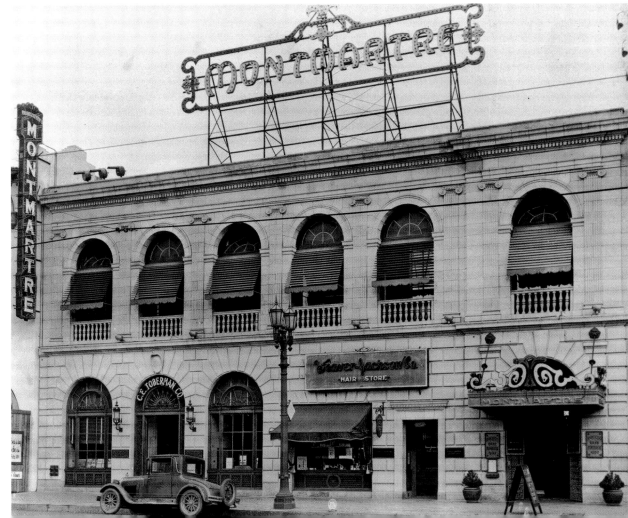

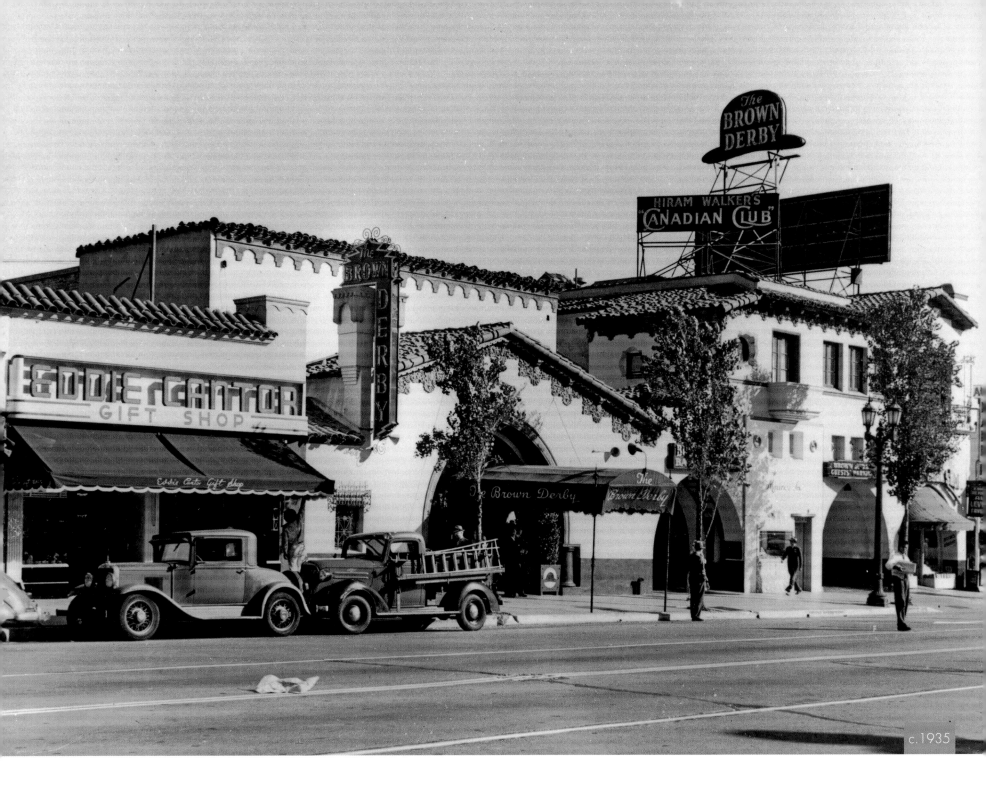

c.1935

THE BROWN DERBY
Popular with Hollywood's stars until 1985

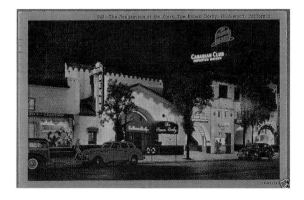

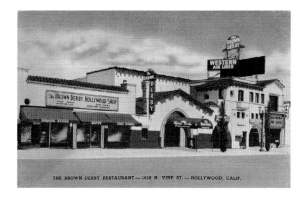

ABOVE: A selection of postcards of the Brown Derby.

LEFT: On Valentine's Day 1929, Herbert Somborn (Gloria Swanson's husband) opened the Brown Derby on Vine Street in a rambling Spanish structure owned by Cecil B. De Mille. (The original hat-shaped Derby was on Wilshire.) This Hollywood Brown Derby was an immediate success; the food was simple and good and the stars piled in for lunch and dinner. Eddie Vitch's cartoons of the celebrity guests soon covered the walls. After Somborn's death in 1934, Robert Cobb, inventor of the Cobb salad (and soon-to-be-investor in the Hollywood Stars baseball team), became the owner. Regulars included George Burns, Gracie Allen, George Raft, Cary Grant, and Barbara Stanwyck; just about every big Hollywood name was here at some point. Actors, writers, and producers had themselves paged for telephone calls while dining to make themselves seem more important. Clark Gable proposed to Carole Lombard here in Booth 54.

ABOVE: In the late 1970s the 1628 North Vine Street Brown Derby was given a face-lift. The stars and the public kept coming for a while, amongst them Steve McQueen, but it finally closed in 1985. The building was damaged by fire in 1987, and after further damage in the 1994 earthquake, it was demolished. Today there's just a parking lot and a historical marker (Hollywood Historic Site No.22) on the site of what was a great Hollywood eatery.

125

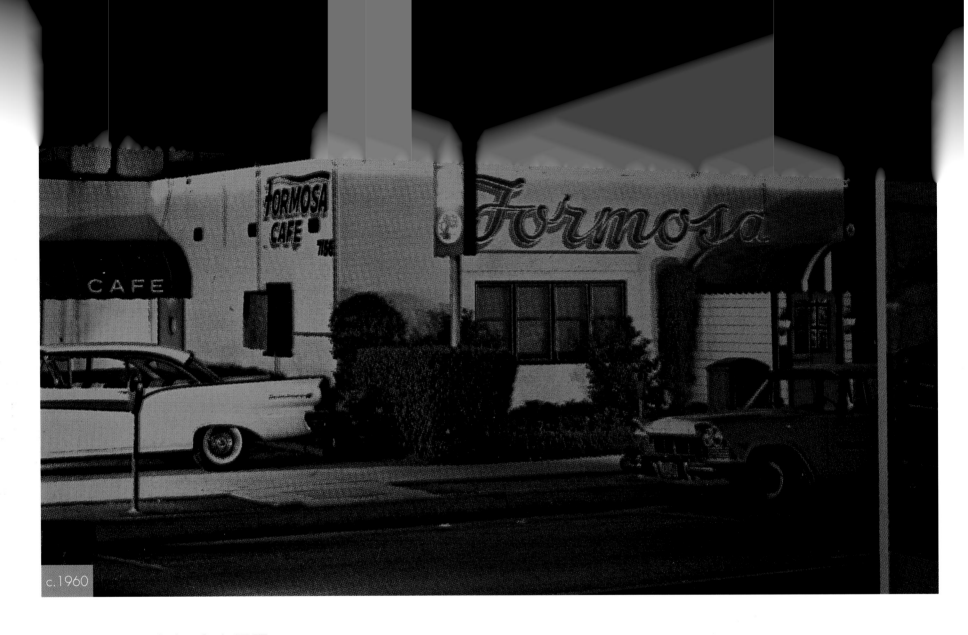

c.1960

FORMOSA CAFE
One of Dean Martin's favorite hangouts

ABOVE: The red-painted Formosa opened in 1925 as Jack's Steak House—until Jack lost the restaurant in a poker game in 1939 to Jimmy Bernstein. That's when it became the Formosa Café—so called because of its location at 7156 Santa Monica Boulevard at Formosa Avenue. It was built on the site of the huge Maid Marion castle in Douglas Fairbanks's *Robin Hood* of 1922, and in the 1940s a Red Line trolley car was added in the back. All the stars working at the United Artists studios next door ate here, including Humphrey Bogart, Clark Gable, Roy Rogers, and Tyrone Power. When Sam Goldwyn bought another studio nearby, even more stars rolled in. John Wayne (when finishing *The Alamo*) would spend so much time here that one night after work he fell asleep in his booth. He was too large for anyone to move, so they left him, and the next morning when the staff came in, they found him in the kitchen fixing himself breakfast. Bogart sat at the bar, as did Jack Webb, while Jack Benny, Marlon Brando, Grace Kelly, Rock Hudson, Billy Wilder, and James Dean all enjoyed the Chinese-American food. It is reported that Bernstein had to loan the fabulously wealthy Howard Hughes the cab fare home a few times. Elvis Presley and Marilyn Monroe had their own booths.

126

ABOVE: Lovingly preserved, the restaurant is still run by the family of the original chef Lem Quon.

BELOW: A galaxy of stars above: Tony Curtis, Jack Lemmon, Dean Martin and Jerry Lewis were much loved regulars.

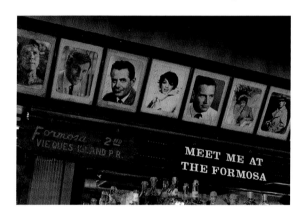

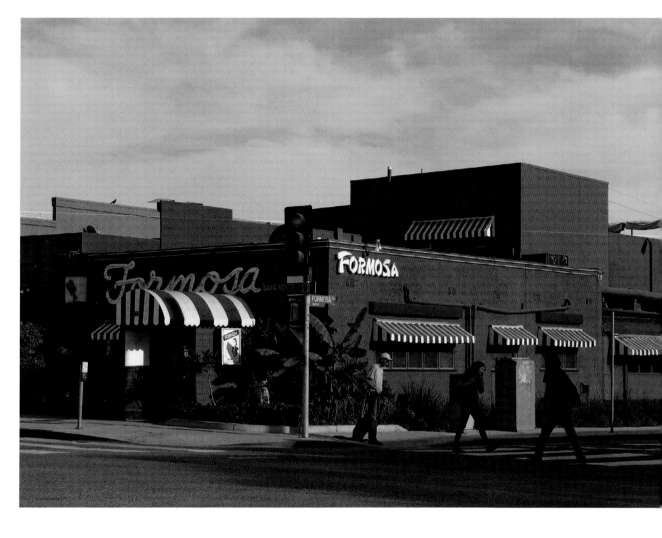

ABOVE: In the early 1990s, a back patio and a roof deck were added for smokers. The neighbors were now called Warner Hollywood Studios. The interior of the legendary Formosa Café reveals its history: Over the bar and on every inch of wall space are photographs that tell the history of this funky little restaurant. The colorful Formosa has been used in many films: scenes for *L.A. Confidential* and Jim Carrey's *The Majestic* were shot here, as were *Swingers* and *Still Breathing*. Films have their wrap parties here and today's stars like Nicholas Cage, Lisa Marie Presley, Matthew Perry, Jodie Foster, Christian Slater, and Johnny Depp are perpetuating the tradition. However, this legacy was almost lost in 1991 when the Formosa's lease ran out. The restaurant, unable to buy the land it sits on, has always been a tenant of the neighboring studio. After decades of loyal service, the Formosa was given ninety days to leave. However, the customers were outraged and rebelled. After picketing and plotting, they finally managed to get a Historic Preservation Order for the old place. There is a multistory shopping plaza built right behind the café that provides customers with much-needed parking spaces.

SCHWAB'S PHARMACY

Film columnist Sidney Skolsky worked from an office upstairs

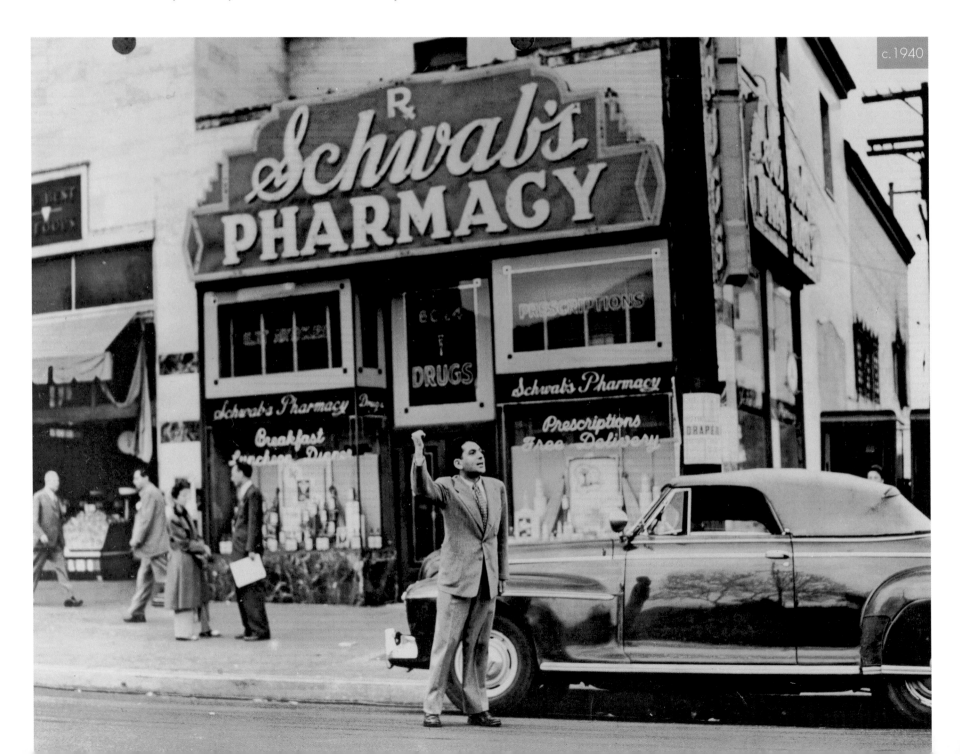

c.1940

1945

LEFT: In 1932 the Schwab brothers started a drugstore at 8024 Sunset Boulevard that became a movie business hangout, catering to actors, writers, producers, and industry insiders. It even had a pager and a special phone installed for the growing show-business clientele. Lana Turner was not actually discovered here, but the Marx brothers, Charles Laughton, Cesar Romero, and Judy Garland were regulars. James Dean relaxed here, William Holden (as Joe Gillis) hung out here in *Sunset Boulevard*, and Sidney Skolsky had an office upstairs where he wrote a column called "From a Stool at Schwab's." A unique drugstore, Schwab's sold top-quality cosmetics and the best ice-cream sodas. Charlie Chaplin made his own milk shakes at the famous soda fountain.

BELOW: Up until 1986 when Schwab's closed, managers, agents, and talent scouts discussed business in the booths. Shelley Winters was there most mornings; Cher, Robert Forster, Sally Kellerman, and Jack Nicholson came, too. Schwab's was torn down in 1988 and replaced with a multistory complex housing movie theaters, stores, and a gym. Today modern stars such as Calista Flockhart, Ben Affleck, Leonardo DiCaprio, and Drew Barrymore have been spotted at the new plaza.

LEFT: The future Miss Marple, Angela Lansbury has a soda.

FAR LEFT: Columnist Sidney Skolsky hails a cab outside Schwab's in the early 1940s.

GREENBLATT'S DELI

From delicatessen to comedy club

LEFT: Founded in 1926, this wonderful old delicatessen has served regular folks and the Hollywood elite for decades. It moved west a few blocks to this Sunset Boulevard location on the corner of Laurel Avenue in 1940. From there it became a Hollywood Landmark, known especially for serving the best turkey sandwiches and chicken noodle soup around. The establishment was also renowned for its extensive wine department, which delivered to movie and recording stars living in the Laurel Canyon area. The original building it occupied was once owned by Groucho Marx.

c.1950

RIGHT AND BELOW: In 1979 Greenblatt's moved next door. Now a hip, upscale deli, it serves the best tasting kosher and hearty American food, with the restaurant upstairs and the deli and impressive wine store below. Brad Pitt and Brendan Fraser are among today's celebs who use it. The corner building left vacant by the deli's move was quickly taken over by a sixteen-year-old Jamie Masada, who opened the Laugh Factory here. The Laugh Factory has become one of Hollywood's most successful comedy outlets, mixing new names with established comics, and has also become a great source of new talent for the Hollywood scouts. Richard Pryor was first to play here in 1979, and after his performance he handed the young Masada a $100 bill saying, "You need this for your rent, boy." Masada has built on that philanthropy with many charitable community initiatives and further Laugh Factories in Long Beach, Las Vegas and Chicago.

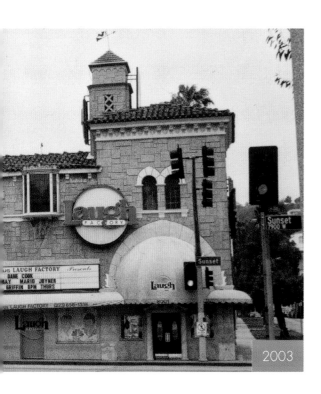

2003

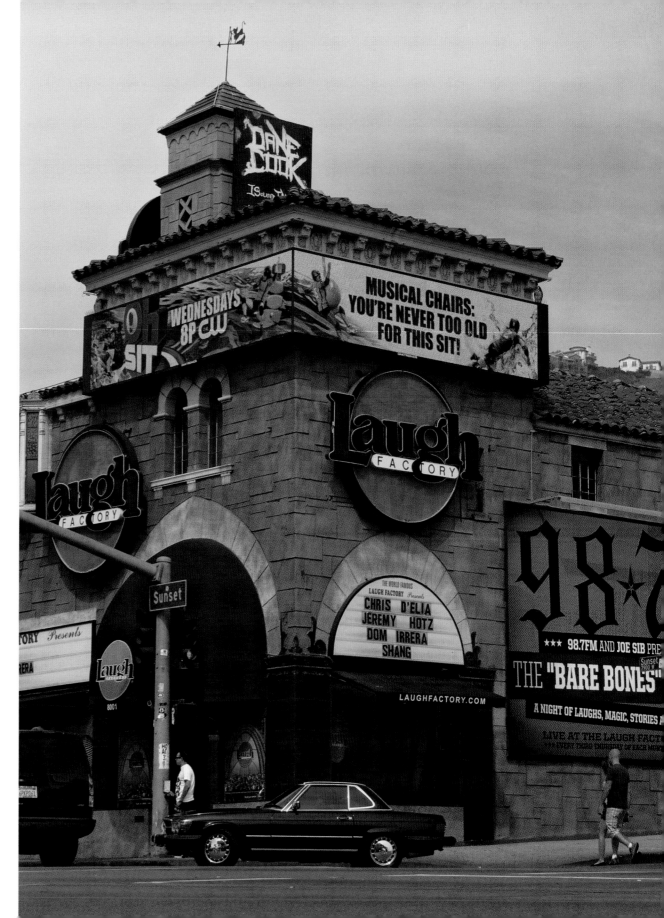

1936

SARDI'S
This 1930s restaurant became an adult club in the 1980s

ABOVE: The filming of Paramount's aptly named *Hollywood Boulevard* in front of Sardi's in 1936.

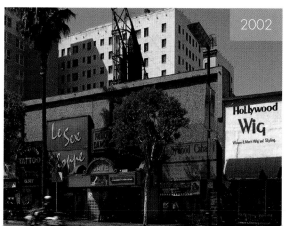

2002

LEFT: Designed in ultramodern metal and frosted glass by Rudolph Schindler, Sardi's opened at 6313 Hollywood Boulevard, near Vine Street, in 1932. The Depression called for a scaling back—even in Hollywood—and the big bands were now gone, as was any lavish entertainment. Breakfast and lunch were the big things at Sardi's, which was the sister of New York's Sardi's. Tom Breneman broadcast his national radio show from here and Maurice Chevalier loved the new restaurant, as did Wallace Beery, Marlene Dietrich, and Joan Crawford. After the golden era melted away, the center of Hollywood changed and adult movie theaters and discount shops moved into the deserted buildings. The site where Sardi's once stood housed a popular dance hall during the 1960s and 1970s, and now has a tattoo shop and a range of adult entertainment.

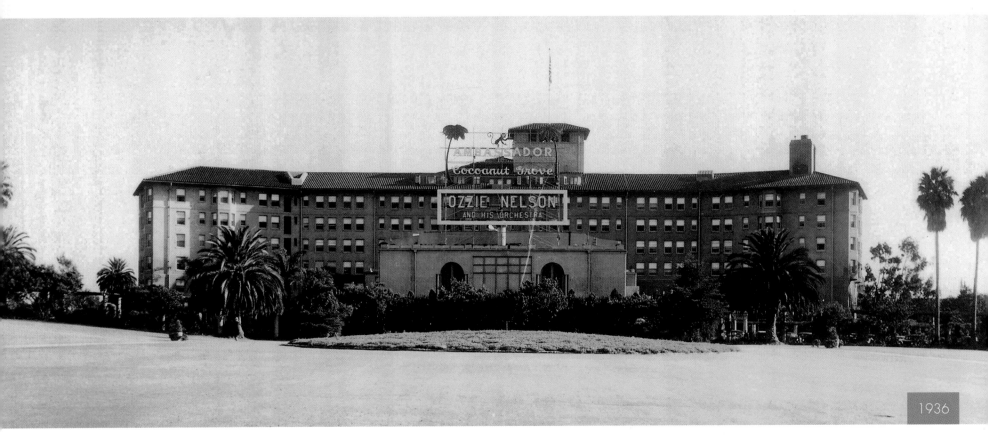

1936

COCOANUT GROVE

A tropical jungle in the heart of a luxury Italian-style hotel

ABOVE AND ABOVE RIGHT: When the sprawling 400-room, Italian-style Ambassador Hotel opened on Wilshire Boulevard in 1921, it quickly became the place to be seen. By April 21, the Grand Ballroom had been converted into a nightclub that became world famous: the Cocoanut Grove. Guests enjoyed a tropical grove of several hundred fake palm trees (left over from the filming of Valentino's *The Sheik*) with fake monkeys climbing them. The tables and chairs were bamboo and wicker. This was the height of exotic glamour in the 1920s and the stars lined up to attend and play. Chaplin entertained, Howard Hughes danced the rumba, Judy Garland sang, and Joan Crawford and Carole Lombard were said to have competed for dance trophies here. Pola Negri would walk her pet cheetah on the manicured grounds of the hotel. During the 1930s, six Academy Awards ceremonies and the first Golden Globe Awards dinner were held at the Cocoanut Grove.

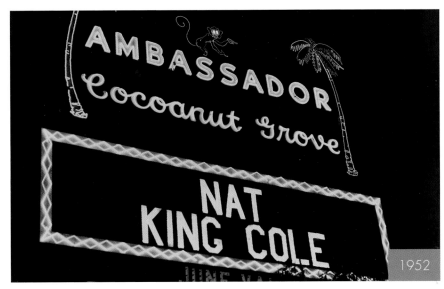

1952

BELOW: A postcard from the 1930s and a matchbook promoting the hotel.

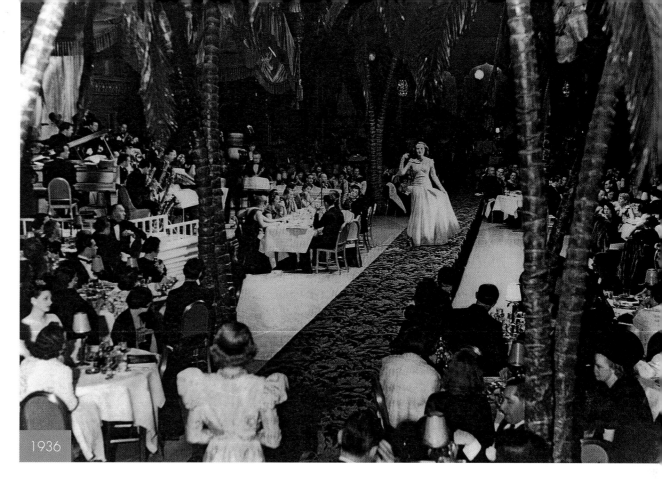

RIGHT: During World War II the Ambassador Hotel was used for war fundraisers and along with the Hollywood Canteen and the Palladium was a popular haunt for service personnel.

LEFT: Nat King Cole was a star attraction at the Cocoanut Grove from 1949 to 1955.

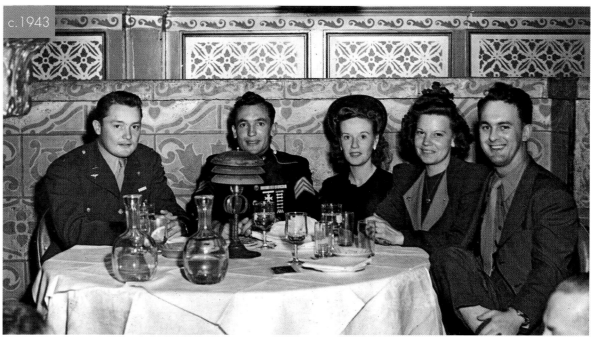

2003

AMBASSADOR HOTEL / ROBERT F. KENNEDY
COMMUNITY SCHOOLS
The assassination of Robert Kennedy heralded the decline of the Ambassador

LEFT AND ABOVE: Having just secured the California Democratic presidential primary election on June 5, 1968, Senator Robert F. Kennedy was assassinated as he passed through the kitchen area of the hotel by Palestinian gunman, Sirhan Sirhan. The tragedy helped accelerate the hotel's demise, along with the slide of the neighborhood. Despite a mid-1970s renovation overseen by Sammy Davis, Jr., the hotel was closed in 1989. A liquidation sale of the hotel's contents was conducted in 1991. It was used as a backdrop to many films as it slowly declined over the next twenty years. It featured in *Pretty Woman*, *L.A. Story*, *The Wedding Singer*, *Apollo 13*, *Beaches*, *Scream 2*, *Catch Me If You Can*, *The Mask*, *Forrest Gump*, and *Fear and Loathing in Las Vegas*. Emilio Estevez's movie about RFK *Bobby* was filmed there during late 2005. Perhaps the greatest memorial to the Ambassador Hotel was the movie *The Thirteenth Floor* which transformed it back to 1937 Los Angeles. From 2004 to 2005, it became the subject of a legal tussle between the Los Angeles Unified School District, who wanted to build a school on the site, and preservationists (including Diane Keaton), who wanted the hotel restored. Donald Trump wanted to build on the site and was defeated while Sirhan Sirhan's lawyers wanted access to the kitchen for more tests. Eventually the Robert F. Kennedy Community Schools were built on the site and opened in 2009 and 2010. Although there were attempts to incorporate the old nightclub as the school's auditorium, and preserve the coffee shop designed by architect Paul Williams, they were demolished due to a reported lack of structural integrity.

1941

CIRO'S

This prestigious nightclub became a comedy club in 1972

ABOVE: Entrepreneur Billy Wilkerson opened his nightclub, Ciro's, on January 1940, at 8433 Sunset Boulevard on the Sunset Strip. It was built on the site of the old Club Seville. Ciro's had a baroque green, red, and gilt interior and was an instant hit. "Everybody that's anybody will be at Ciro's" ran the ads in the *Hollywood Reporter*. Here, the audience watched Sophie Tucker, Edith Piaf, Billie Holiday, Peggy Lee, Dean Martin, and Jerry Lewis, along with the Emil Coleman Orchestra. Betty Grable, Gary Cooper, Lucille Ball, and Desi Arnaz

were regulars before the nightclub closed in the late 1950s. Frank Sinatra and his wife Nancy celebrated Frank's first Academy Award win at Ciro's nightclub—he was given an honorary Oscar for *The House I Live In*, a film advocating racial, ethnic, and religious tolerance. Directed by Mervyn Leroy, its theme song was written and performed by Sinatra. Frank Sinatra went on to win an Academy Award for Best Supporting Actor in *From Here to Eternity* in 1953.

BELOW: Ronald Reagan shows first wife, actress Jane Wyman, to her seat in Ciro's in 1944.

1944

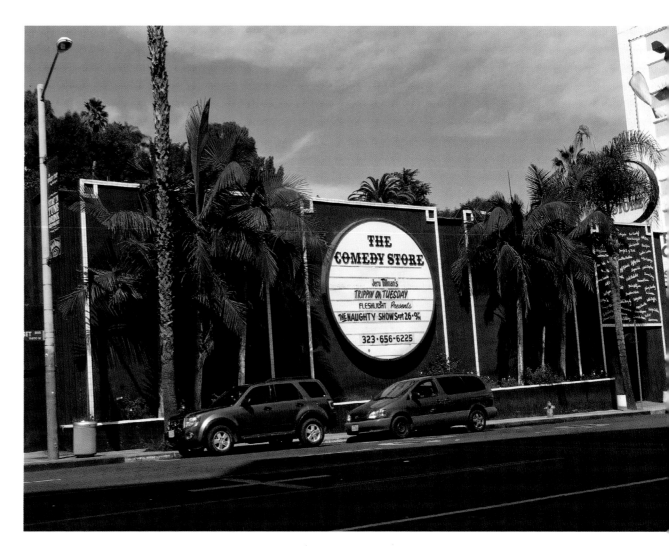

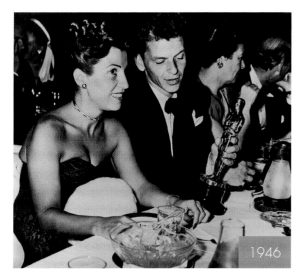

1946

ABOVE: Frank celebrates his first Oscar win with wife Nancy Barbato Sinatra at Ciro's in 1946.

ABOVE: The site of the great nightclub now plays host to the Comedy Store, which opened in 1972 when comedian Sammy Shore and his wife Mitzi leased space inside the building. Johnny Carson was one of the first comic acts in the ninety-nine-seat theater. By 1973 Mitzi was running operations and was able to buy the building in 1976. She immediately renovated and expanded the club to include a 450-seat main room. Richard Pryor staged his comeback here, and for nearly forty years many other comedians have appeared, including David Letterman, Jay Leno, Gary Shandling, Whoopi Goldberg, Eddie Murphy, Michael Keaton, Paul Rodriguez, Elaine Boosler, Roseanne, and George Carlin. The Comedy store now stands as an icon in the world of American stand-up comedy.

HANDPRINT CEREMONY

Sid Grauman's inspirational idea for promoting the Chinese Theatre

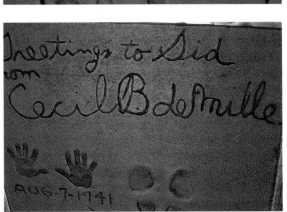

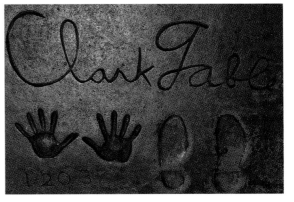

RIGHT: Some like it quick-drying... Marilyn Monroe and Jane Russell make their mark in June 1953.

1953

ABOVE: The famous handprints and footprints in the forecourt of Grauman's Chinese Theatre began back in 1927—by accident. Actress Norma Talmadge stumbled onto freshly laid cement in the theater forecourt, causing showman Sid Grauman to come up with the brilliant idea of having stars make impressions in the sidewalk on purpose. The very first hand and footprints were actually those of Mary Pickford and Douglas Fairbanks on April 30, 1927. Norma Talmadge's ceremony was the second, on May 18, 1927—her unique block boasts two sets of footprints. Since then more than 240 celebrities have been immortalized in the forecourt. In 1939, when Ginger Rogers made her

1953

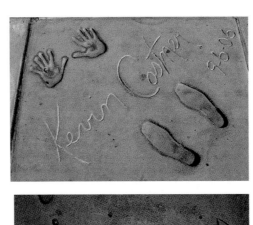
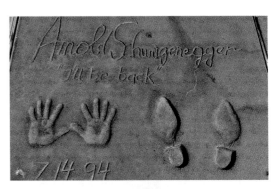
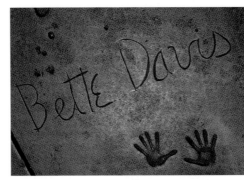
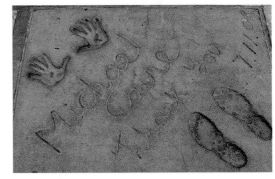
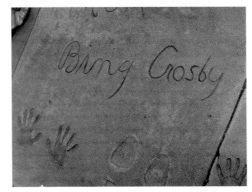
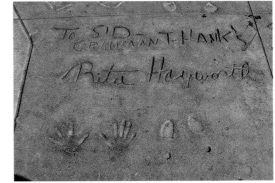
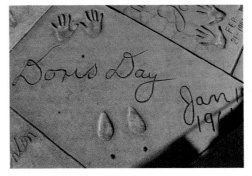
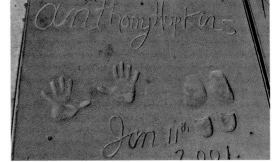

prints, she borrowed her mother's shoes, which were smaller. Steven Spielberg and George Lucas left sneaker prints. In some decades there have been more ceremonies than others. In the 1940s there were thirty-nine handprint ceremonies, while in the 1970s, just six. Fictional characters to leave their mark have included *Star Wars*' R2-D2 and C-3PO, Herbie, and Donald Duck. More recent handprints and footprints have been made by Cher, Jennifer Aniston, the *Twilight* series stars; Robert Pattinson, Kristen Stewart and Taylor Lautner, and *Batman* director Christopher Nolan.

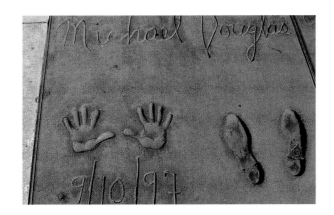

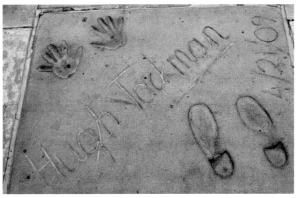

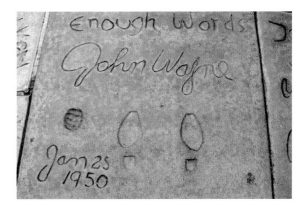

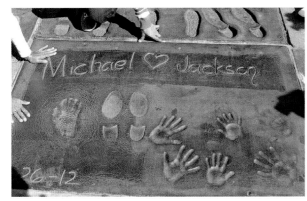

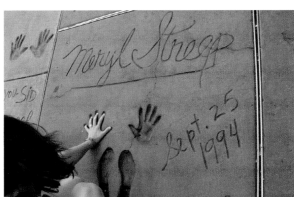

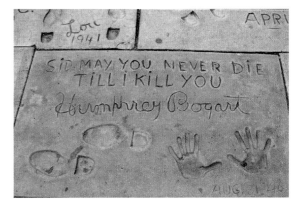

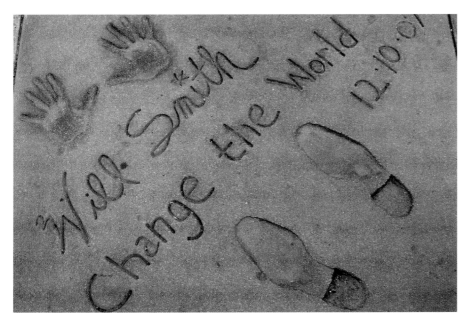

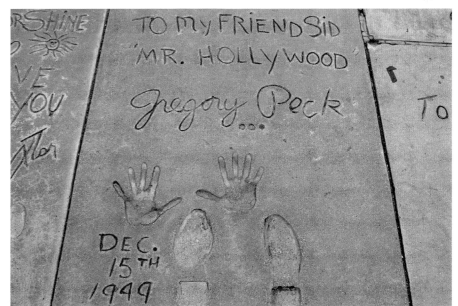